SHÔJO MANGA
POP & ROMANCE

SHÔJO MANGA: POP & ROMANCE

Copyright © 2010 Collins Design and Monsa Publications

All rights reserved. No part of this book may be used or reproduced in any manner whatsoever without written permission except in the case of brief quotations embodied in critical articles and reviews. For information, address Collins Design, 10 East 53rd Street, New York, NY 10022.

HarperCollins books may be purchased for educational, business, or sales promotional use. For information, please write: Special Markets Department, HarperCollins*Publishers*, 10 East 53rd Street, New York, NY 10022.

First published in 2010 by
Collins Design
An Imprint of HarperCollins*Publishers*
10 East 53rd Street
New York, NY 10022
Tel: (212) 207-7000
Fax: (212) 207-7654
www.harpercollins.com

Distributed throughout the world by
HarperCollins*Publishers*
10 East 53rd Street
New York, NY 10022
Fax: (212) 207-7654

Editor:
Josep Mª Minguet

Art direction, text, and layout:
Rubén García Cabezas
(Kamikaze Factory Studio)
for Monsa Publications

Illustrations:
Alicia Ruiz, Aurora García, Ayame Shiroi, Helena Écija,
Inma R., Irene Rodríguez, Miriam Álvarez y Pásztor Alexa.

Book produced with the collaboration of Eli Basanta
www.elibasanta.com

Page four artwork "Something warm" courtesy of Aurora García.

Translation:
Globulart

Library of Congress Control Number: 2010932367

ISBN:978-0-0-6202351-3

Printed in China
Third Printing, 2012

SHÔJO MANGA
POP & ROMANCE

KAMIKAZE FACTORY STUDIO

COLLINS DESIGN
An Imprint of HarperCollins Publishers

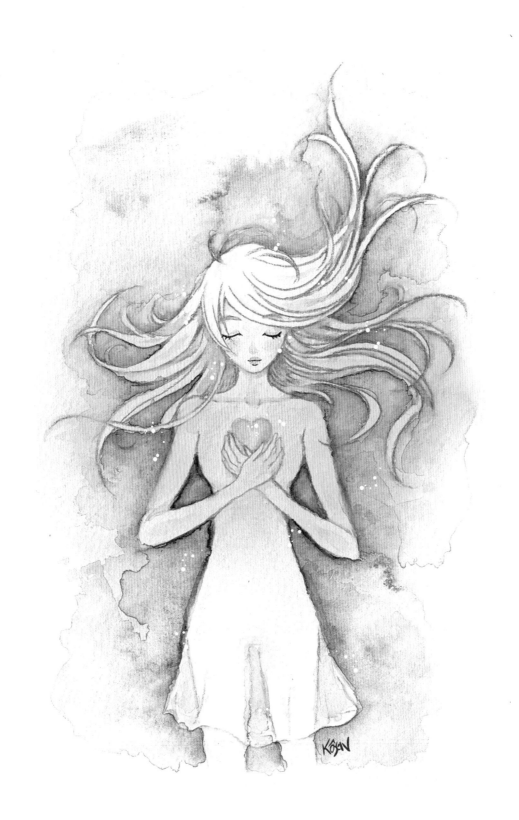

CONTENTS

Introduction

Chapter 1: Vintage Romance

Chapter 2: Pop & Love

Chapter 3: Gothic Zone

Chapter 4: Magic Lovers

Chapter 5: Legends

Extras

Introduction

PREFACE
DIGITAL WORKSHOP

PREFACE

A LITTLE HISTORY ON SHÔJO MANGA

Shôjo is a Japanese word that means "girl." Thus *shôjo manga* is used to refer to Japanese comics aimed at female readers between ten and eighteen years of age.

Shôjo is defined by its themes: high school love stories, girls with special powers or a love of fashion, sports, music and mythology. Its characters are highly stylized with fashionable clothing, petite figures, big eyes and long eyelashes

Historically, the most iconic *shôjo* are *Ciao* (a magazine published by Shogakukan), *Asuka Langley Soryu* (a character from various Neon Genesis Evangelion publications and games), *Hana to Yume* (a magazine published by Hakusensha), *Nakayoshi* (a magazine published by Kodansha), and *Ribon no Kishi* (titled *Princess Knight* in English and also published by Kodansha). These publications defined

the *shôjo manga* genre and set high standards for the characters and plots that make it easy to identify.

Modern *shôjo* reflects the high standards set for its genre, but during the past twenty years it has come to contain several variants, such as *josei* (manga for women) and moe animes (highly detailed animation series featuring cute characters and a rounded drawing style) that have delighted enthusiasts of Japanese stories.

Today, *Ribon no Kishi* by Osamu Tezuka is still one of most well known shojo publications. Others like *Candy Candy* by Kyoko Mizuki, *Versailles no Bara* by Riyoko Ikeda, Naoko Takeuchi's *Sailor Moon* and CLAMP's *Cardcaptor Sakura* have also become extremely popular and achieved their own loyal fans.

An appreciation for *shôjo* throughout the world has lead to a legion of girls and now young boys as well, who regularly devour it. The sugary sweetness of the genre has decreased and it is now more appealing to a variety of tastes.

SHÔJO STEP BY STEP

This book is born from a unisex conception of *manga*. We have created a modern *shôjo* drawing manual, fit for all readers and useful for everyone who wants to improve their digital illustration and coloring skills.

Eight sensational artists, great professionals with years of experience and enjoying international recognition, will guide us through twenty-two exercises grouped in five chapters, showing us their personal view of *manga* from traditional *shôjo* to more specialized and precious *moe* drawings, and

others with gothic or vintage touches.

The visual approach chosen for the illustrations of all exercises references *shôjo animes* (animated series for girls), which are usually finished like design illustrations.

Therefore this book is useful for illustrators and both *manga* and *anime* enthusiasts alike, as well as all kinds of designers (advertising, fashion, videogame designers...), to use as a source of inspiration for their own creations.

Rubén García
Art director
Kamikaze Factory Studio

DIGITAL WORKSHOP

It is a must for modern illustrators to have at least a basic understanding of image digitizing. Since all of the exercises in this book were digitally colored, we offer tools and techniquest possible with Adobe Photoshop, although we also recommend the use of programs like Corel Photo-Paint Tool, SAI and Illust Studio.

SCANNING

A good scan is the most essential element to start the process of creating *shōjo manga* illustrations. If we start with a black and white image, we will import the drawing as a gray scale image; this will speed up the digitizing process.

Scanning resolution must be set to at least 300 dpi, although all the exercises in this book were scanned at 600 dpi in order to have an image of greater quality and resolution.

If we scan the drawing as a pure black and white bitmap, an appropriate resolution should be at least 1200 dpi.

Once we have the line drawing on our computer, we will clean it so that there is sufficient contrast between black and white areas.

Going to the Image menu in Photoshop, which is inside the Settings sub-menu, we can use the Levels and Curves tools to tweak the image so that lines are as dark as possible and the background is white and clean.

Once our line drawing is ready, we will use the Image menu again and change the Mode to CMYK, since we are working on an image for printing, thus needing an image with four channels, one for each ink. If you would rather start working in RGB mode and then change the image to CMYK, be warned that colors may vary.

Once the image preparation process has been completed, we can begin the coloring process in Photoshop or save it in .psd or .tiff format and color it using other software.

Naturally, it is also important to have our computer screen well adjusted and calibrated.

DIGITAL COLORING

If the line drawing is displayed as the Background layer in the Layers pane, it will be locked. We unlock it by double-clicking on it, making it Layer 0. Starting here, we can create new layers, in which we add color to the drawing.

In a standard coloring process, these layers are set to a Blending mode of Multiply or Darken. This way, color overlays the black line drawing as if the white parts were transparent.

This makes black lines appear over the colored areas, as if the white parts of the drawing were transparent. There are other ways of doing it, but this is the simplest, fastest and most efficient one.

To apply digital color, different tools from the Toolbar can be used: Marquees, Lasso, Brushes, Fills (Paint Bucket and Gradient). Any method can be valid if we use different layers and remember how blending modes work. It is also advisable to name each layer to help with organizing the task.

The effects achieved by using the different Blending modes can prove very useful to applying overlaid gradients, creating outlines with strokes on the outside, shadows, highlights and other effects. It is advisable, though, not to overuse these types of resources or the finished product will look too cold and digital.

Be aware that the use of overlaid textures and watercolor brushes with different opacities is an interesting option to give a more traditional feel to the coloring.

It is necessary to point out that graphic tablets are not mandatory for the coloring process, however it is true that, once mastered, they speed up the process and allow us to work with brushes in a much more comprehensive and effective manner.

The creators of the illustrations in this book recommend using any of the tablets made by Wacom, even the cheapest ones, as they easily allow you to take full advantage of the features offered by digital coloring software.

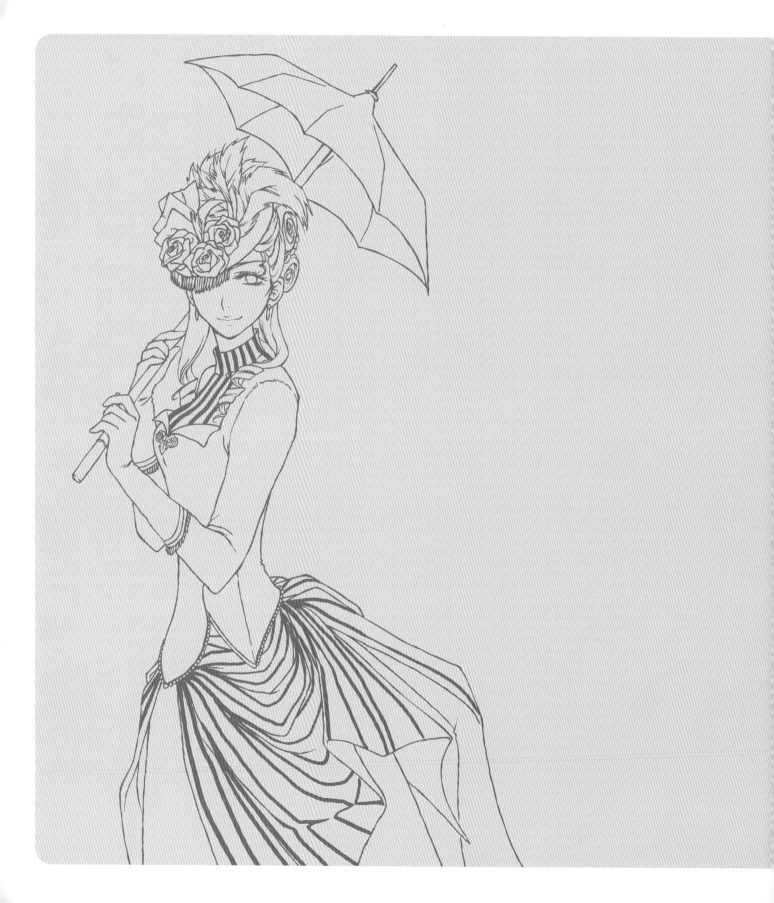

Vintage Romance

VICTORIA

At the height of the industrial revolution, Victoria takes a stroll through mid 19th century London, dressed up in her finest garments and shielding herself from the incipient sunlight with an elegant parasol. Few people are aware that she struggled for her status among the upper class ladies. Now, no party takes place in town without having Victoria among the guests. But everything comes with a price...

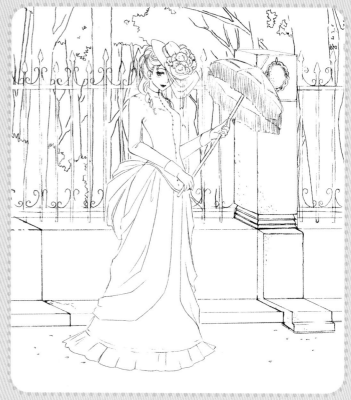

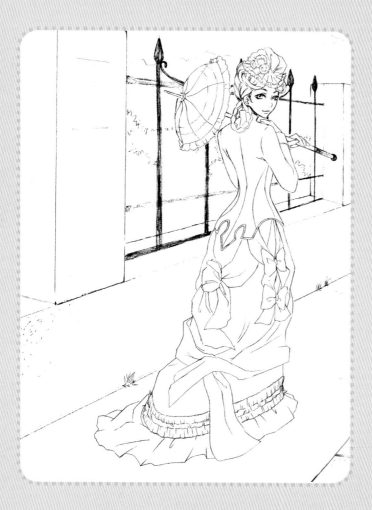

1. SKETCHES

We try different points of view, perspectives and compositions to come up with an image that is elegant and allows our Victorian lady to show off her attire.

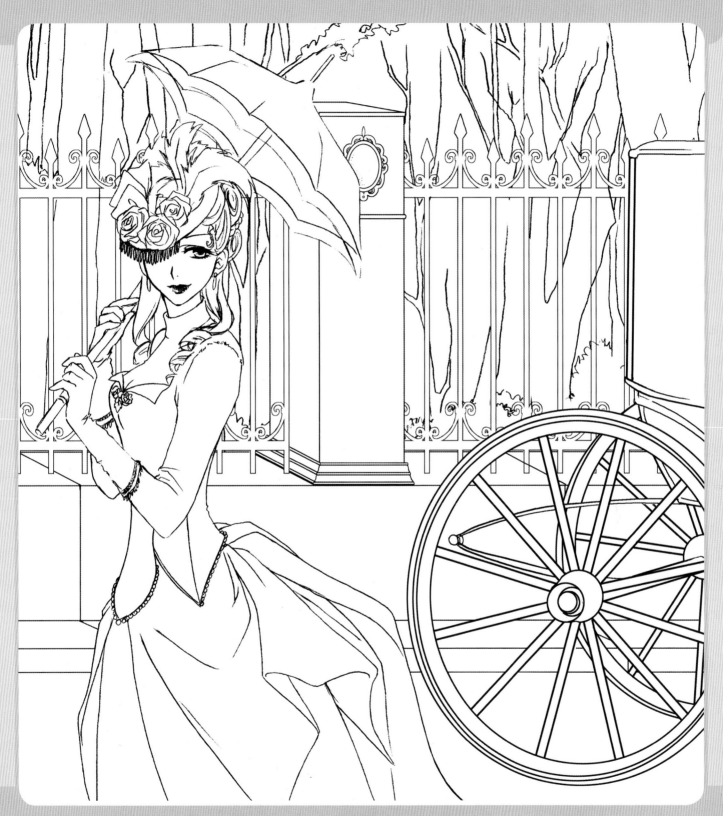

2. STRUCTURE

We lay out all the elements that are part of the scene, both on the character and in the background. We also make a preliminary mock-up of the shape and position of the hands while holding the parasol.

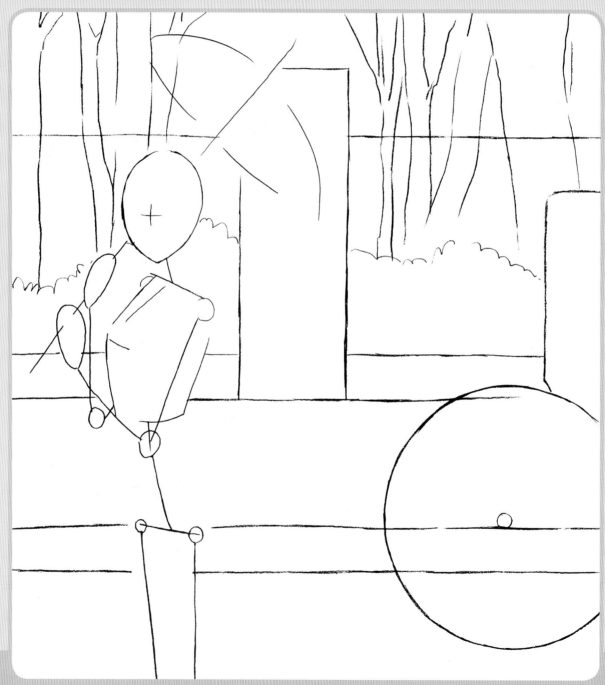

3. VOLUME

The girl must have a slender figure, so we must be careful not to make the arms excessively thick. The hands and the position of the wrists require special attention, so we will outline them with ovals to simplify them and pave the way for the final drawing.

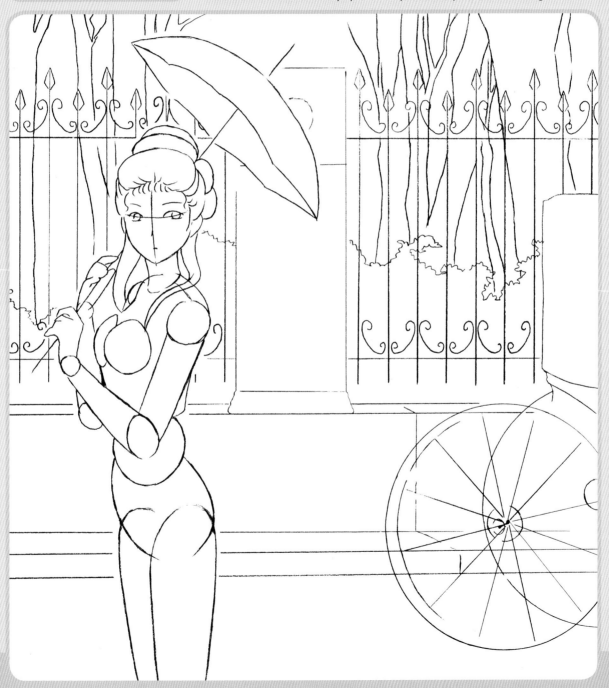

4. ANATOMY

In order to fit the elaborate dress and hairdo, we carefully add details to the hair and chest. We finish drawing the hands paying special attention to make the fingers slim, as befits a young lady, and make them grip the width of the parasol.

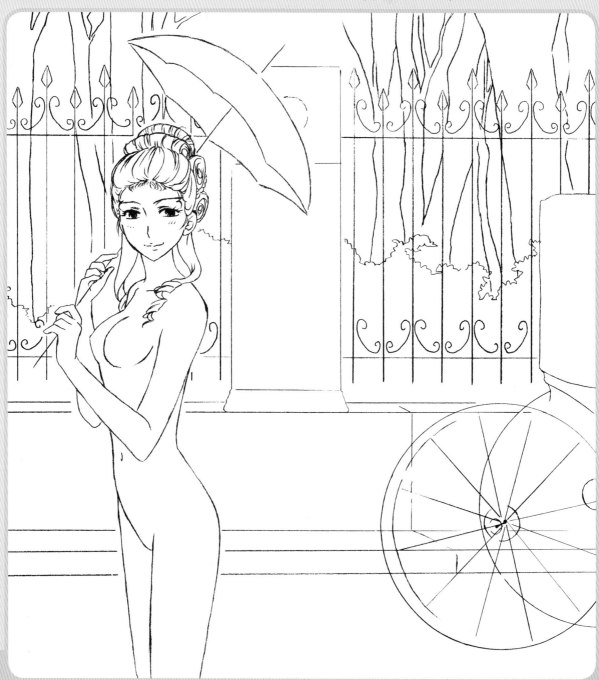

5. DETAILS

The dress is the hardest part to draw. We can trace a compass for the coach wheels and use a ruler for the straight lines in the background. This can also be done digitally, with vector shapes and outlines.

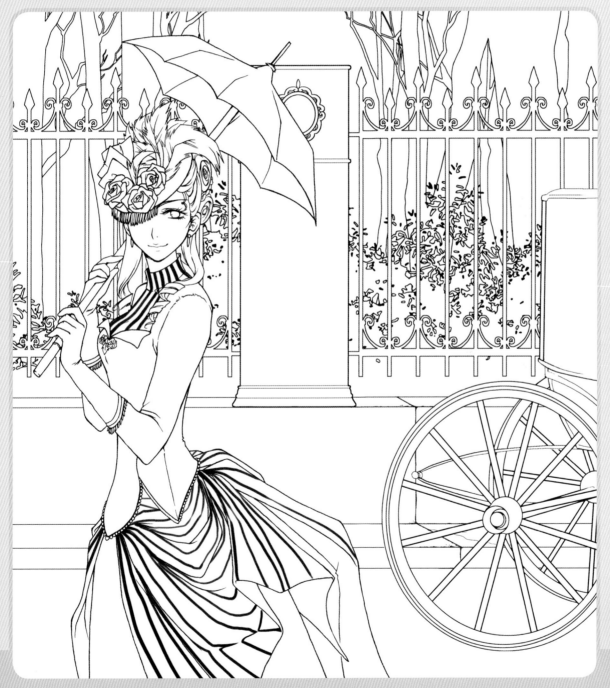

6.1. COLOR

We set the chromatic range of the drawing using flat colors for the character and the objects, and a gradient for the background. To organize things better, we arrange the different tones along various independent layers with their blending mode set to Multiply.

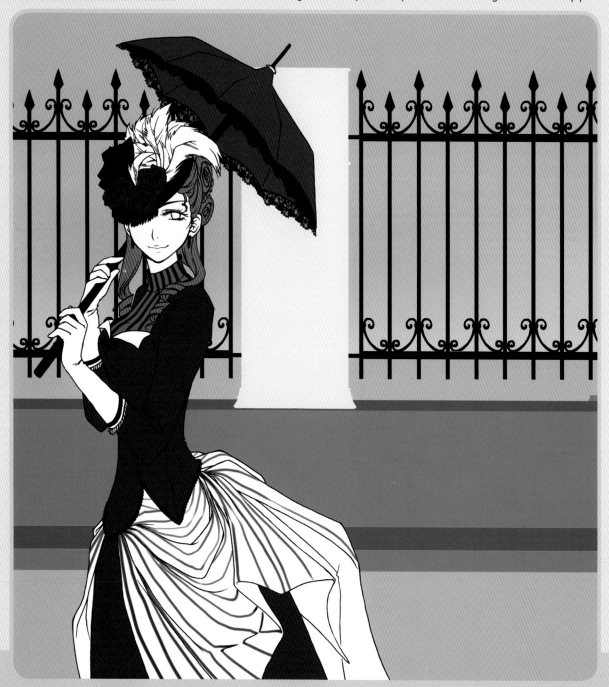

6.2. COLOR

We apply shadows using watercolor brushes and our graphic tablet. It is a good idea to start applying brush strokes with a light opacity and make tones gradually darker as we apply each stroke. We enrich the background by adding outlines of shrubs filled with flat colors.

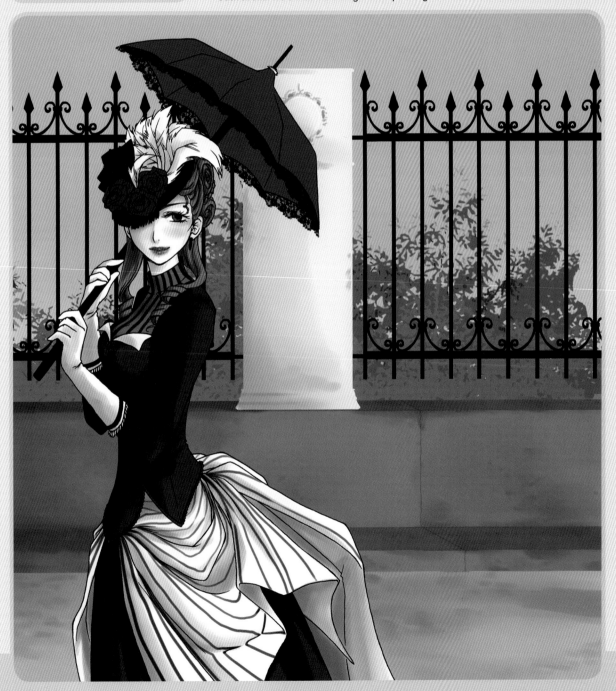

6.3. COLOR

After adding the coach, we add detail to the elements in the background, for instance adding clouds to the sky. We apply some highlights to our character to add volume.

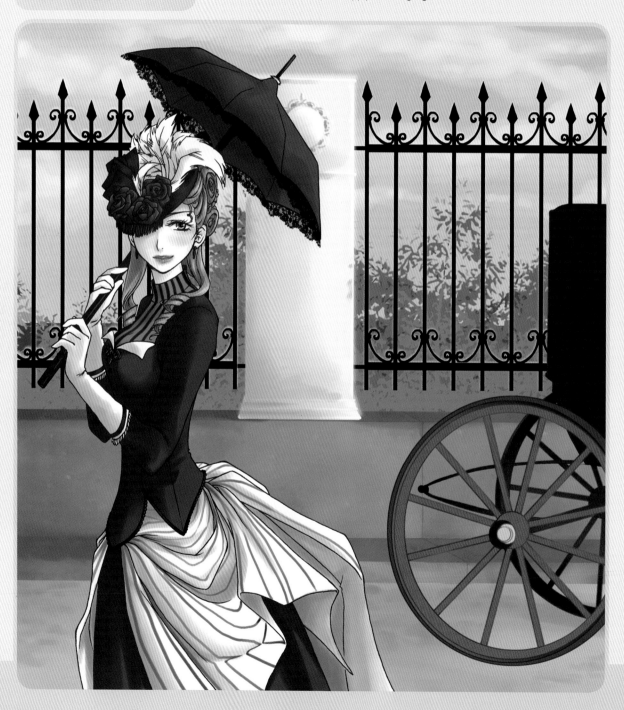

6.4. COLOR

Now we pay special attention to the elements in the background. We paint the shadows on the coach and add outlines of trees and more shrubs to increase the sense of depth of the park that can be glimpsed behind the railing.

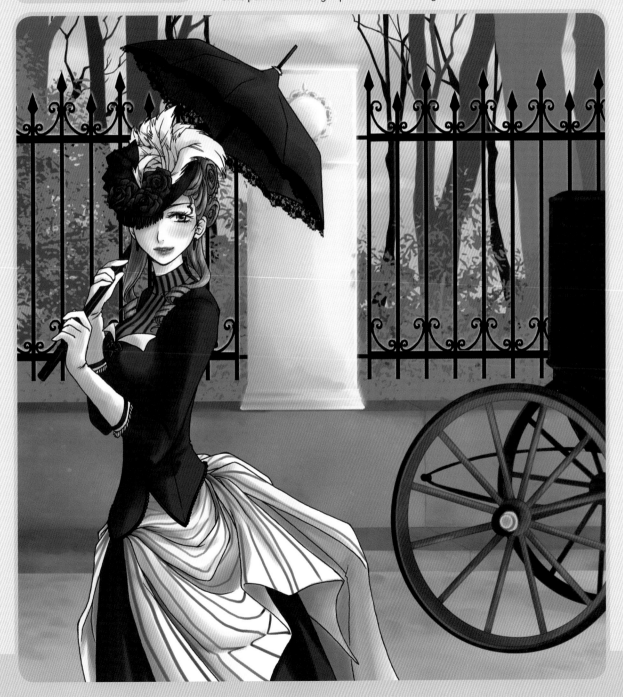

6.5 COLOR

We shade the trees and redistribute some of the elements in the background. We then draw the shadows projected on the ground by the coach and add highlights.

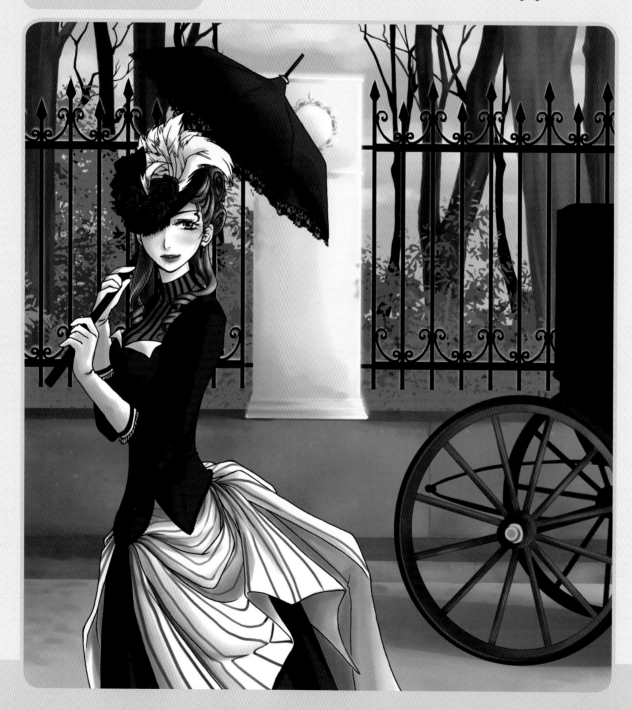

6.6. COLOR

Once the coloring is complete, we adjust the lighting of the illustration. The background is lightened so that our lady, who predominantly uses dark tones, stands out. We also blur the background using a Gaussian Blur filter to enhance the sense of depth.

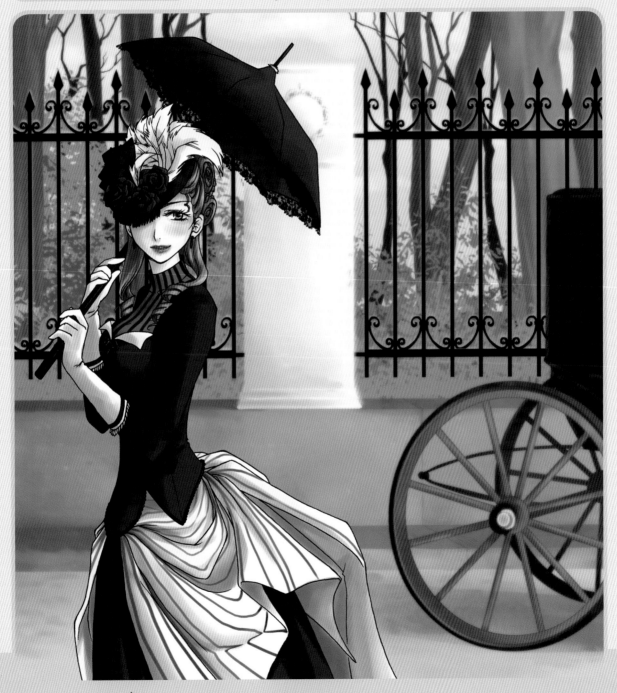

6.7 COLOR

To create the atmosphere of a sunny day, we add a few sun rays with a low opacity and paint a glow around Victoria using softened brush strokes. We then add several white light spots to her dress.

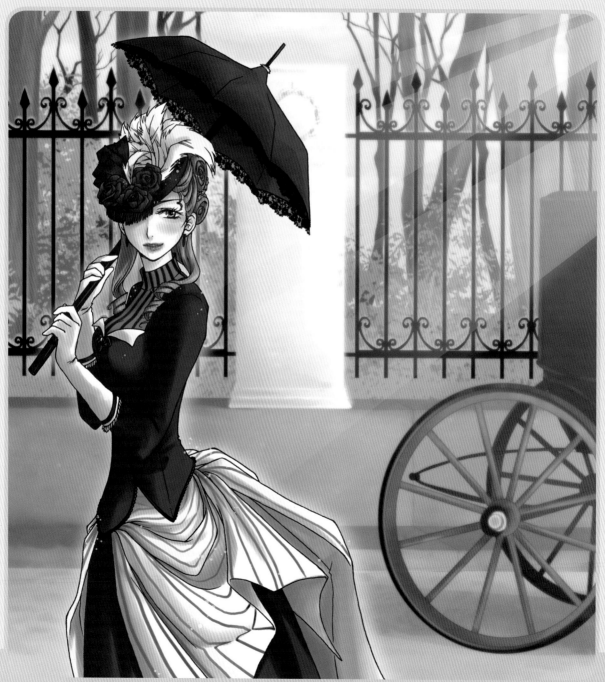

6.8. COLOR

We further lighten the background, adding blurred layers of sunlight with low opacity.

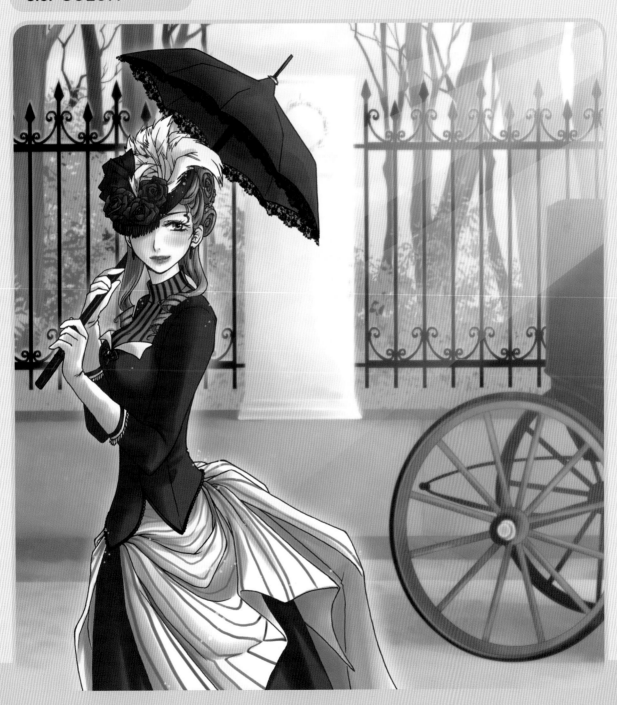

Finishing touches

- We apply several final light touches with two additional layers that will make the background even brighter.

- We rescale Victoria slightly and move her a bit to the right, so that the image has a better composition.

- We enhance the subtle glow around the railing. This makes it stand out over the park, and it will be even more noticeable with the final lighting.

Tips & tricks

- Before finishing the line drawing, it is advisable to outline the composition of the picture.

- Once the image has been digitized, it is good practice to set different elements in separate layer groups, not only to make the coloring process easier, but also to prevent potential corrections and changes.

- In order to design classic dresses like this one, it is very important to collect documentation in the form of photographs and illustrations that will serve as a reference.

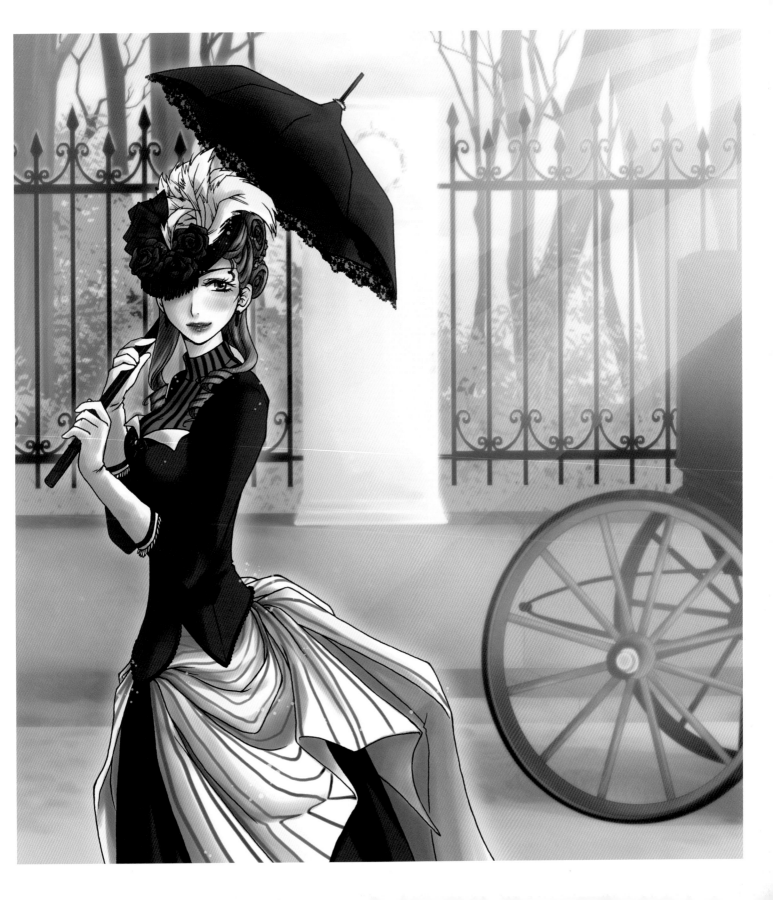

THE LADY OF SHANGHAI

The daughter of a Japanese mother and a Chinese father, this young lady manages a peculiar tea shop located on the outskirts of the Chinese city of Shanghai. It is a mysterious and magical place with Japanese decor whose exclusive clients wish to appease their innermost desires. But there are a series of rules to observe. If you are unfortunate enough to break one of said rules, the Lady of Shanghai will take revenge.

1. SKETCHES

At first we considered drawing a typical Japanese geisha, but then we decided it would be better to create a mysterious lady with a magical aura combining different Asian characteristics, a mixture of sensuality and elegance. Above all, we focused on the facial expression which must express the strength that corresponds to the madame of a business of such characteristics.

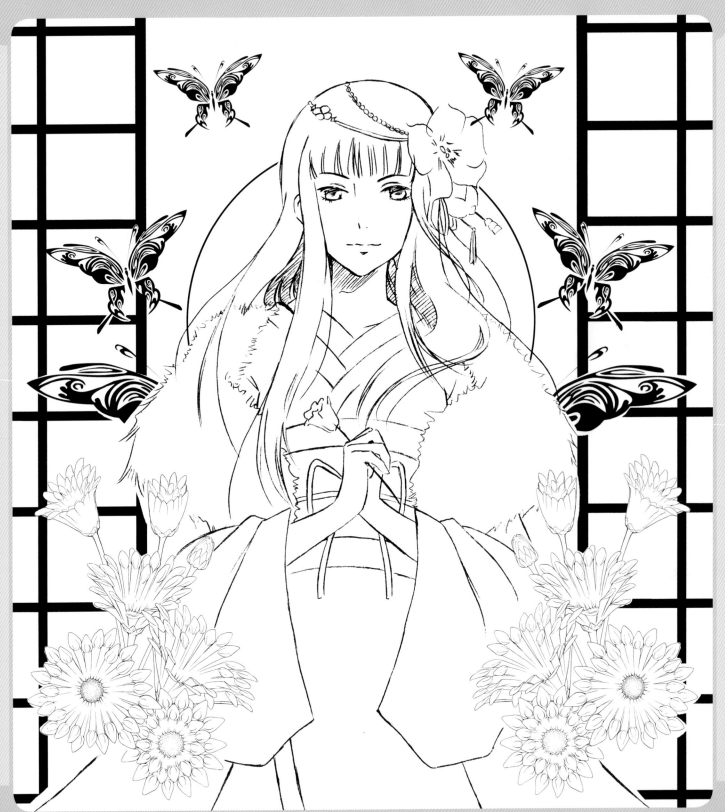

2. STRUCTURE

We start by laying out the various elements in the illustration and defining the pose of the character holding her hands together. This way, we can make sure the arms have the right size.

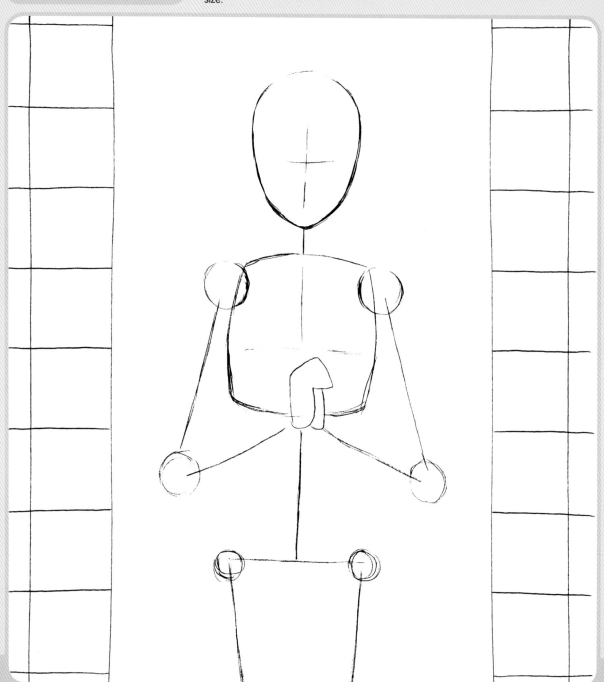

3. VOLUME

We finish the drawing a bit more, adding the elements that define our character, such as the hair, hips and chest.

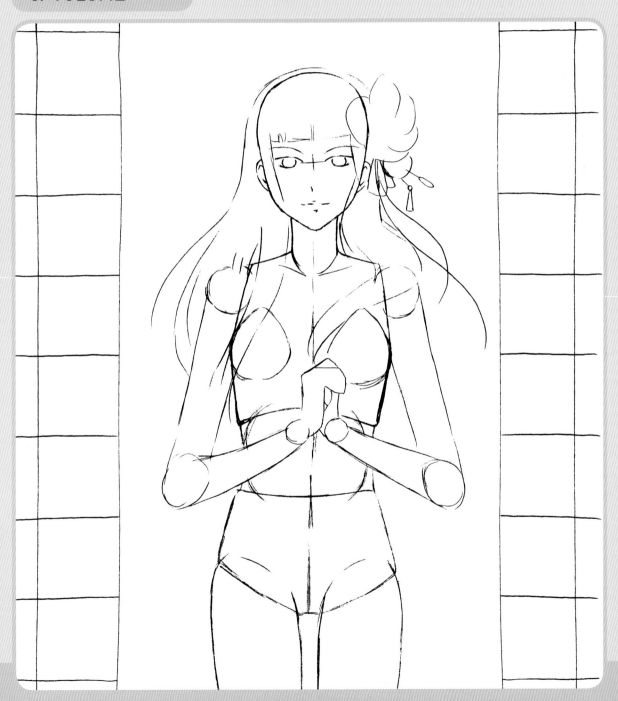

4. ANATOMY

We clean the drawing of unneeded lines and finish the outline of the character to make sure the anatomy is correct, before adding more detail. We have to pay attention when drawing the eyelids and eyebrows to get a mysterious look in her eyes.

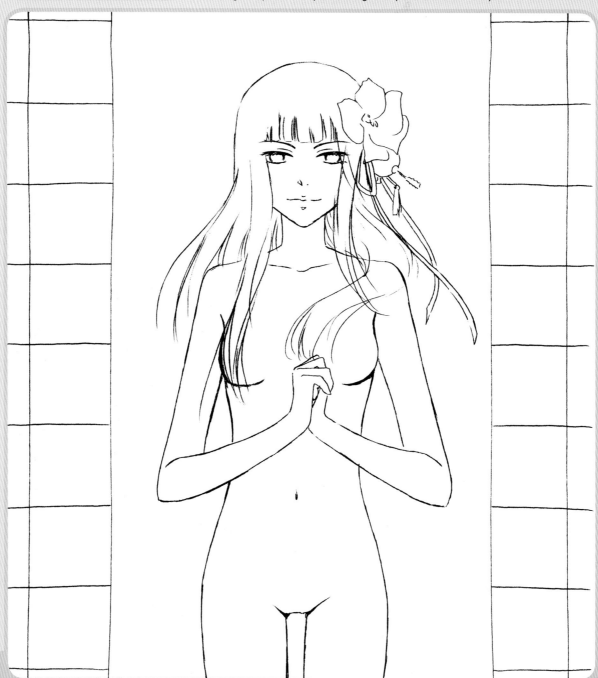

5. DETAILS

The traditional Japanese look is achieved with the kimono, held in place by an *obi*, and hair accessories. For the background, we draw a typical sliding door made of bamboo and paper.

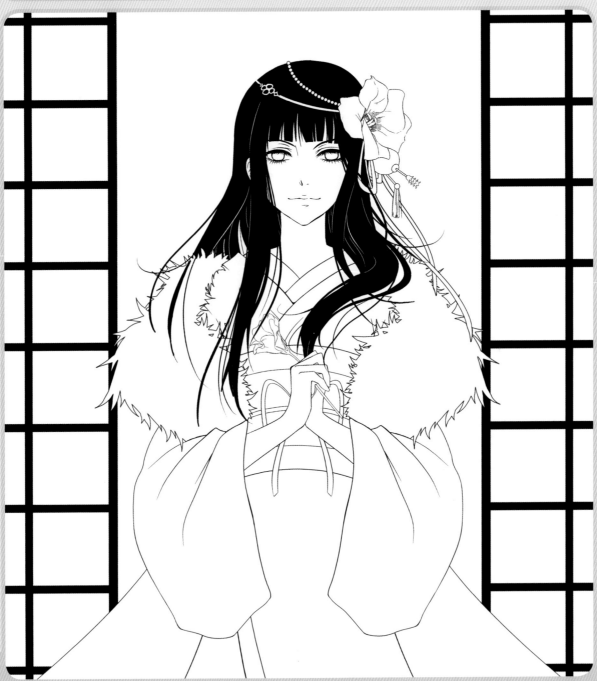

6.1. COLOR

We start applying flat colors, and simple gradients for the clothes; this is how we set the chromatic range of the illustration.

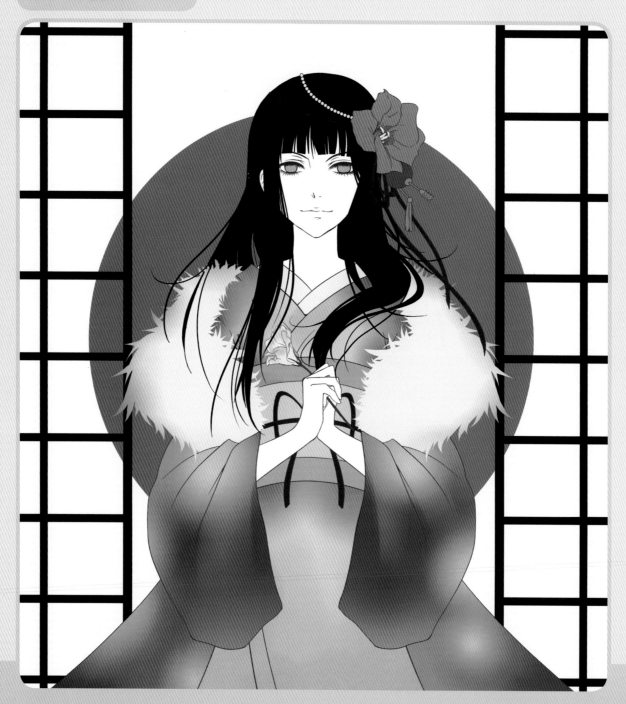

6.2. COLOR

The areas of light and shadow in the illustration are created painting with brushes on the color base we just created. Using soft, semi-transparent brushes we create the makeup of our character.

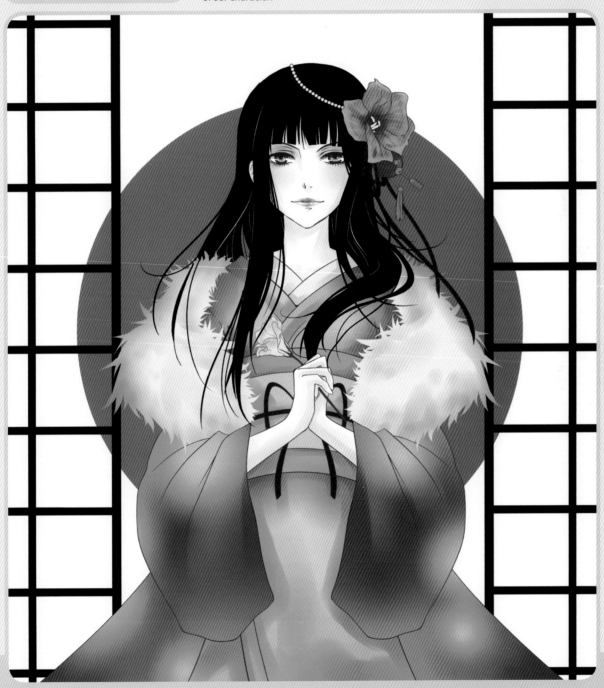

6.3. COLOR

Using a new layer we add textures over the drawing, lowering its opacity. Both the *obi* and the kimono have the same fibrous paper texture appearance, but the kimono is patterned with flowers and fans on its upper and lower parts.

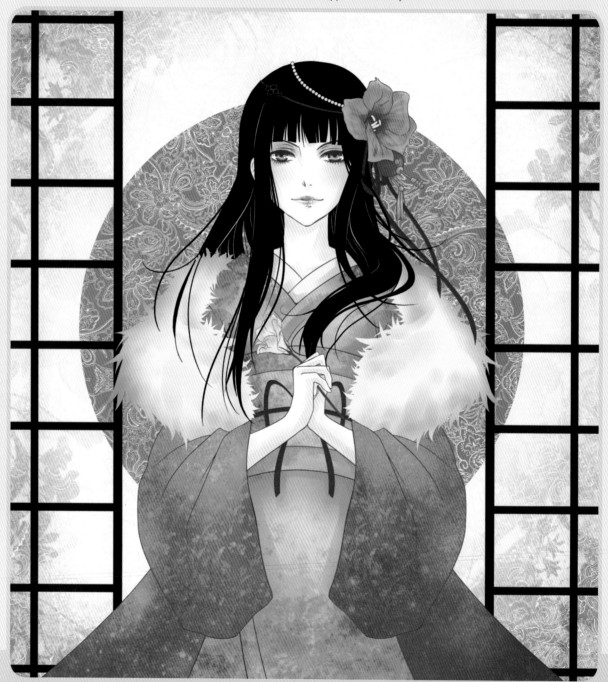

6.4. COLOR

We add a white shadow to the windows in the background and several golden butterflies. In the lower part of the illustration, we have included flowers with low opacity. Around the character, we apply a white Stroke with the Blending options for that layer.

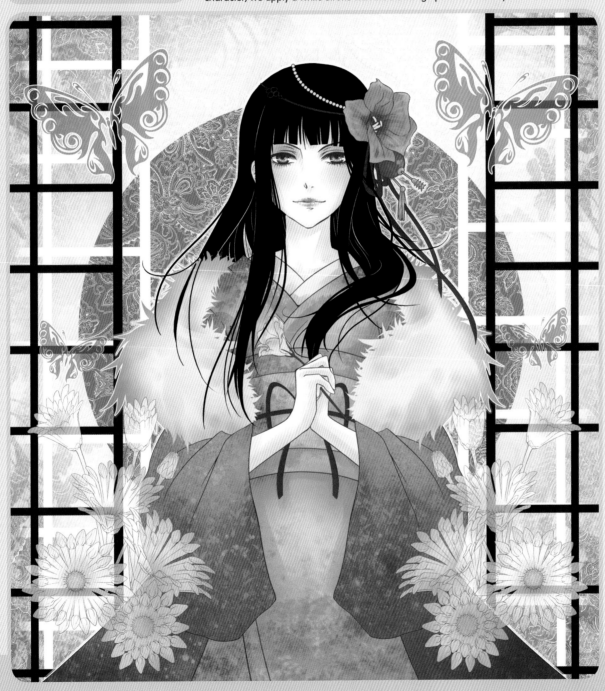

Finishing touches

- We lower the opacity of the white stroke outlining the butterflies.

- We apply hints of white acting as highlights; they give the image a special appeal and make it more eye-catching.

- In order to apply textures only in certain areas, we use layer masks, which let us show only certain parts of an image.

Tips & tricks

- The white stroke that outlines the lady and the butterflies detaches the elements from the background to make them stand out.

- The butterflies and the flowers both serve a decorative purpose and help balance the composition.

- When placing the ornaments it is vital to keep them from overshadowing the main character. A good way to do this is by playing with the opacity of the layers containing them, thus taking away some of their visual weight.

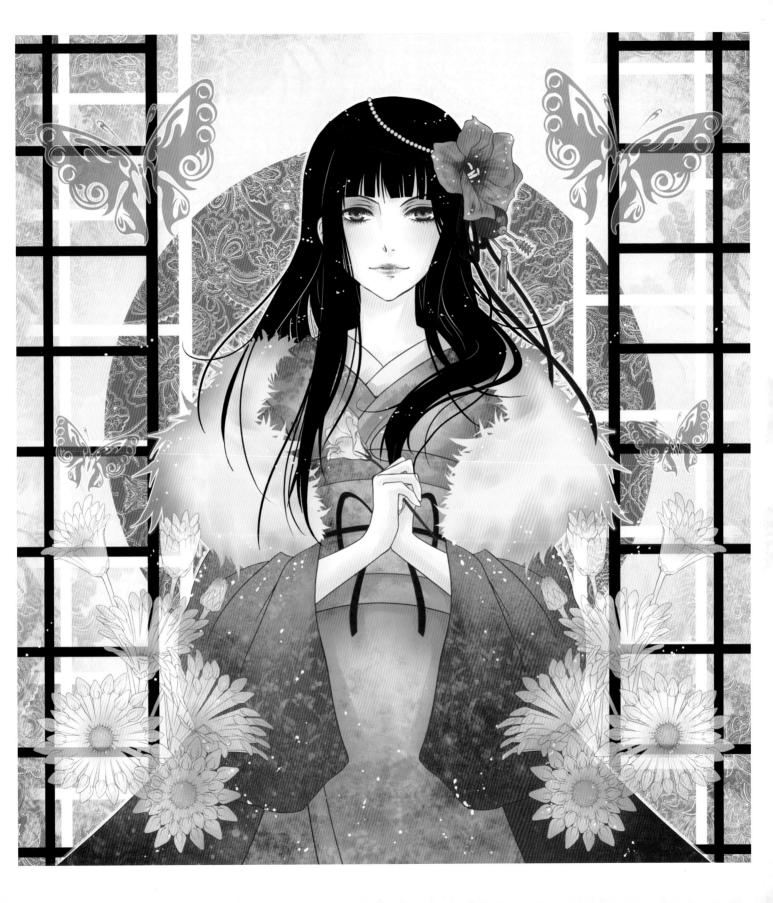

THE ARISTOCRATS

Dance, laugh and enjoy your privileges; eat, drink and surrender to the pleasures of life. Parties and revelries help you put aside the problems of your people, whom you keep subjugated and mostly out of your mind. But be wary a seed is growing among us, a seed that will soon germinate and stir the world up. For Napoleon will soon get hold of that which always belonged to us.

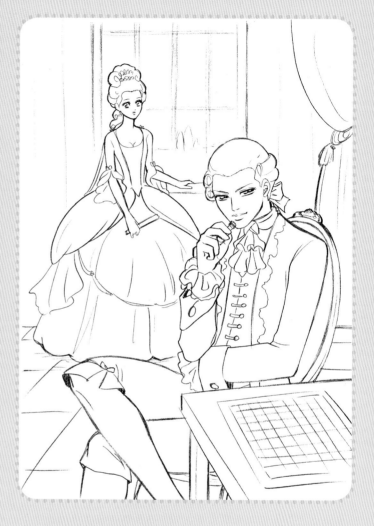

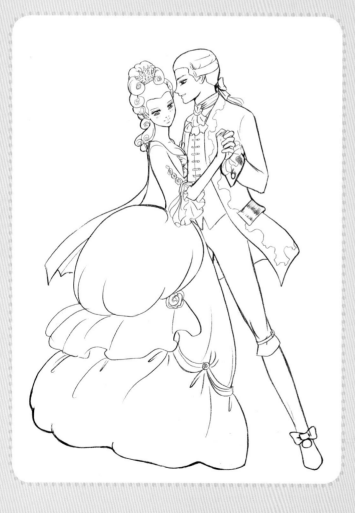

1. SKETCHES

The image depicts a lady and her beloved gentleman, with whom she maintains a dangerous friendship. After discarding a dance scene, we decided to show the characters in a typical room of the time. We tried different features for the Duke, some of them rougher, others more ambiguous or realistic, until we hit a sweet spot that combined a little of them all.

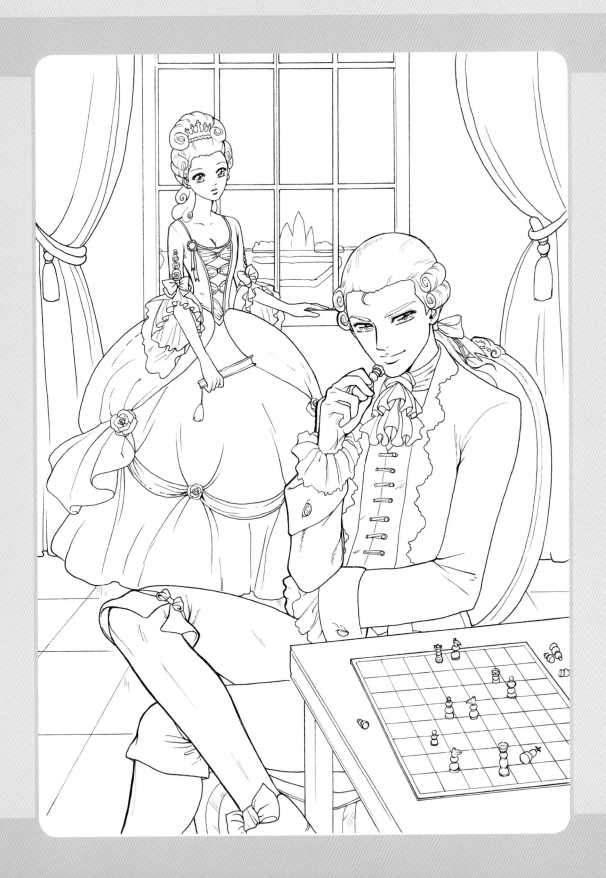

2. STRUCTURE

We place the characters, drawing them in their final poses, and the background. If we simplify the lines we can make the poses more dynamic.

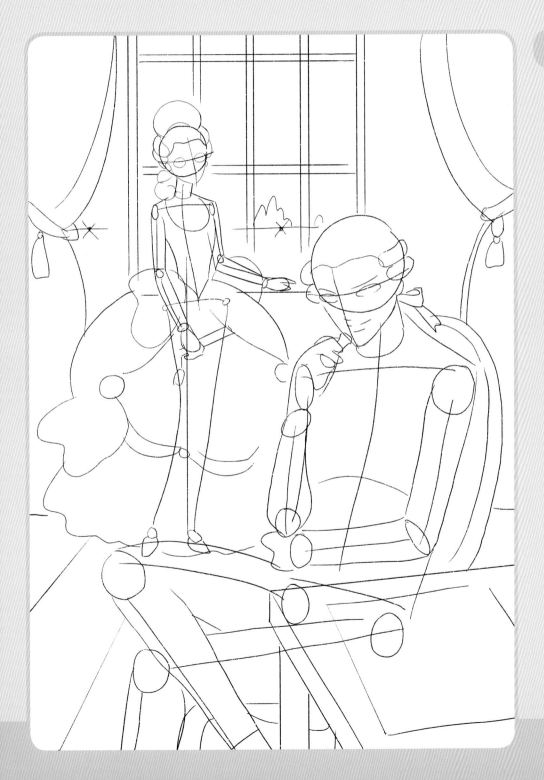

3. VOLUME

We keep using ovals to build the illustration. When characters are interacting with the background, it is better to draw everything at the same time to make their figures match the elements of the background.

4. ANATOMY

Although clothing will cover most of their bodies, we must still make sure that both the poses and the proportions are right if we want everything to fit convincingly.

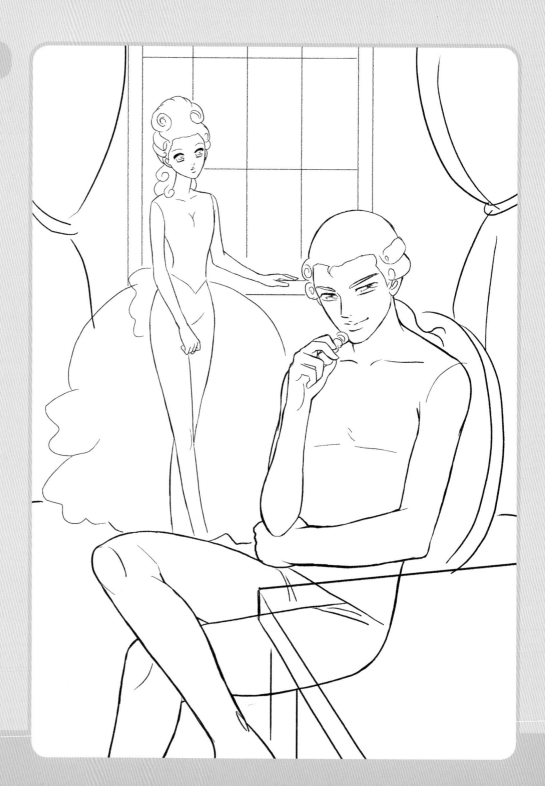

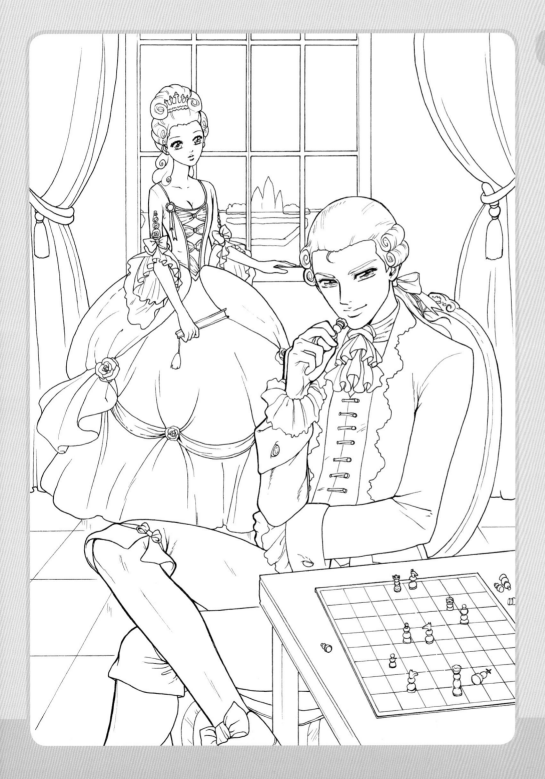

5. DETAILS

The style of the characters' clothing has a clear French influence, as if these two nobles were members of Queen Marie Antoinette's court. Her dress has a corset, lace and frills, whereas his garments are a velvet jacket and tights.

6.1. COLOR

We detach the main two parts of the image. The lady and the background both use cold tones; the nobleman and the foreground elements have warm colors.

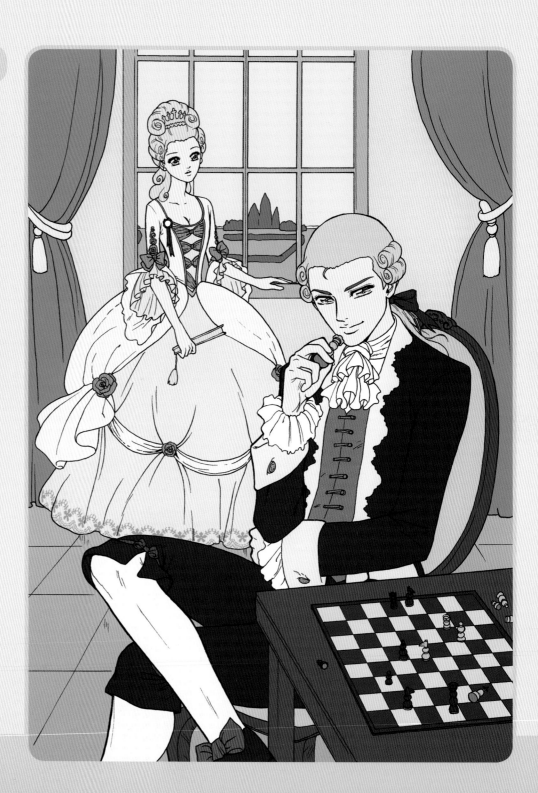

6.2. COLOR

We apply a first layer of highlights and shades with soft strokes that will create different areas and give the illustration volume by following the shapes in the drawing.

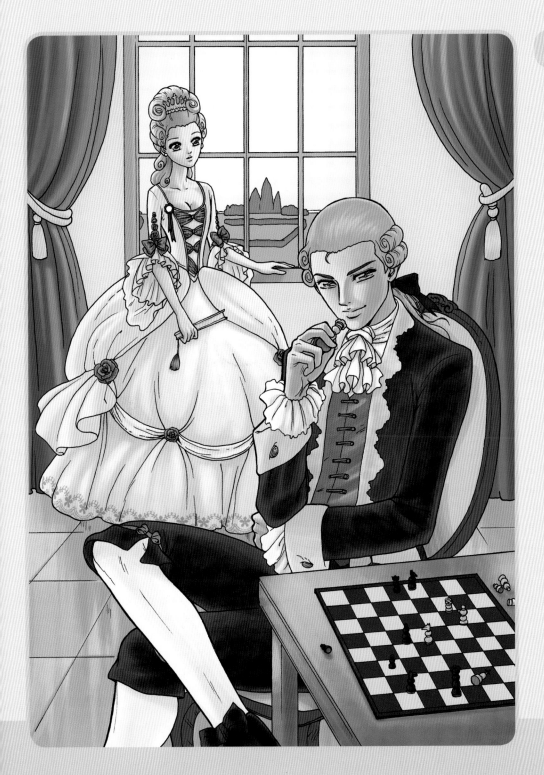

6.3. COLOR

Colored areas are further defined, always remembering that light is coming from the window in the wall.

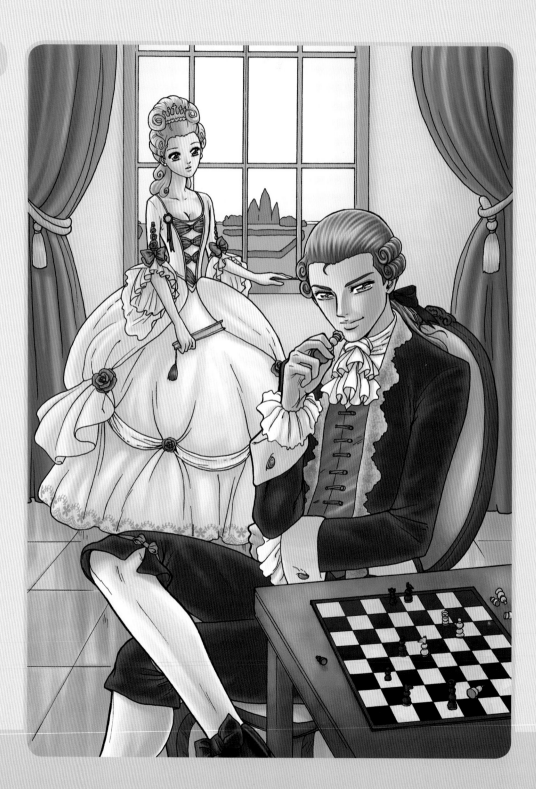

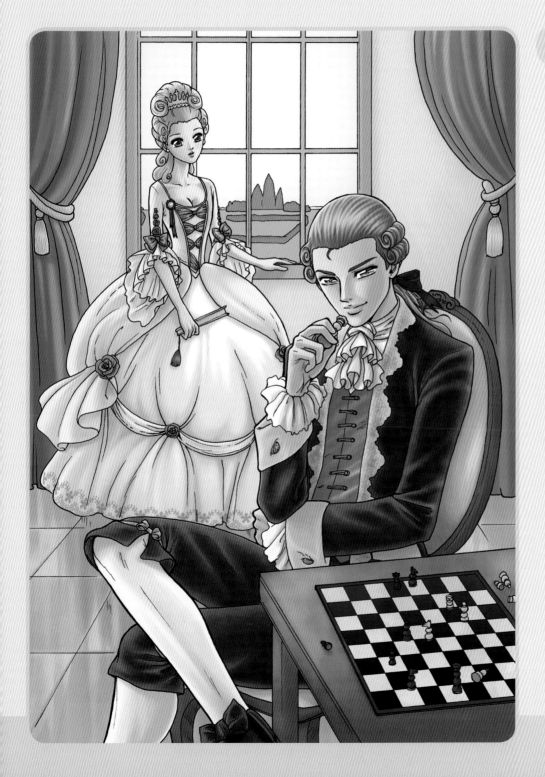

6.4. COLOR

Once the coloring process is finished, we adjust the balance between light and dark to prepare the image for its final details.

6.5 COLOR

We apply textures to the drapes and the dress of the lady, and draw the lines on the chair's upholstery.

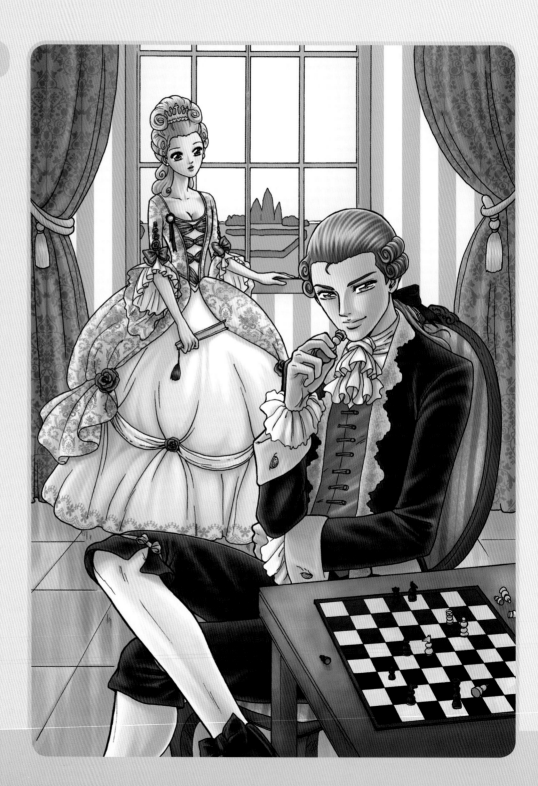

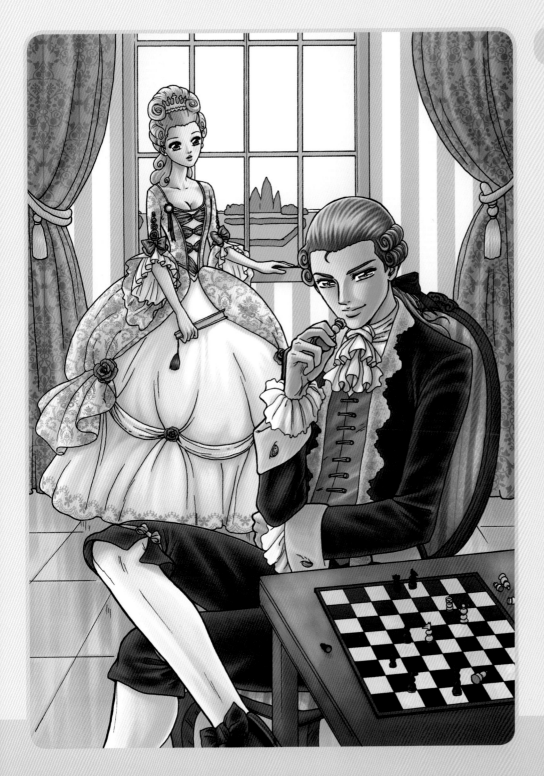

6.6. COLOR

We check the colors again, making slight adjustments until we get a warmer overall tone. To achieve this, we use several overlaid color fill layers to unify the colors in the image.

Finishing touches

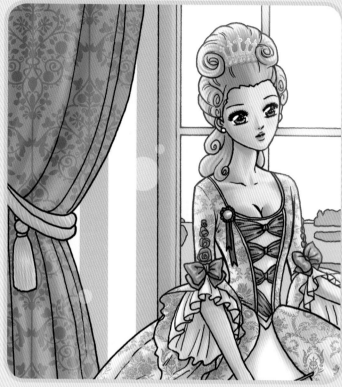

- To produce the effect of light coming through the window, we simulate a lens flare in a new layer with its blending mode set to Soft Light and setting its layer blending options to create an Outer Glow effect.

- This lens flare effect is reinforced by whitening the color of the window and the lady's crown.

Tips & tricks

- To cast shadows on the table, we duplicate its color layer and set its blending mode to Multiply. Then, we gradually erase the lit areas with a series of brush strokes. We can also use a Layer Mask to make sure that the whole layer can be displayed again if we make a mistake.

- The patterns on the clothes are applied using different layer blending options.

- For the drapes we have set their layer blending mode to Multiply and the layer blending options to Pattern Overlay, with its blend mode set to Screen.

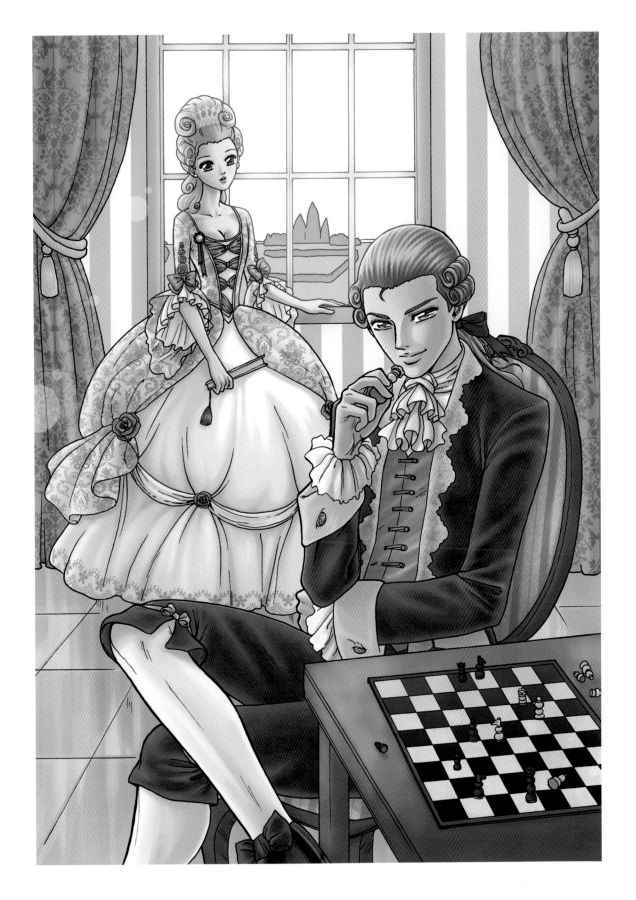

LITTLE CHINESE GIRL

This little Chinese girl lives in one of Peking's humblest neighborhoods. Her family has always grown all kinds of colorful fish; she enjoys playing with them for hours on end. She wants to visit Hong Kong someday, but she has to work a lot by helping her family before she can do that. This little Chinese girl lives a happy life, but she wants to see the world. She dreams that she will one day meet the man of her dreams during her travels.

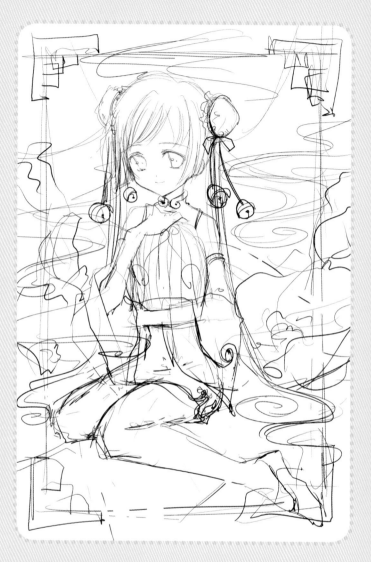

1. SKETCHES

Although the first two drafts looked pretty convincing, the scene with the little Chinese girl and the fishes jumping around her was really magical and evocative, as well as being more dynamic.

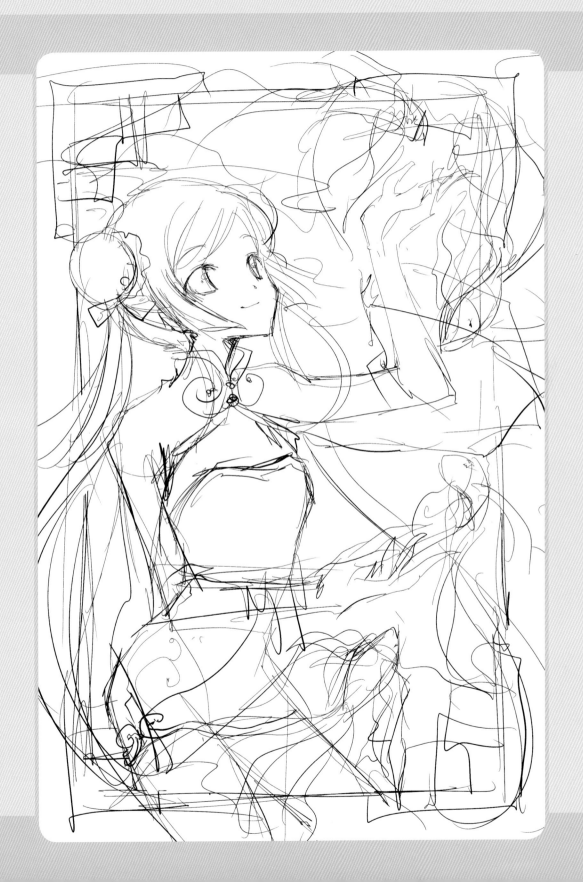

2. STRUCTURE

The girl's pose is not too complex, the key elements being the curve of her spine and the flexing of her wrists. Also, the layout guides the eye through the illustration following the path indicated by the fishes.

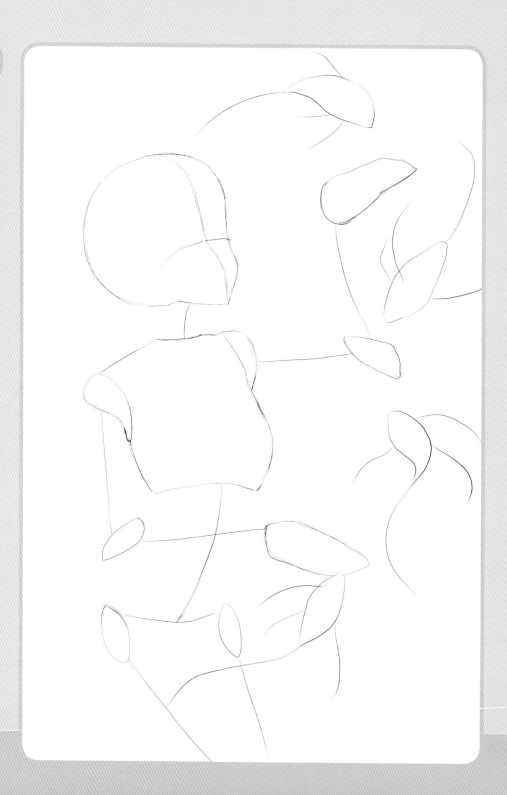

3. VOLUME

In this step, we outline some of the key elements in the illustration, such as the hands and the fishes that surround the character.

4. ANATOMY

We add the hair, delete the sketch lines and add detail to the girl's features and to the fishes.

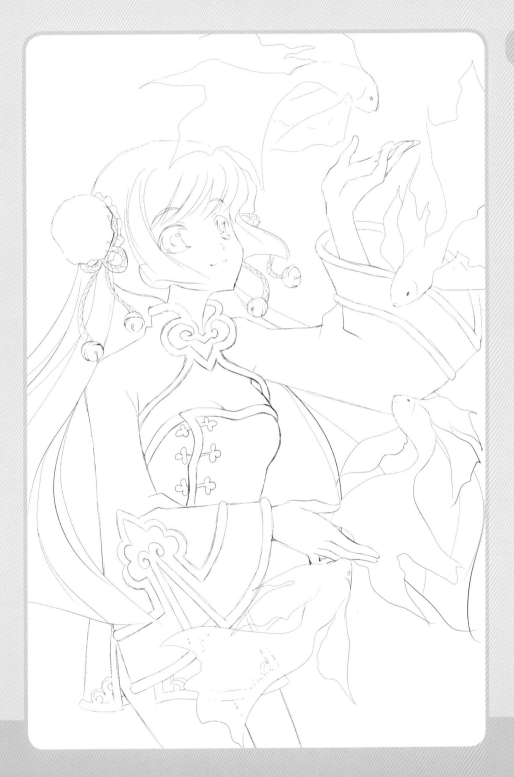

5. DETAILS

The girl is dressed in a style befitting of a beautiful young Chinese girl, which pays special attention to the oriental ornaments on her clothes and spicing it up a bit.

6.1. COLOR

We start with the flesh tones, defining areas of light and dark with the brushes. A color base for the background allows us to visualize contrast better, so it is a good idea not to leave a white background when painting with this technique.

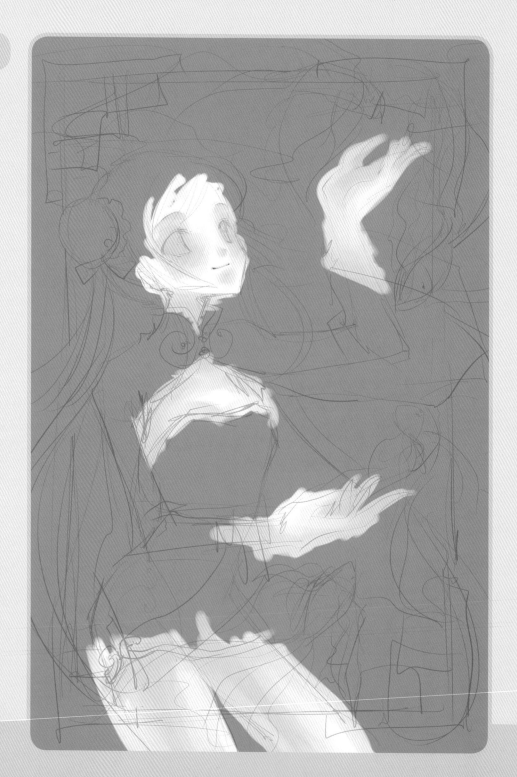

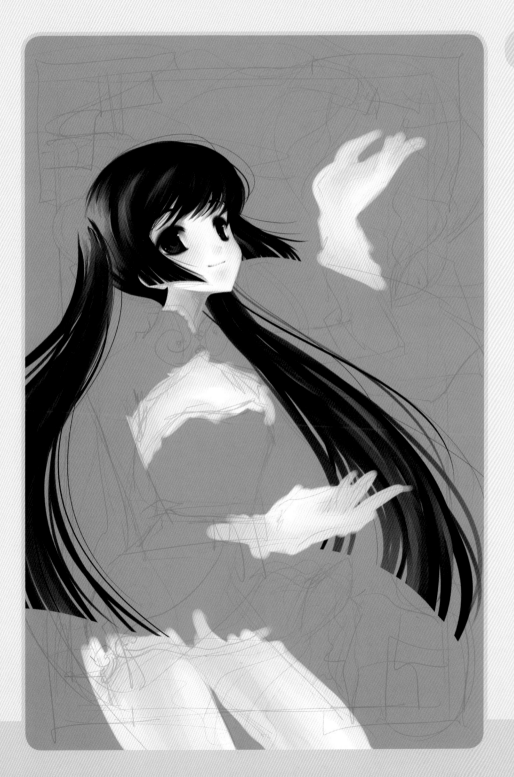

6.2. COLOR

We continue applying color to the hair, trying to simulate the locks with brush strokes. We use the same color tone for the eyes.

6.3. COLOR

Her dress will be predominately white and red, but we will also add some gold and pink elements.

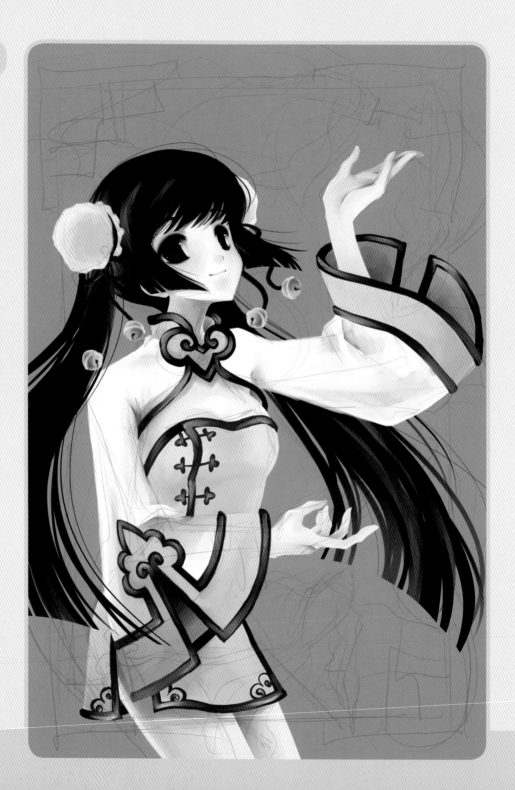

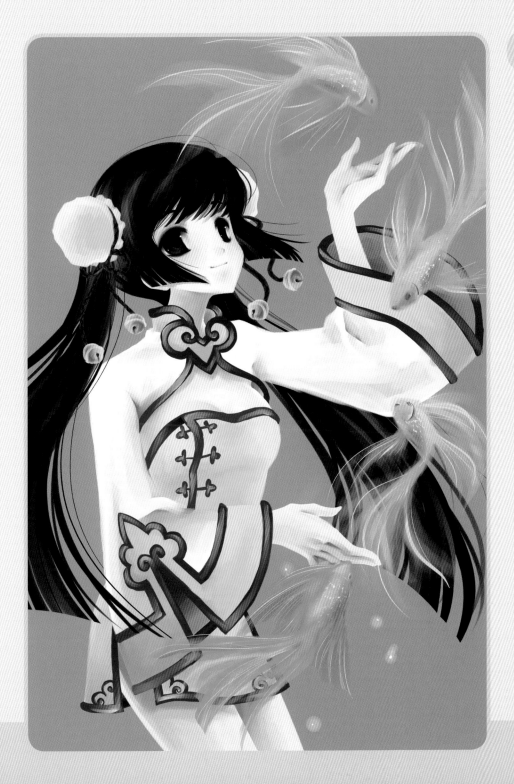

6.4. COLOR

Once her dress has been painted, we color the fishes using gold and orange tones.

7.1. BACKGROUND

We substitute the current background color with the final color for the illustration: dark navy blue with white ornaments.

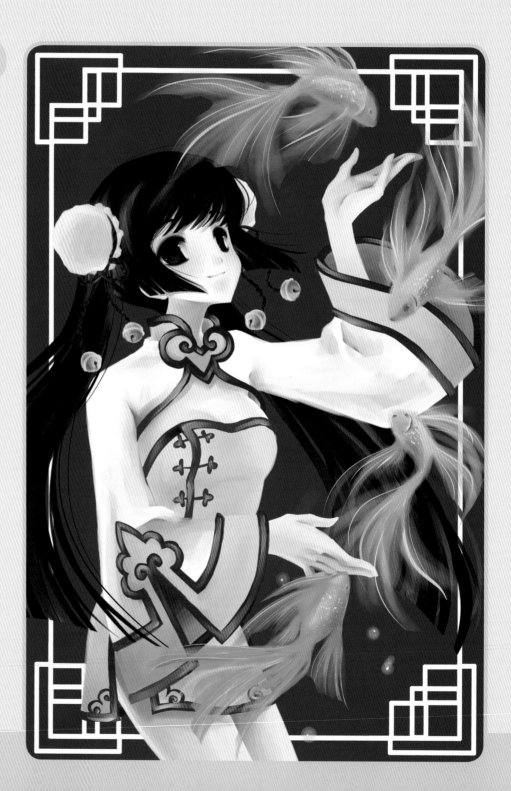

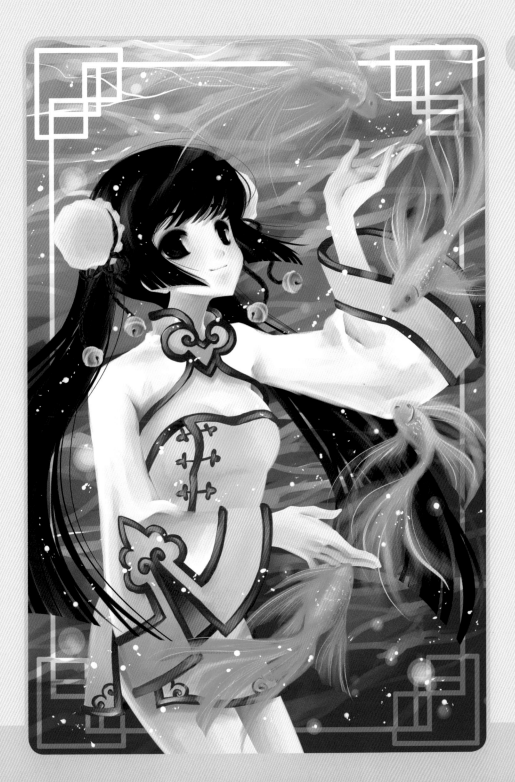

7.2. BACKGROUND

We finish decorating the background with an aquatic theme using white brush strokes with low opacity. The white ornament we had included in the previous step will now have its blending mode set to Overlay.

Finishing touches

- We apply a paper texture on a layer with Overlay blending over a few brush strokes that follow the shape of the character to mark the areas of light and shade.

- Lastly, we place white Chinese characters in two of the corners of the image, with 58% opacity and their blending mode set to Overlay.

Tips & tricks

- Distributing the various parts of the characters over different layers allows us to apply different effects and textures in separates planes at a later stage.

- Using varying degrees of opacity when coloring the fishes helps them naturally meld with the background and makes the overall image better integrated.

- When applying textures, it is better to have them in black and white or grayscale, so as to prevent them from altering the color of the image they affect.

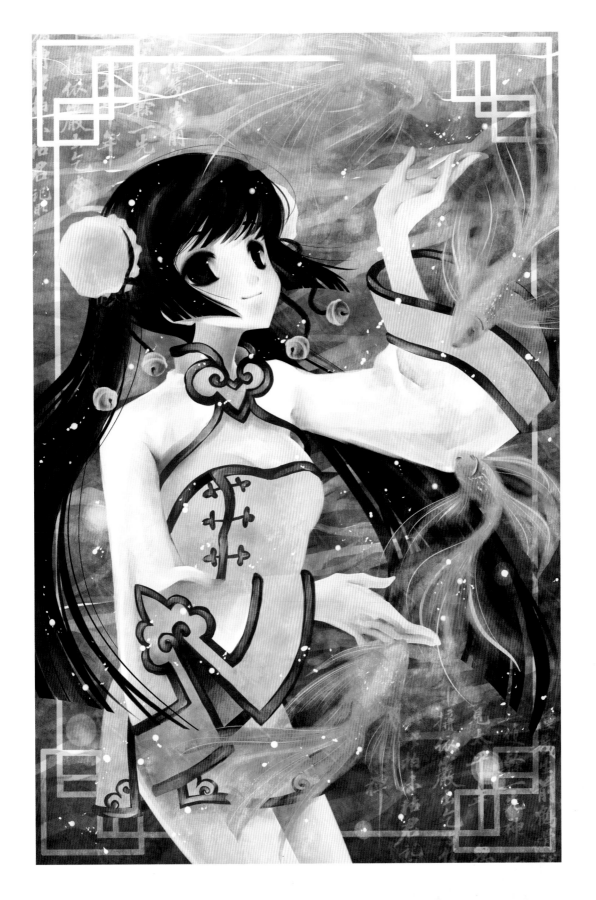

THE VIOLINIST

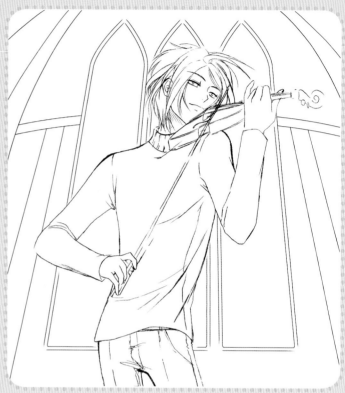

Michael's dream has always been to demonstrate his violin playing skills inside a big European cathedral. Today is the big day and he is filled with happiness. His travel from the U.S. has been long and complicated, but nothing can disturb him today. On top of that, he is dedicating the concert to his mother, who died in his infancy.

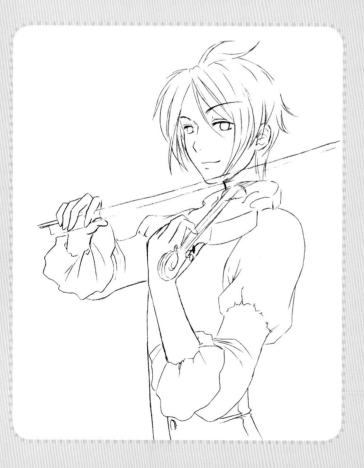

1. SKETCHES

We wanted to portray a young and modern violinist, albeit with a classical touch, which is why we adjusted the clothing until we found a style that conveyed that message. In the final illustration, we can see Michael rehearsing just before his big day, with magnificent stained glass windows in the background.

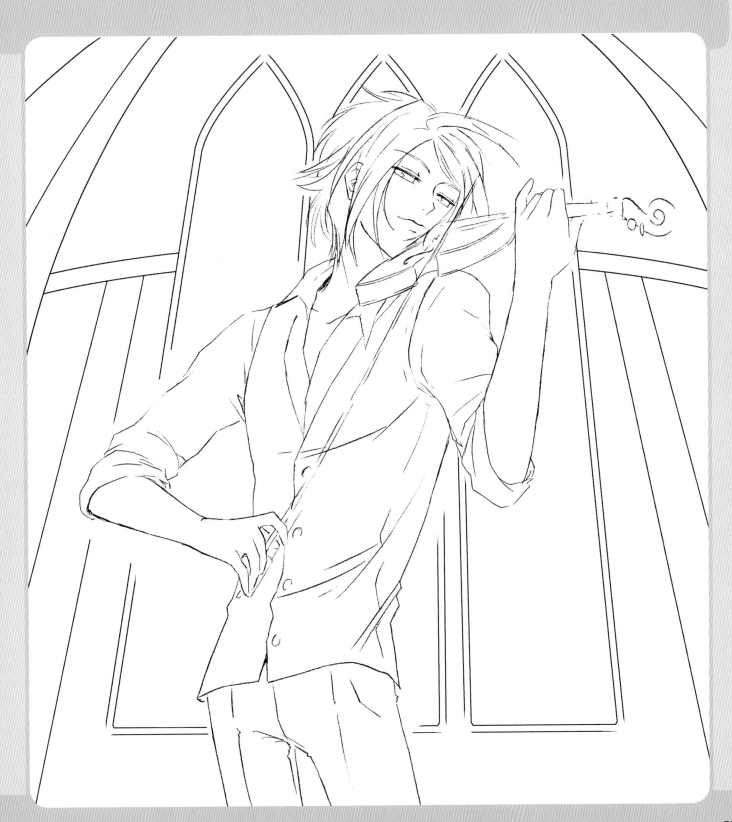

2. STRUCTURE

Portraying accurately the pose of a violinist while he is playing is quite difficult, especially when we want to give the illustration a dynamic quality.

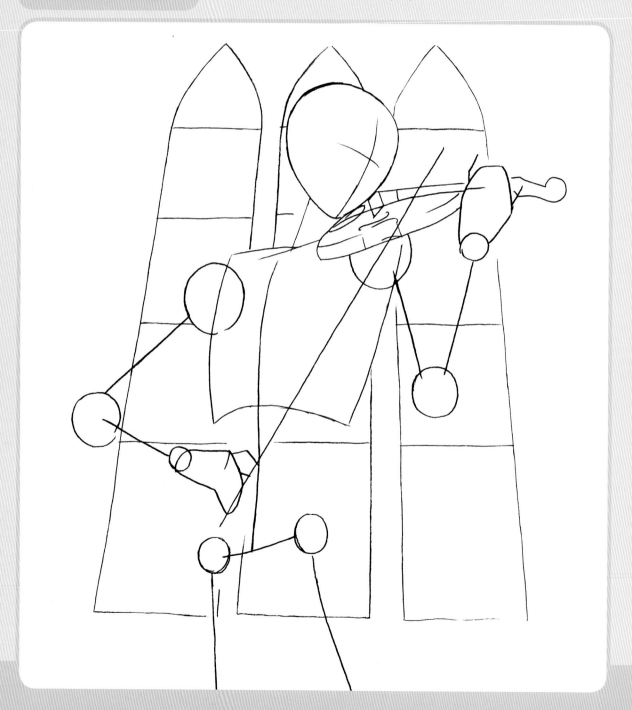

3. VOLUME

Special attention is required when defining the position of the shoulders and hips, which should never be completely parallel to each other.

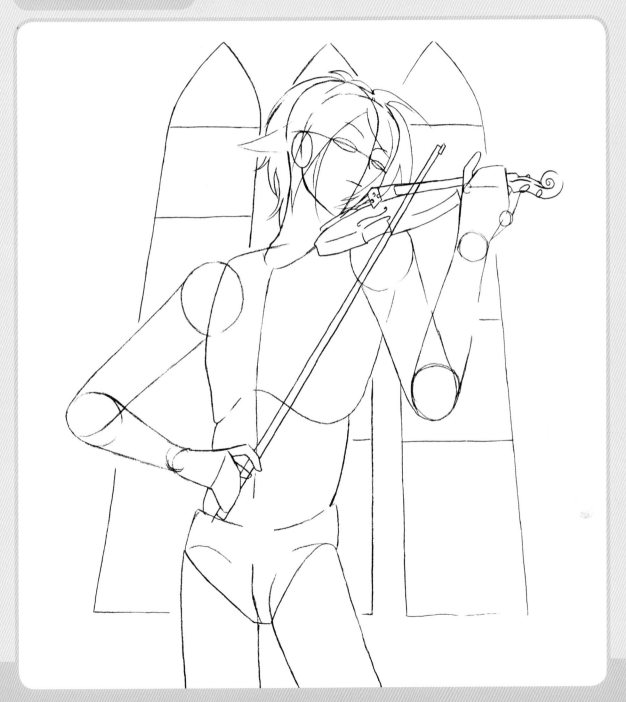

4. ANATOMY

Now we draw the facial expression and finish the shape of the hands; we confirm if the volume of the body was correct.

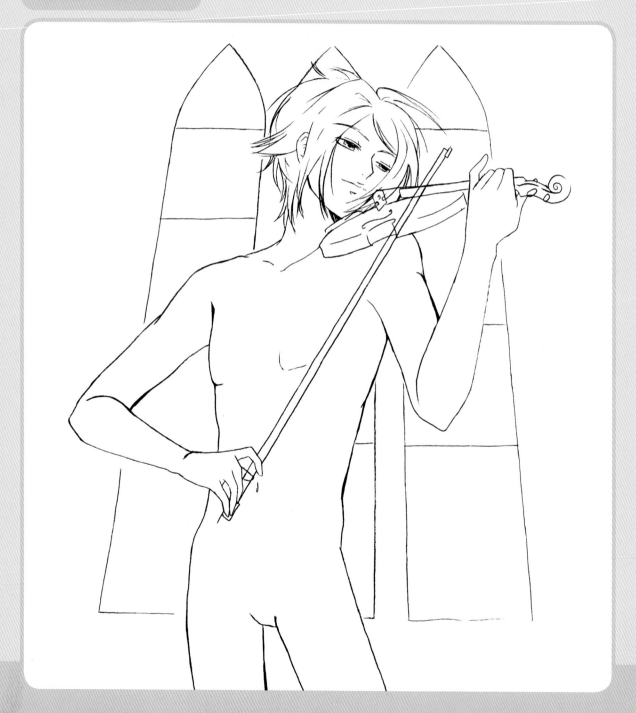

5. DETAILS

We apply final touches to the violin and design the pattern of the vest, along with the rest of the clothing.

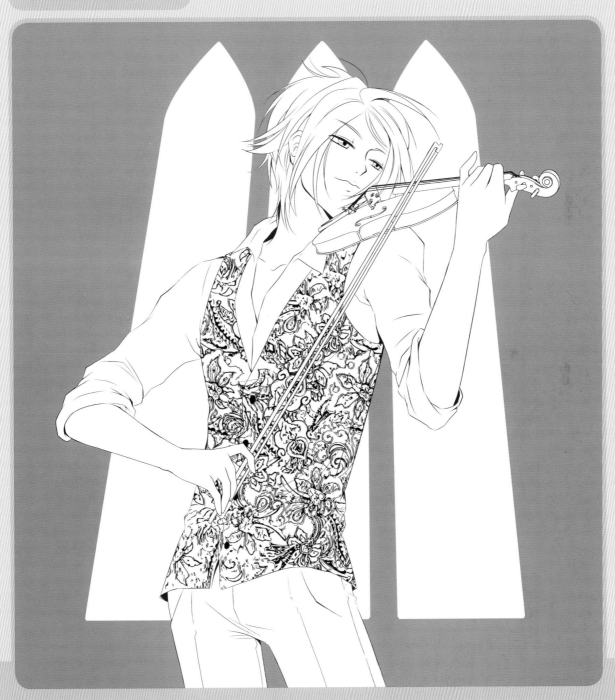

6.1. COLOR

The base colors for this illustration are shades of brown, sepia, cream and gray. They are all warm colors that perfectly match the chromatic range inside a cathedral.

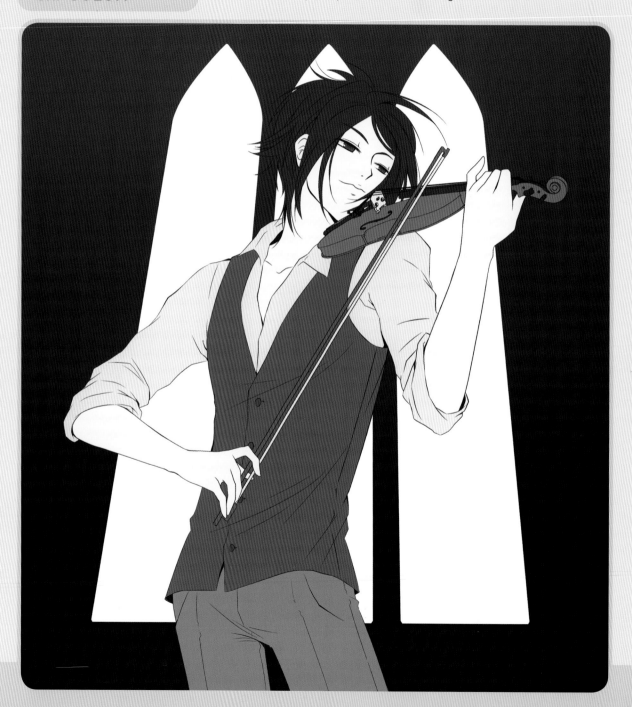

6.2. COLOR

We fill the space of the windows with a pattern we will have created to resemble the stained glass. The coloring of the violinist is started with bright colors that are gradually darkened, whereas the background is started with a dark color to which brighter colors are added.

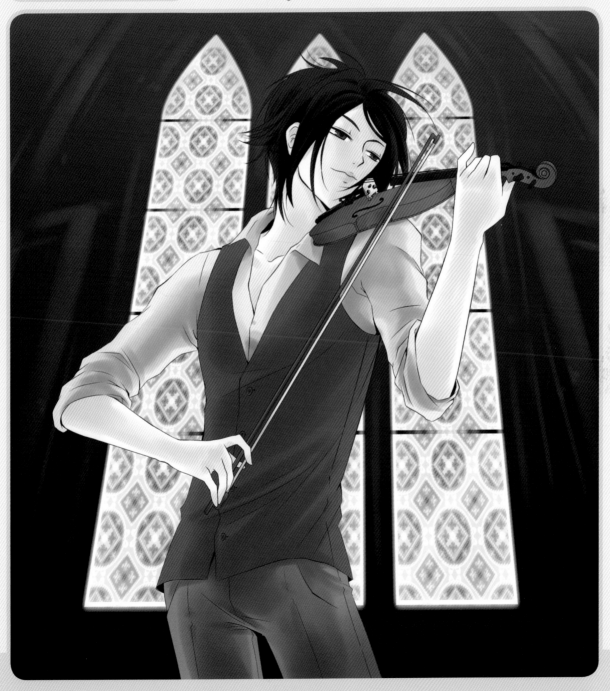

6.3. COLOR

Since our character is backlit, the contours of his figure are brightened as they receive the light coming through the window. In the background, we add a blurred white gradient on the upper part of the windows, as well as some highlights in the interior of the cathedral.

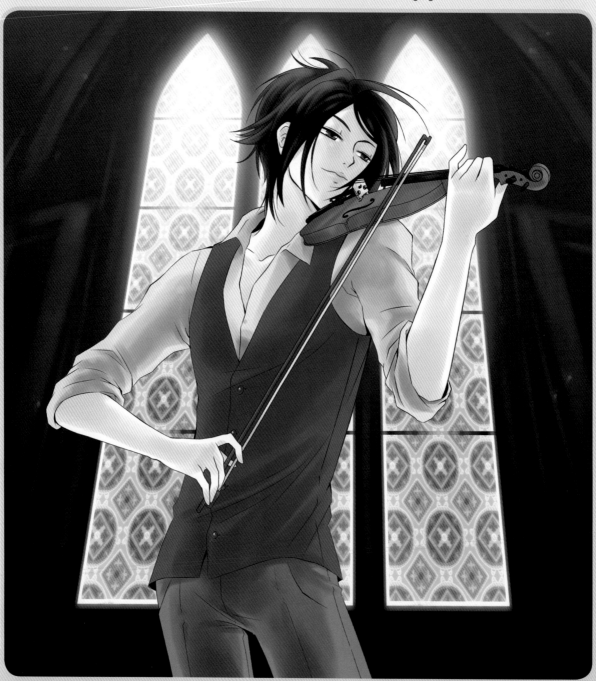

6.4. COLOR

Around the character we draw a lighter and blurrier halo; this simulates the effect created by the backlight when it hits the character. To create this halo, we just need to outline the character with a bright yellow, which we then blur.

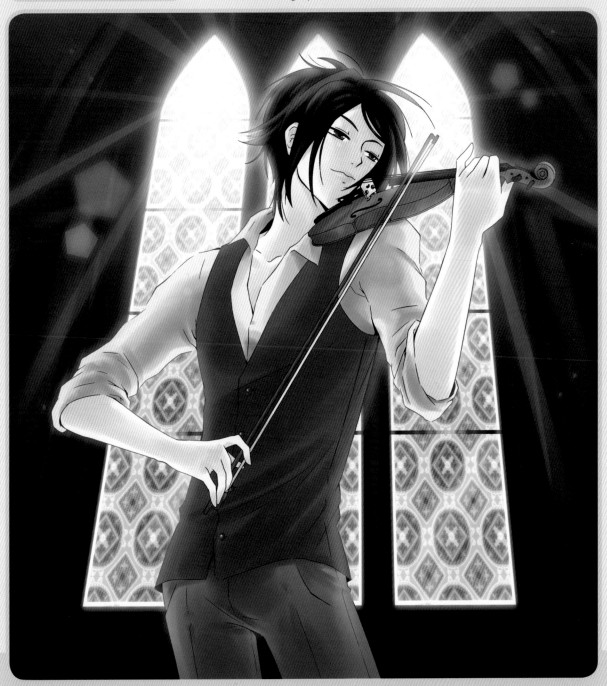

Finishing touches

- We apply our previous brocade texture to the vest. We lower its opacity to make it blend more with the forms of the fabric.

- For the pants, we add a layer with a darker gradient in order to differentiate the areas of light and dark in the image.

Tips & tricks

- For the stained glass we create a square motif that we turn into a pattern thanks to Photoshop's Edit > Define Pattern option. To use it, we just select the area we want to fill, choose the Paint Bucket tool and then Fill Pattern using the one we have just created for the stained glass windows.

- The color on the stained glass windows has been changed slightly applying color variations that allow it more bluish tones, which are more consistent with these kinds of windows.

- To create the pattern we have used actual motifs which we have recreated using Photoshop's Shape Tools.

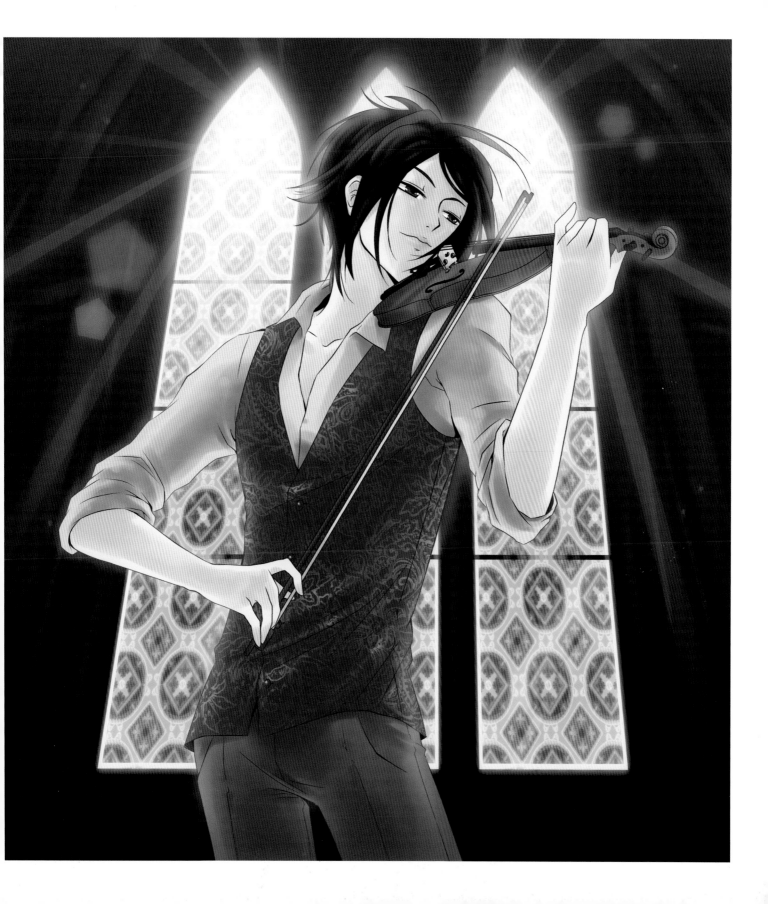

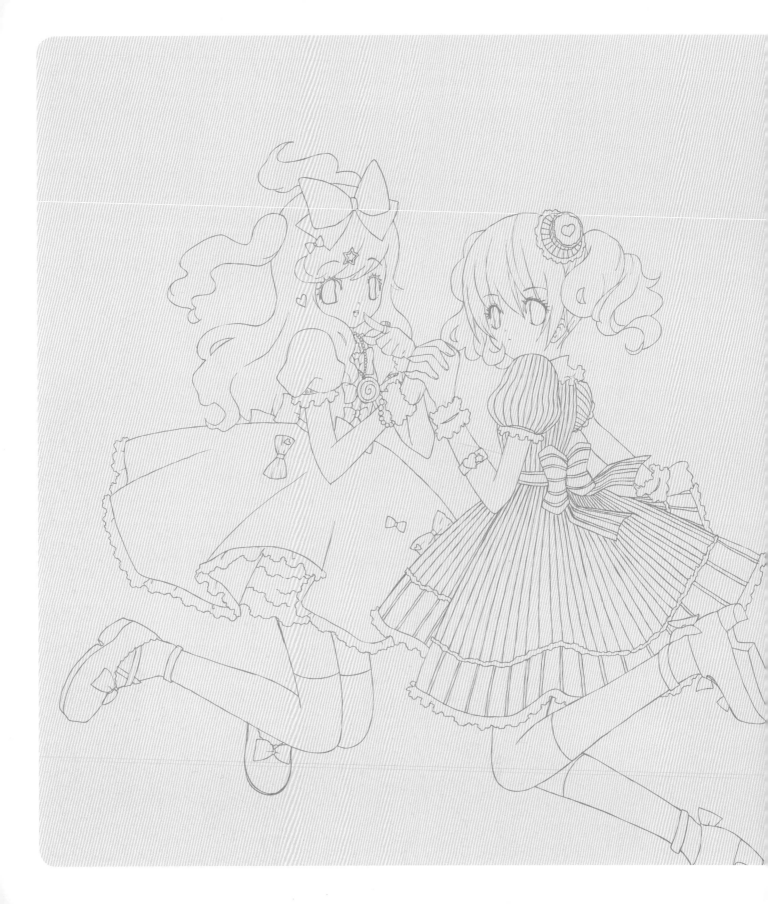

Love
& Pop

THE POPULAR GIRL
LOLITAS
A DAY AT THE FAIR
DETECTIVES
SURFER GIRL
HIGH SCHOOL LOVE

THE POPULAR GIRL

Yuri never expected to feel so in awe of Reiko, the student representative of her classroom. It is not just admiration or respect. She wants Reiko to take her under her wing—to mentor her, to teach her how to look stylish and how to command attention. Now that they're alone at last, face to face, Yuri is desperate for Reiko to see her potential.

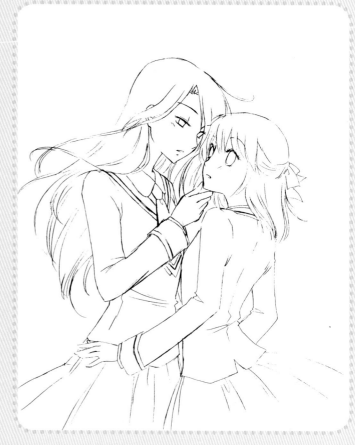

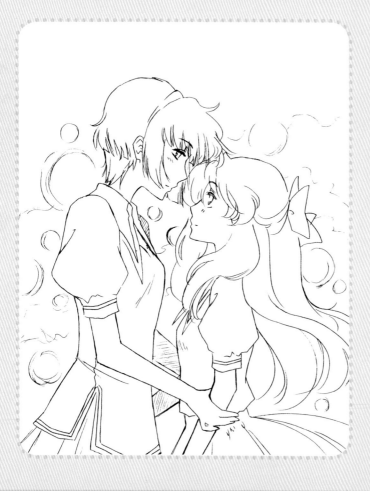

1. SKETCHES

We didn't want the girls to be seen completely from the side as that pose, besides being too typical, is too flat and lacks depth. That's why we chose a different composition, one with more perspective and emotion. Changing a few things in the design of the girls, we found just what we were looking for.

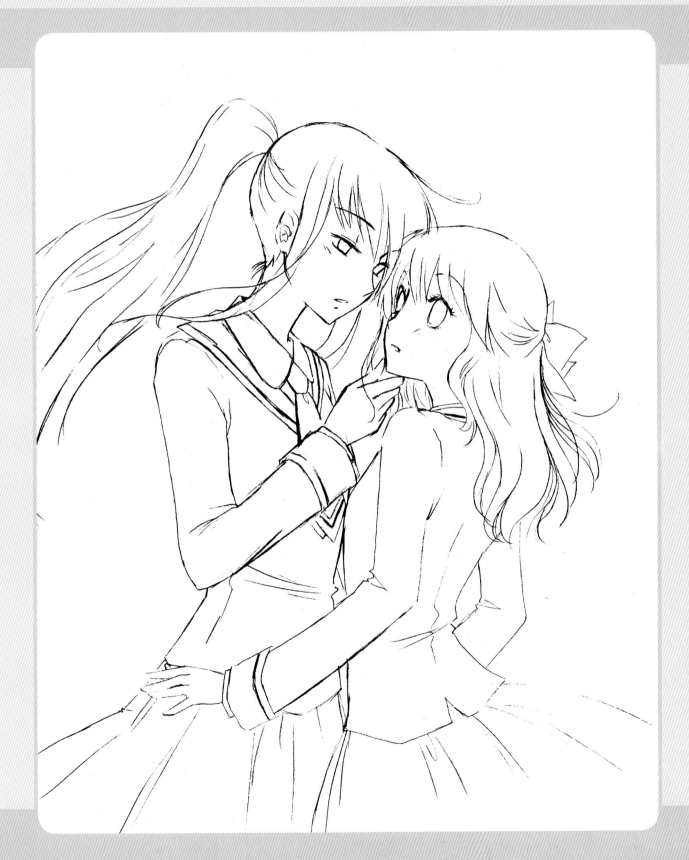

2. STRUCTURE

The structures of the two girls have to fit each other and be inter-twined. The arching of the spine is essential for a dynamic pose.

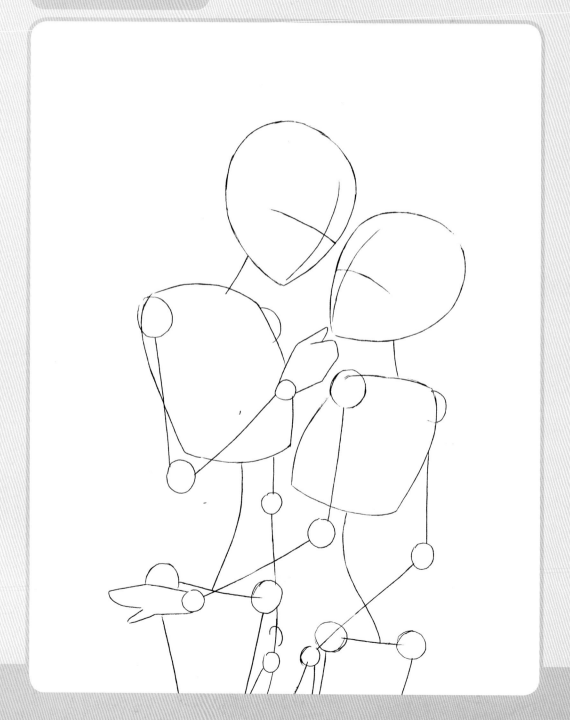

3. VOLUME

In this step we check whether the figures fit well or we need to make any corrections. The girls need to look firm but delicate.

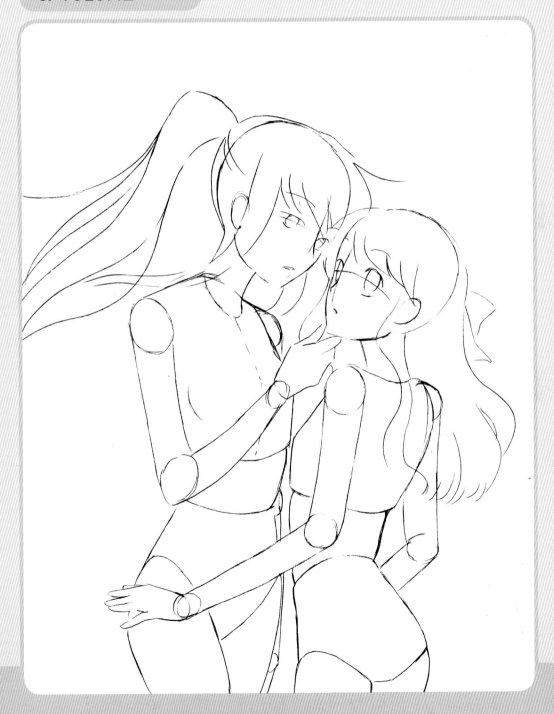

4. ANATOMY

We finish the shapes of their bodies and sketch the background elements.

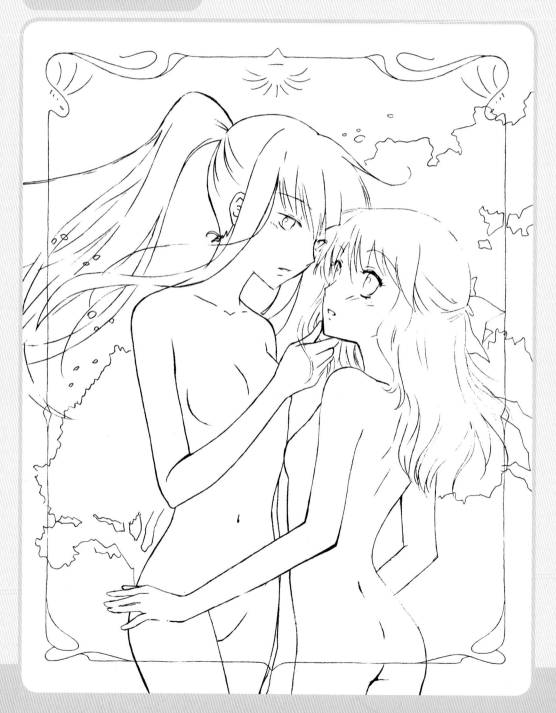

5. DETAILS

We give the second girl a pair of glasses to make her look more innocent. The school uniform is the typical uniform used in Japanese schools.

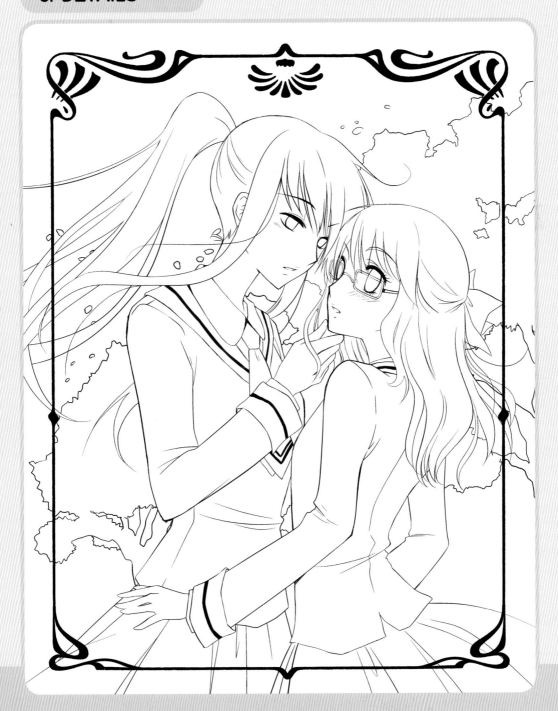

6.1. COLOR

The basic chromatic range of the illustration is based on blue and pink tones, with some hints of brown. To make the image look softer, the line drawing has been changed from black to sepia.

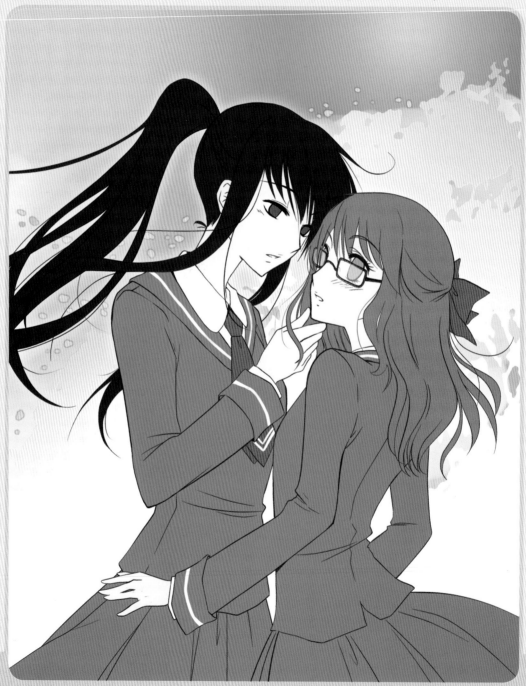

6.2. COLOR

Using watercolor brushes we shade the characters, their skin and hair, and their clothes. We add clouds in the background and we add shadows for the trees.

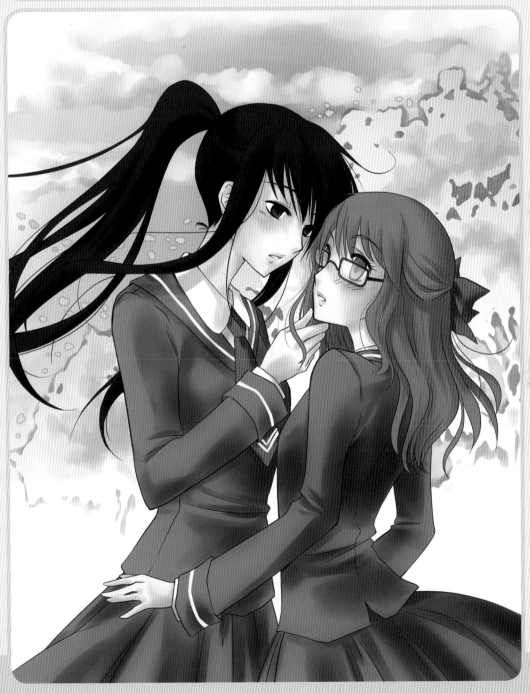

6.3. COLOR

We use the brush to add bright areas to the characters and the background.

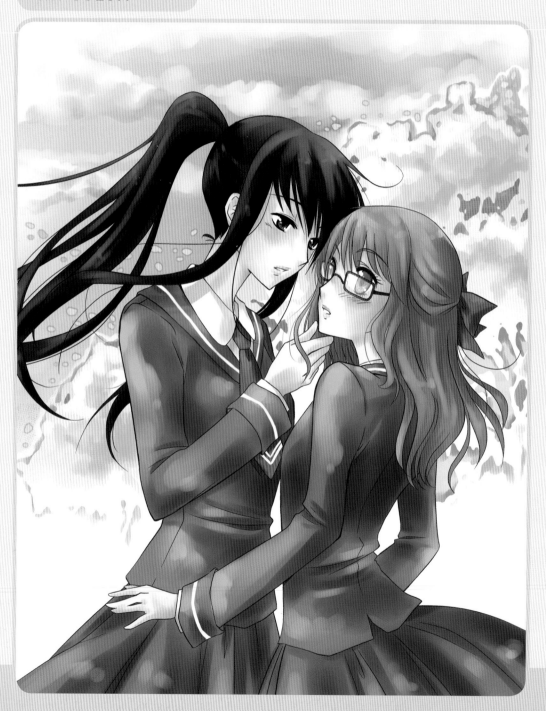

6.4. COLOR

We add more highlights to the image and a screen pattern in the lower part to give it a more romantic look. We also add some sakura petals in the foreground and finish by increasing the color contrast.

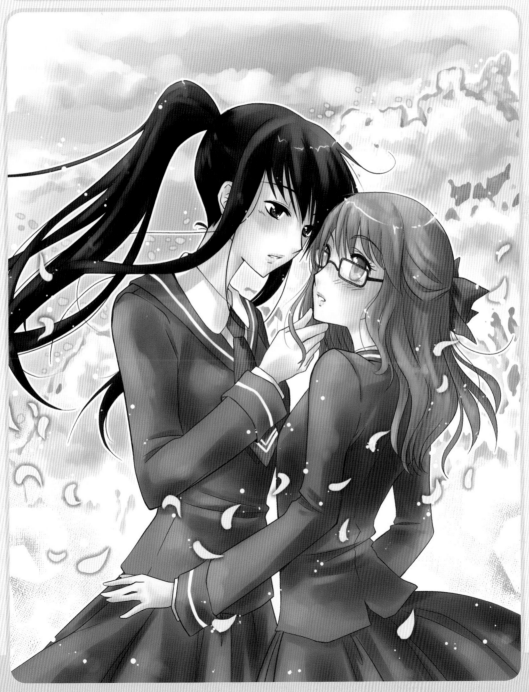

Finishing touches

- We add the ornamental frame, which we had previously drawn, filled with white. Finally, this helps us to frame the image.

Tips & tricks

- Decorative screentones are an essential resource in *shōjo mangas*. In addition to highlighting shadows and gray tones, they also serve to decorate the backgrounds. However, in color illustrations they are not used so frequently, and they behave like any other texture.

- Sakura petals are another common element in these illustrations (sakura is the Japanese word for blossoming cherry trees). They usually symbolize strong feelings and, if placed effectively, they can give an illustration intensity and drama. In this case, they have been arranged as an oval, like they were being swept by a gust of wind.

- The petals also include an Outer Glow effect in the layer blending properties; this makes them stand out and be detached from the main image.

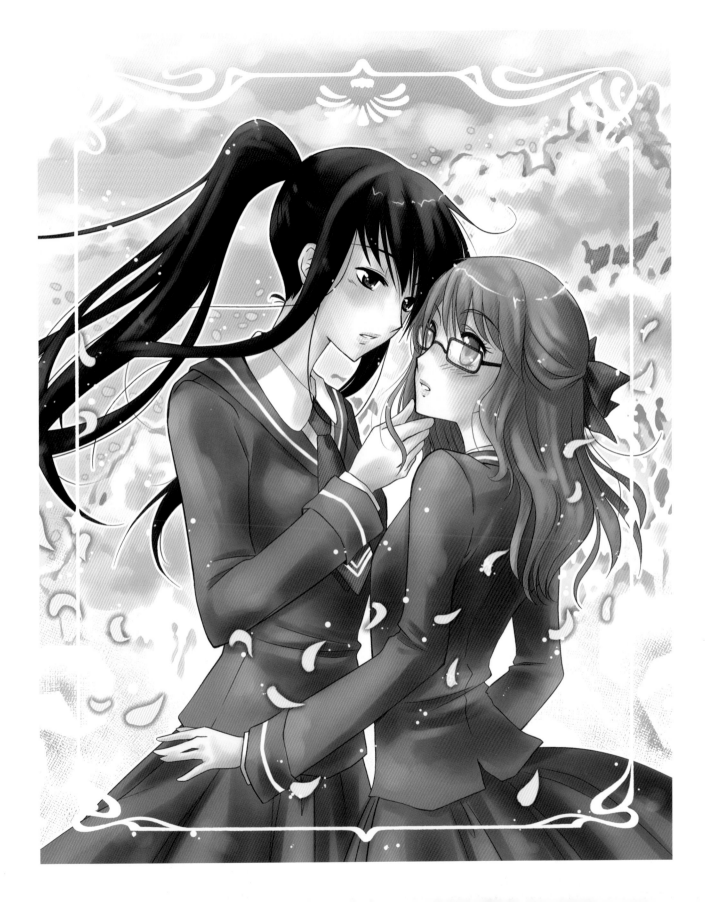

LOLITAS

Many girls believe that, in order to be a real lolita, it is not sufficient to wear beautiful dresses full of flounces, laces and Victorian-style accessories. A real lolita has a natural passion, attitude and behavior. For them, being a lolita is a way of life.

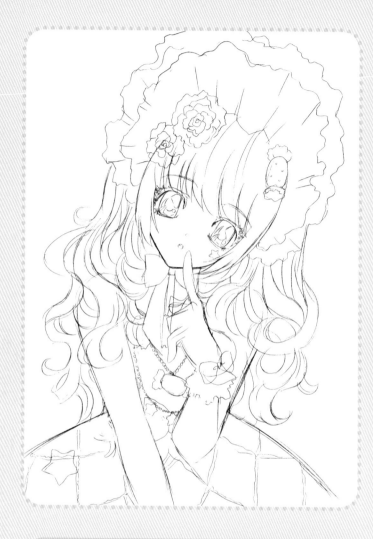

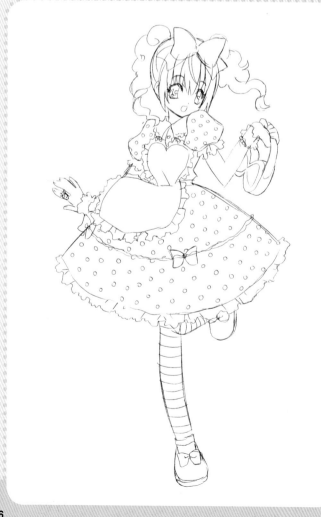

1. SKETCHES

It is hard to pick just one of the three sketches, but we like the idea conveyed by the two lolitas holding hands, showing their friendship. One of them has a pop style, the other one a vintage look.

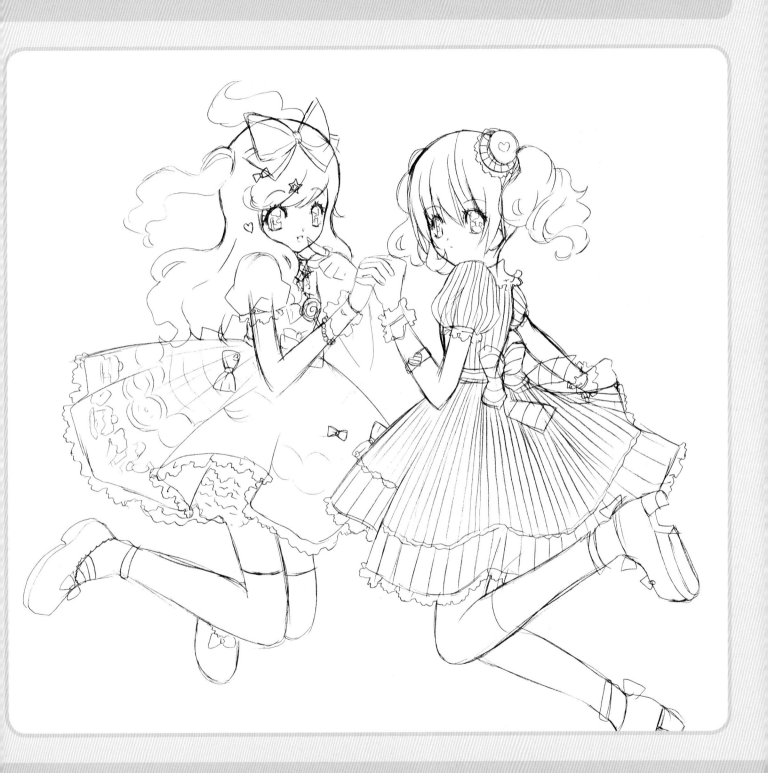

2. STRUCTURE

We lay out the scene so that the girls are in contact with each other, but keeping enough space around them to display their ample, flouncy dresses.

3. VOLUME

To keep their childish and stylized look, we will try not to make the limbs too thick.

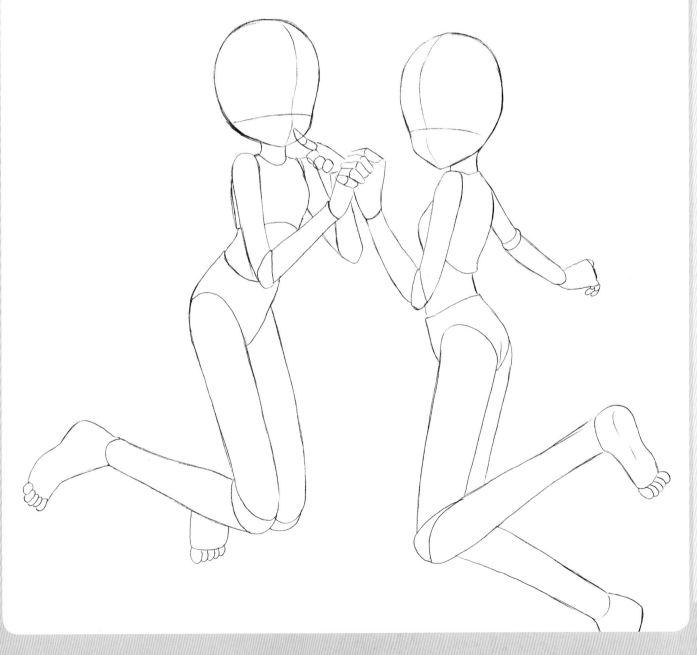

4. ANATOMY

We clean the line drawing and draw the hair. One of them has a looser and lighter hairdo, while the other one has her hair tied up, thus achieving a contrast between them. The priority is to keep a light-hearted look in the illustration.

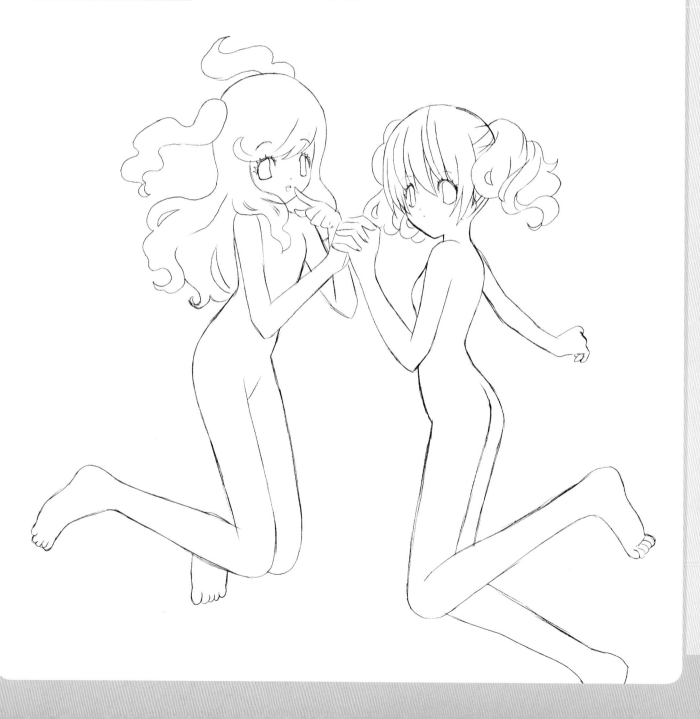

5. DETAILS

The design of the dresses is inspired by the real ones used by lolitas, full of accessories and ornaments. It is easiest to draw the general outline of the dresses and then gradually add the rest of the elements.

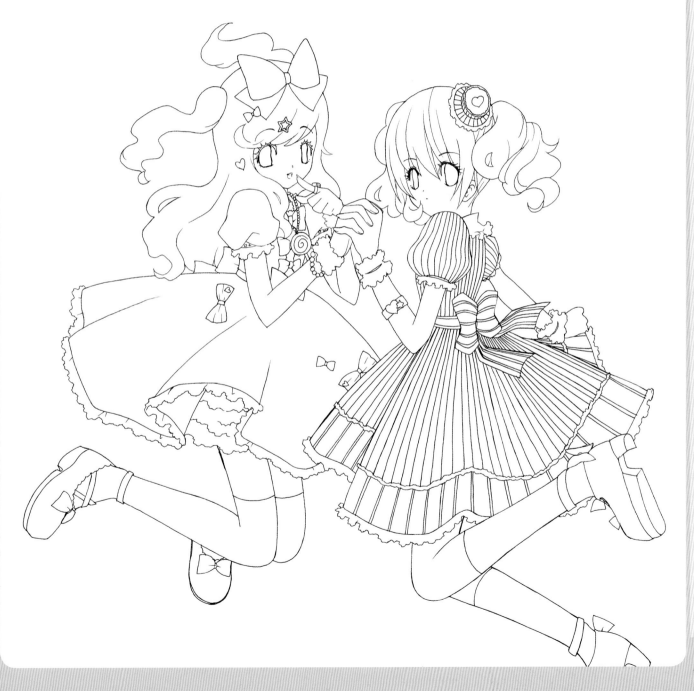

6.1. COLOR

We start with a warm pinkish color range for the two girls, and we also paint the dark lines on the dress of the lolita on the right. The pastel colors we apply have very low saturation, something that will prove useful when we paint the shadows, as it will enhance the contrast of the illustration.

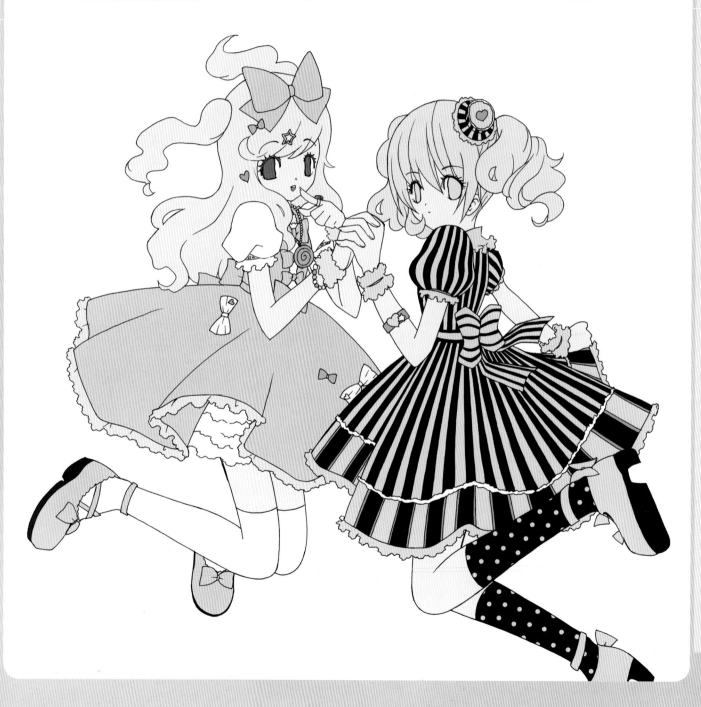

6.2. COLOR

We add the first shadows in a new layer with its blending set to Multiply, and we start to detail some of the highlights on the hair. The shadows for the geometric shapes can be painted with the Polygonal Lasso tool, creating selections that we then fill with color.

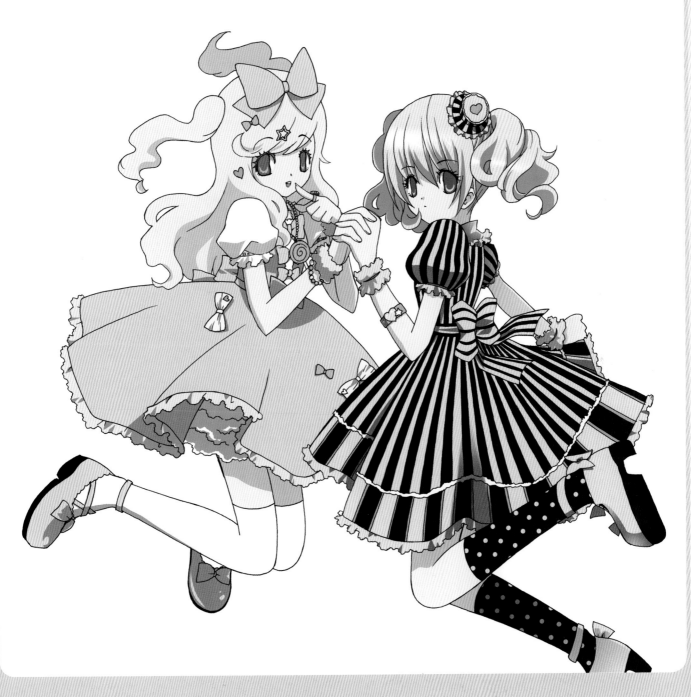

6.3. COLOR

We alter the line drawing to make it pink, adding the motifs and decorations of the pink dress (some of which we will use later for the background).

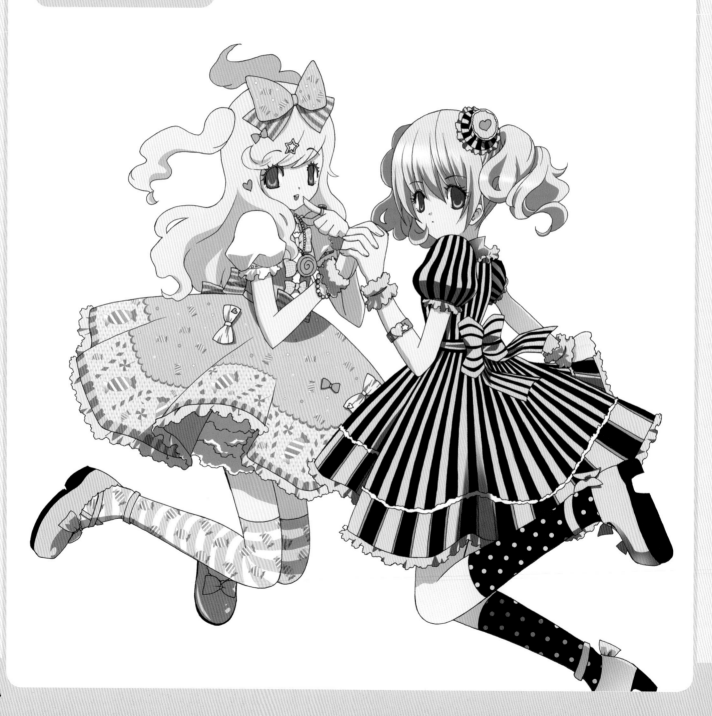

6.4. COLOR

We finish coloring both lolitas applying the highlights on the eyes and a rosy blush to their cheeks.

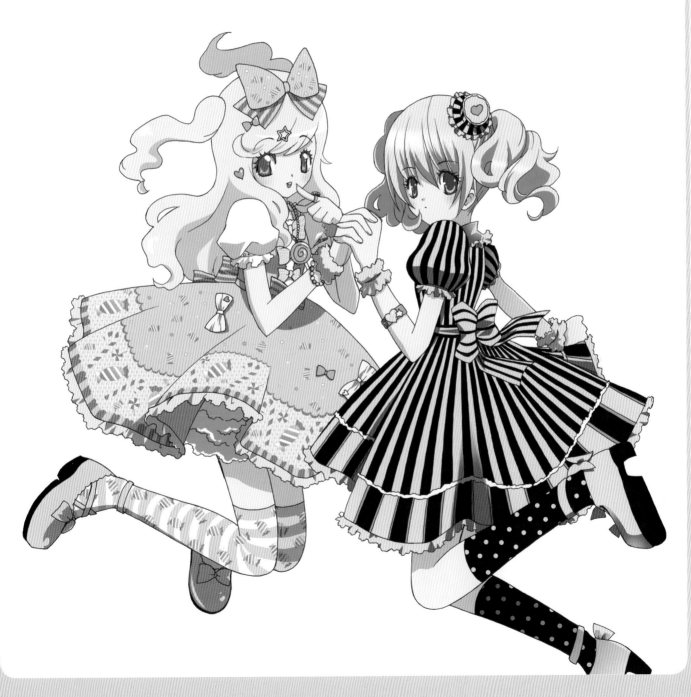

Finishing touches

- The background is applied on three different layers. The first one contains the diagonal lines, the second one has the gradient shadow and the third one has candy.

- To create the gradient shadow, first we create a duplicate of the lolitas on a flattened layer. Then we create a somewhat thick stroke using the Edit > Stroke option in Photoshop and place the layer on the background. Lastly, we change the Blending Options for that layer, enable Gradient Overlay and change it from a white to pink linear gradient.

Tips & tricks

- A simple yet well-balanced background makes the main image stand out and serves as a good companion for it. The main image is much more detailed in this illustration.

- A complex background would have made for an excessively busy illustration.

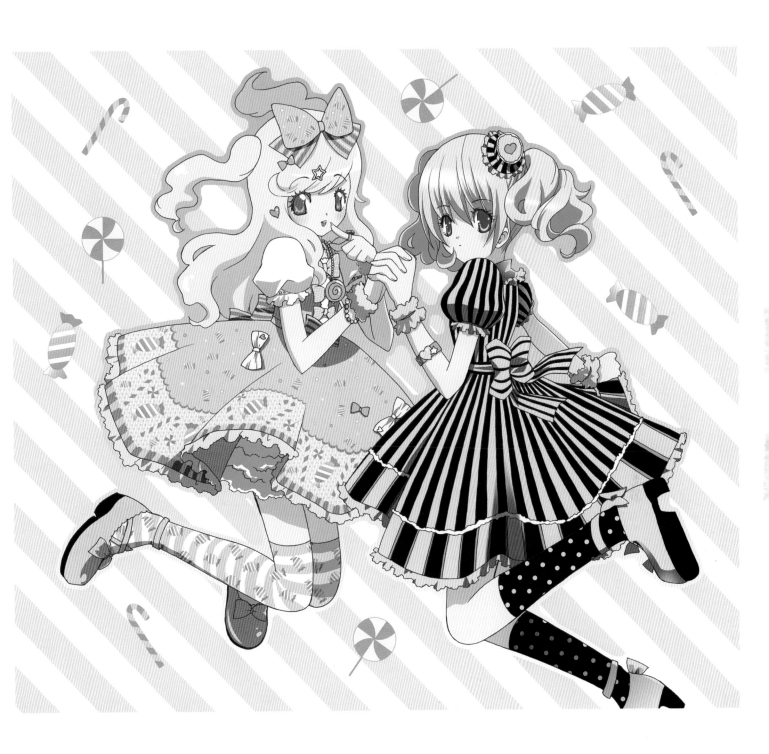

A DAY AT THE FAIR

One thing that a young Japanese girl would really love on a Saturday evening is to stay a while at the local fair. Riding the Ferris wheel or eating cotton candy with her best friend is as good as a plan can be. And who knows, maybe the boy she likes will be around.

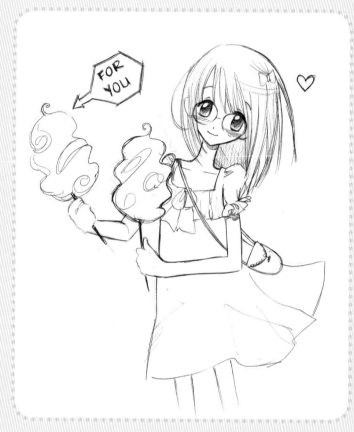

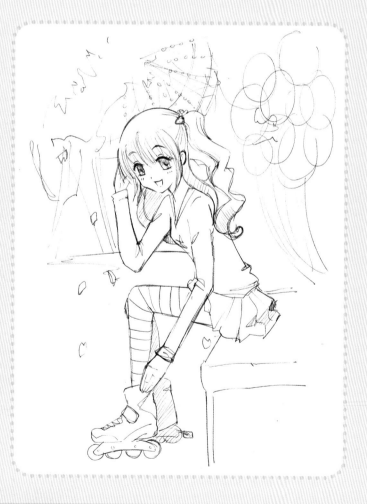

1. SKETCHES

We created several different scenes at the fair, then we decided to go for the option with the two girlfriends enjoying a weekend evening together. Drawing two or more people always produces an interesting illustration because of the interaction and the relationship among the characters.

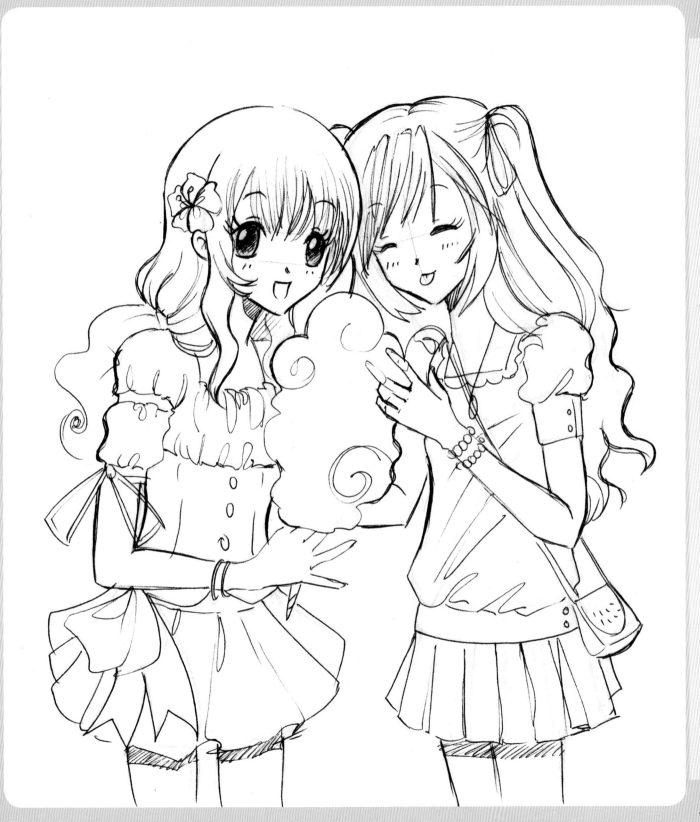

2. STRUCTURE

The overall composition of the image draws an imaginary triangle from both of the girls' heads to their legs. This way we can focus the viewer's attention toward the act of eating the cotton candy. We arch their bodies toward the central element to stress the characters' actions.

3. VOLUME

Since we are drawing two teenage characters, their limbs will be thin and stylized, and their hips neither too evident nor voluptuous. To draw the hands we start with simple shapes to lay out the phalanges of the fingers so that we recreate the correct anatomy of the hand.

4. ANATOMY

We define their bodies, then draw their hair and their facial expressions. Knowing and hinting the placement of the various anatomical features, such as the bellybutton or the collarbone, will help us place their clothing with more precision.

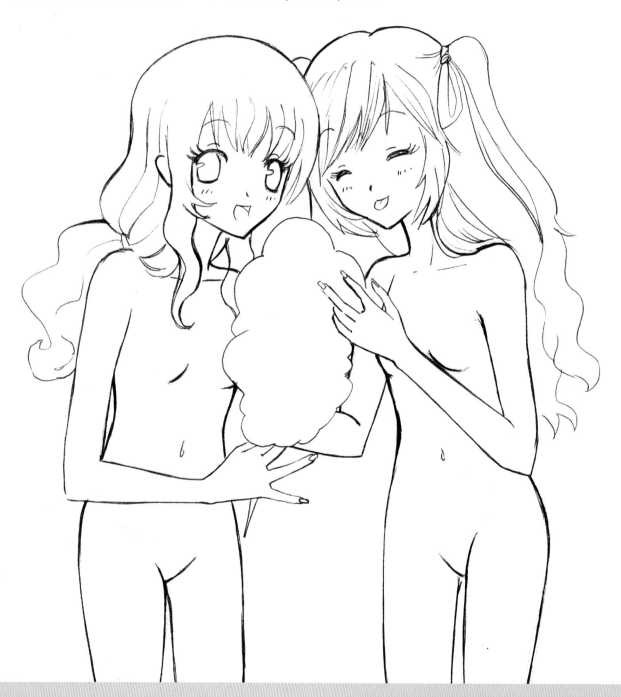

5. DETAILS

In this stage we add the clothing for each teenager, emulating the clothes worn by Japanese girls. Gathering documentation before making a decision about our characters' clothing is strongly advisable. Just look at the clothes used by the characters in your favorite series and create news designs based on them.

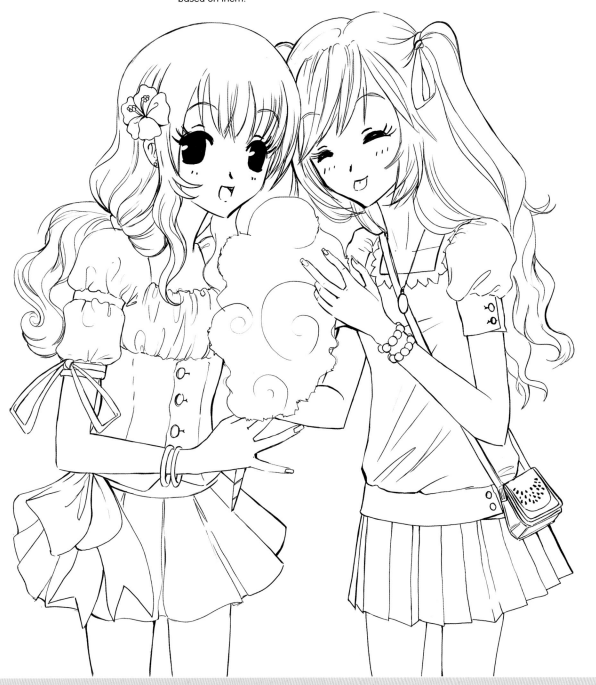

6.1. COLOR

We start with a base of pastel colors with low saturation to set the overall color scheme and check whether these colors produce the desired chromatic range. It is a good idea to use the same colors on different parts of the illustration in order to get a harmonious color palette.

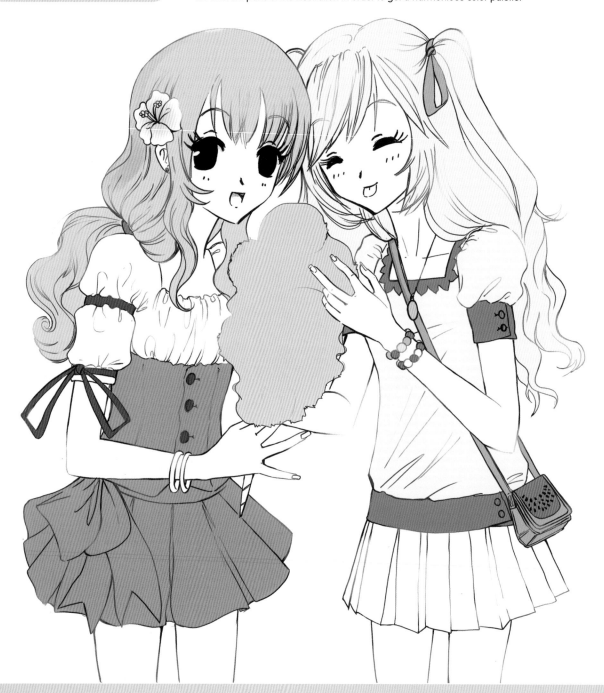

6.2. COLOR

We apply some gradients on the image to define the dark areas of the skin and the hair. This little trick allows us to move from a flat color range to a color palette much richer in shades with which we will more easily achieve greater depth.

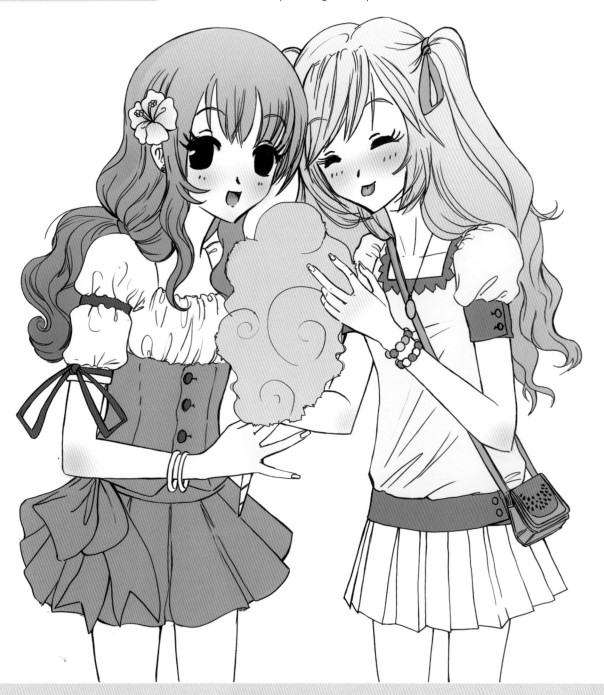

6.3. COLOR

We decide the position of the light source and, using brush strokes with darker tones, we will add volume to the illustration with shadows that follow the shapes of the clothes and the hair; we will do this on a new layer with its blending mode set to Multiply.

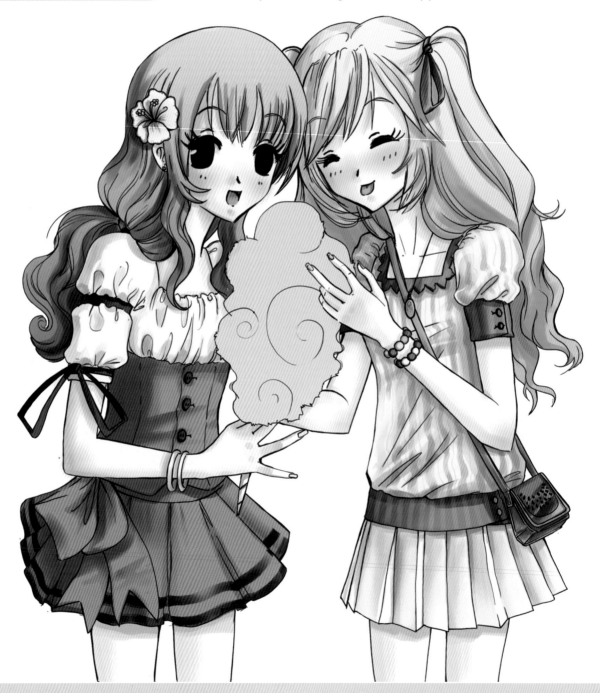

6.4. COLOR

We use the highlights on the eyes and the hair, as well as to add details to the clothes.

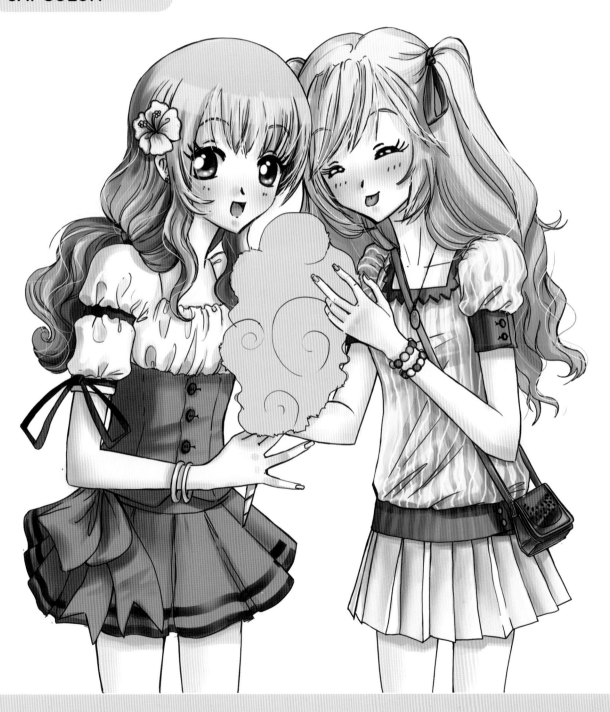

6.5. COLOR

We just defined the highlights remarking some of the lighter parts to have them look brighter. This effect is achieved using additional layers with their blending mode set to Lighten. The highlights can also be produced by secondary light sources, which means they can be colored. In this case they have a warm hue.

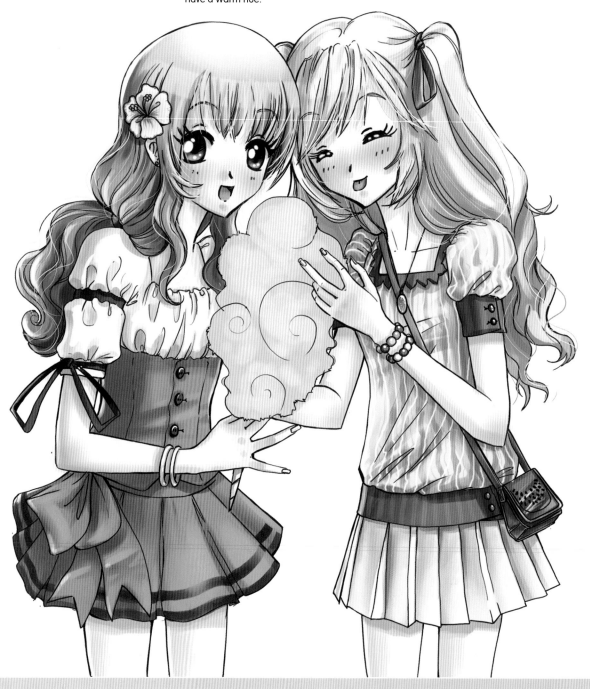

7.1. BACKGROUND

To make the cotton candy look realistic we need to use a texture brush. Once the cotton candy has been finished, we draw the fair in the background with some typical elements in it such as a Ferris wheel, balloons and a tent.

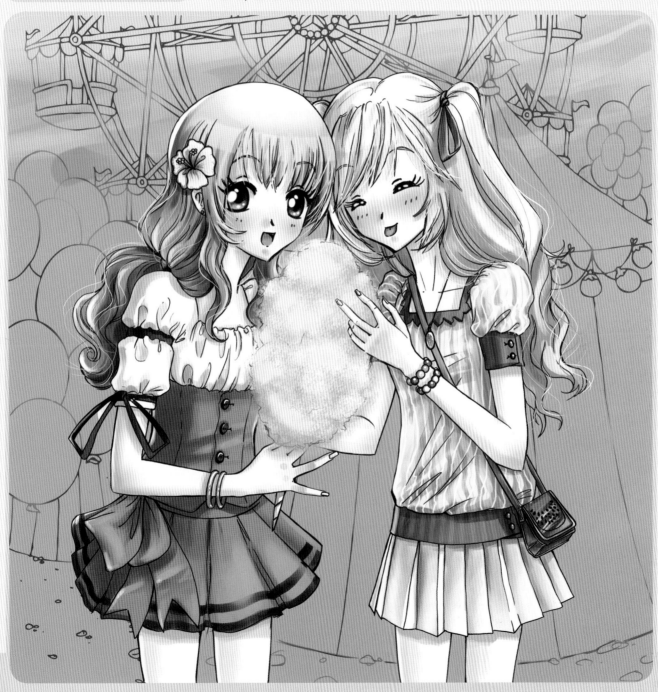

7.2. BACKGROUND

We use brush strokes to color the areas of light and shadow in the background, sticking to the range of blue, red and pink tones so that the chromatic range is as homogeneous as possible. Use complementary colors, such as greens and yellows, on some details to create more contrast.

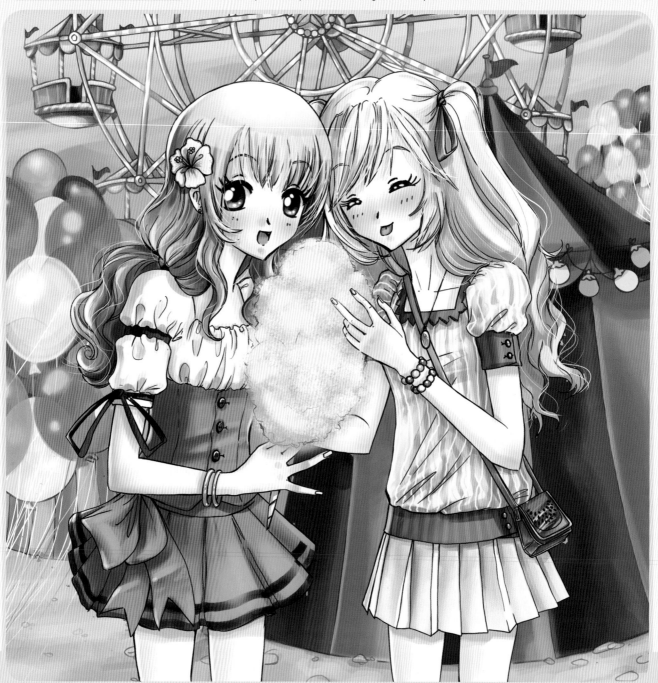

7.3. BACKGROUND

On a new layer with its blending mode set to Linear Burn we add light bulbs using a soft edge brush; we also use slightly different colors for the different bulbs so they have subtle differences in color. We add pentagon-shaped light flares using the Polygon tool, and create a fence behind the girls.

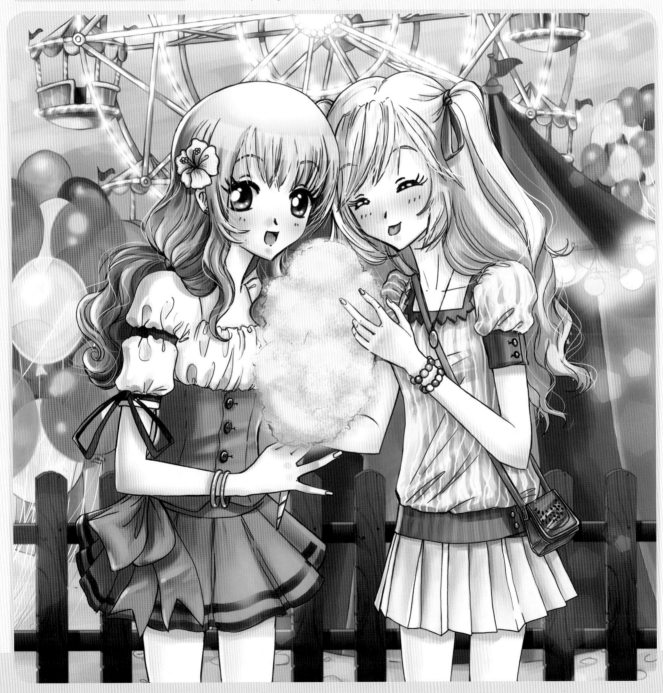

Finishing touches

- We add more pentagon-shaped lights to the background on a layer with Linear Burn blending.

- We draw a glowing contour around the girls editing the layer blending options and enabling the Outer Glow with a yellow tone.

- We get rid of the white lines on the green T-shirt to avoid making the image too crowded.

- The balloons have been added on various layers with 94% opacity.

- The outlines have been erased partially with the eraser tool in some areas to make the image lighter. Remember to duplicate the layer that contains the line drawing before using the eraser, in case we want to recover the original outlines at a later stage.

- We finish by adding a few sakura petals in the foreground to add the final *shōjo* touch to the illustration.

Tips & tricks

- The fence balances the image by establishing a separation between the girls and the background. This is because the fence has a different chromatic range than the rest of the image. Besides the color diversity it offers, the fence also has darker areas that balance the mid-tones that are predominant in the illustration.

- To draw the fence, first we design one of the vertical pieces and give it a three-dimensional look using highlights and shadows, and especially by adding grain that simulates a wood texture. Once the first piece is completed, we will duplicate it to complete the fence.

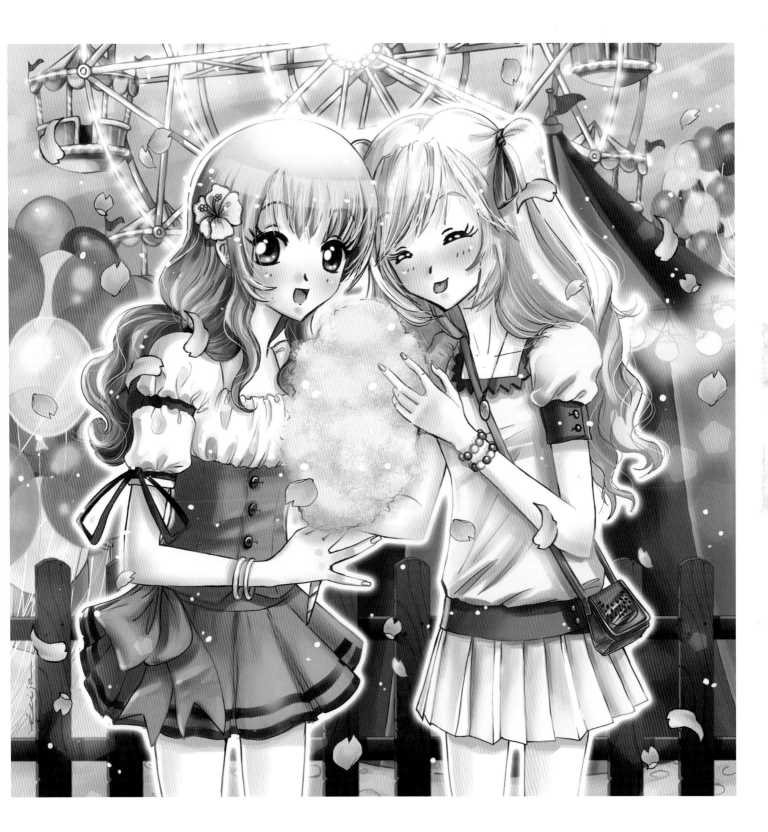

DETECTIVES

No crook eludes them. Kevin and Mark are the perfect detective pair. They always find the necessary clues to solve the most complicated cases. Their intelligence, speed, skills and empathy turn them into a formidable duo, envied by many people and feared by even more.

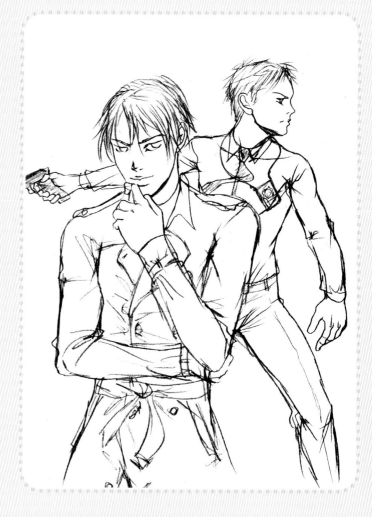

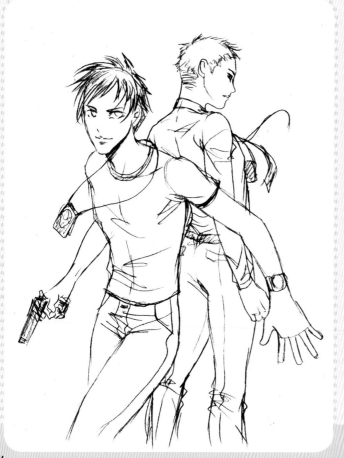

1. SKETCHES

In *manga*, police themes are often recurrent as a means to portray the personal relationships of the characters. Thus this nod to this genre. After making several sketches, we chose one where the characters had more physical contact and displayed their camaraderie.

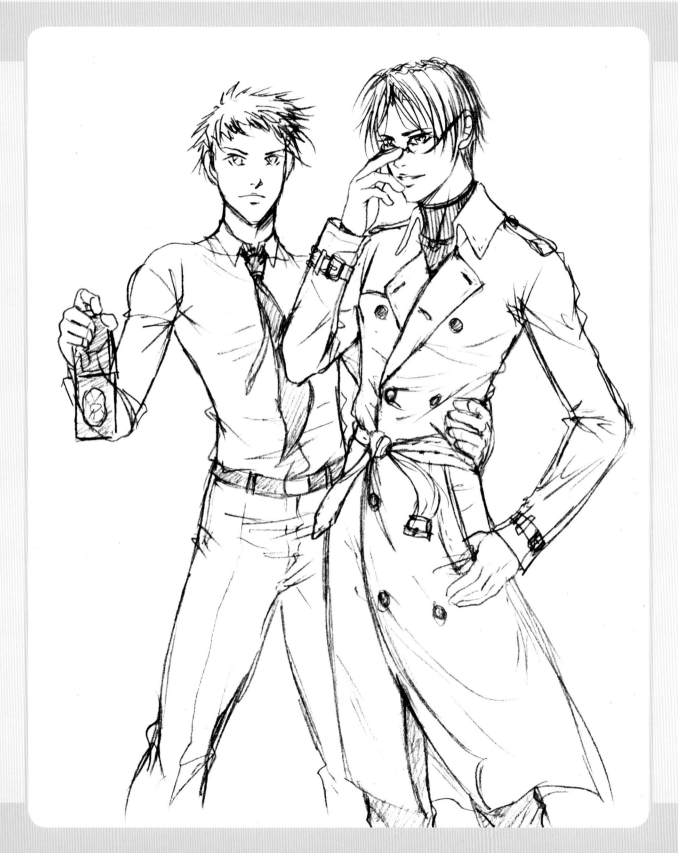

2. STRUCTURE

Male characters like these are greatly stylized, with long legs and wide shoulders.

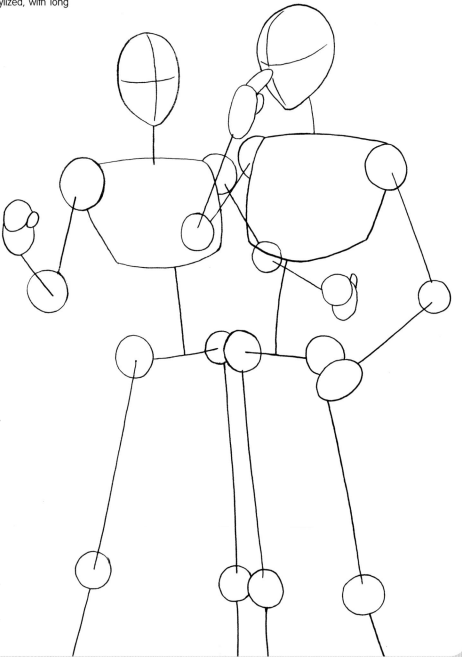

3. VOLUME

Despite the fact that we are dealing with policemen, we must not make them too robust. They have to look strong yet slender.

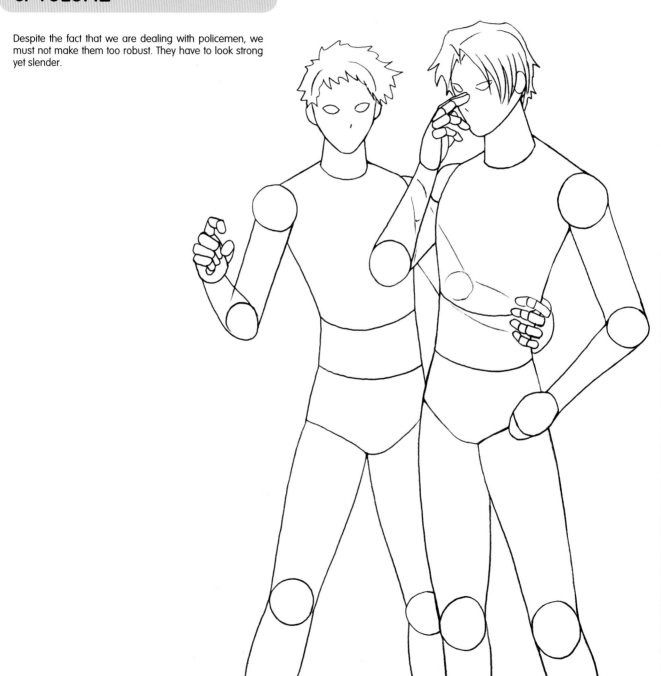

4. ANATOMY

Their athletic bodies prove that they are not only shrewd, but also great sportsmen. We differentiate them by their facial features; Kevin (on the left) looks more childish and impulsive, while Mark (on the right) looks more reflective and mature.

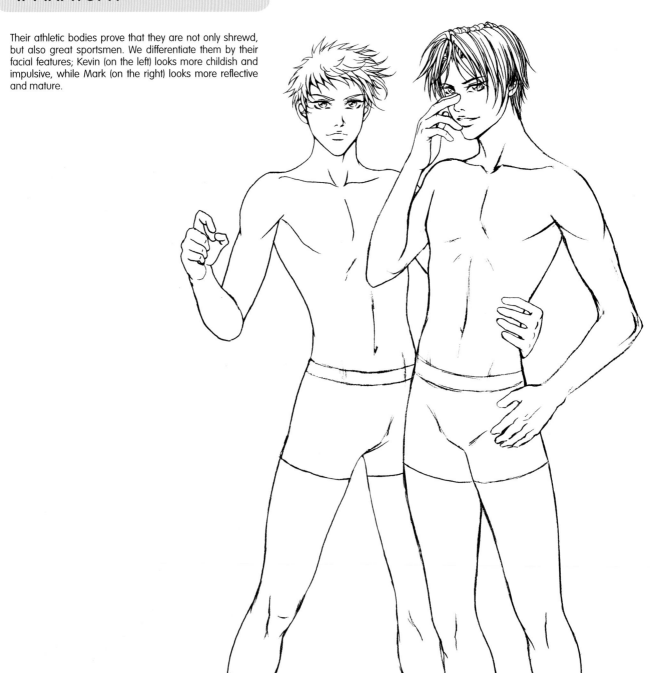

5. DETAILS

Their clothing is another way to tell them apart. One of them wears functional clothes, tight but comfortable, while the other character is more elegant, wearing a raincoat and a turtleneck.

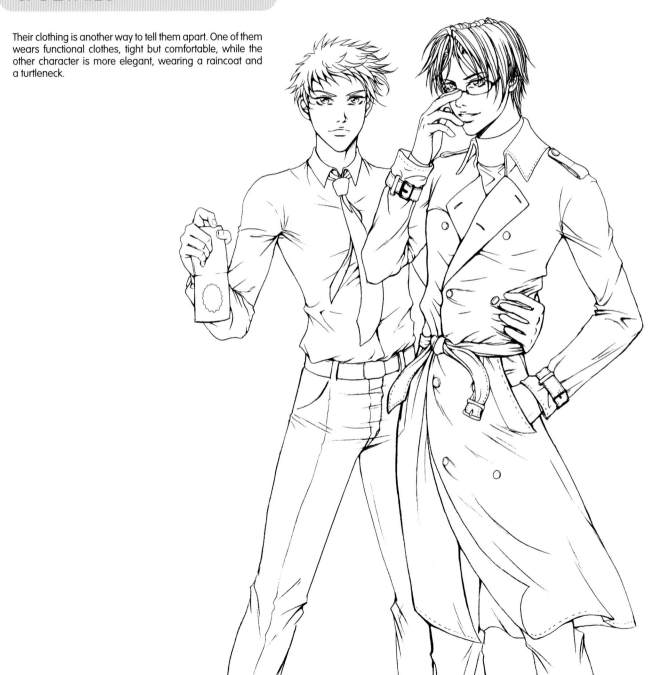

6.1. COLOR

We choose blue tones for Kevin and ocher tones for Mark. Since we have closed lines, we can use the Paint Bucket tool on a new layer with its blending mode set to either Multiply or Darken, remembering to check the All Layers option in the menu.

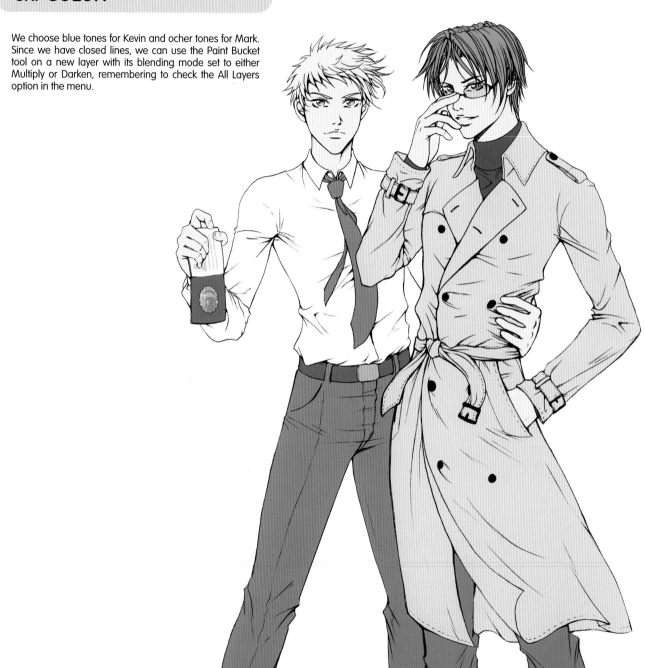

6.2. COLOR

We shade the image on a new layer using strokes of varying opacity on the base color. However, we will use flat colors for the skin.

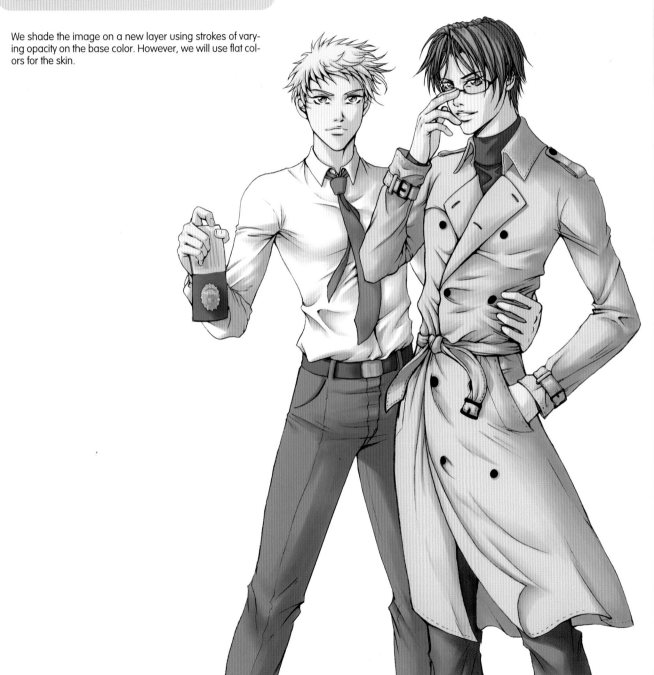

6.3. COLOR

We define the shading by saturating it with additional color brush strokes to stress the shapes and wrinkles of the clothing.

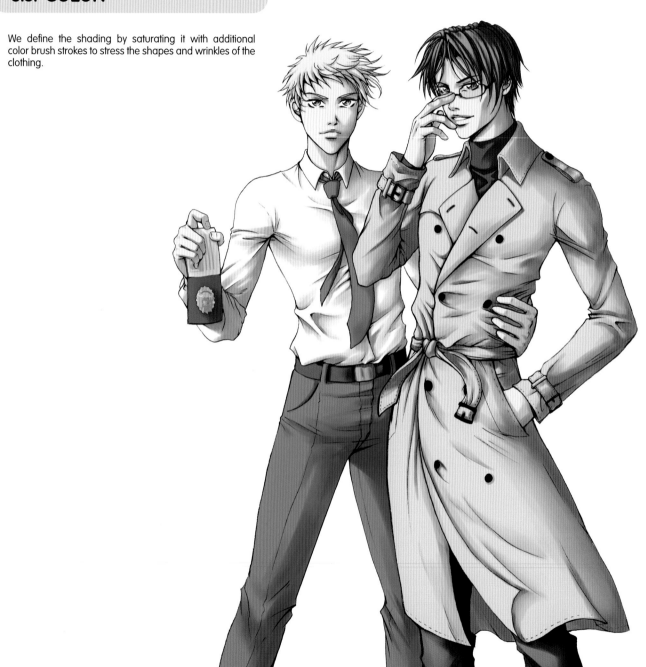

6.4. COLOR

We add volume with some brighter brush strokes to simulate
a light coming from the left.

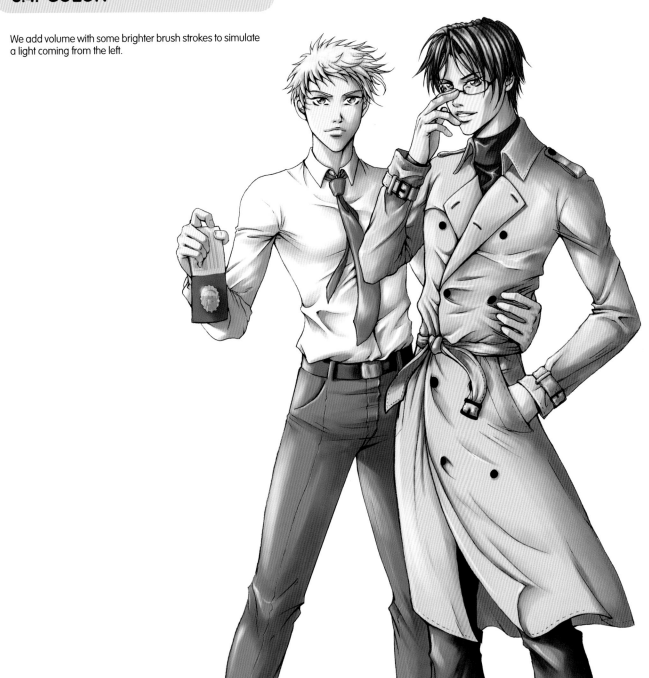

7.1. BACKGROUND

We fill the background with the typical police tape used to seal off the location of a crime.

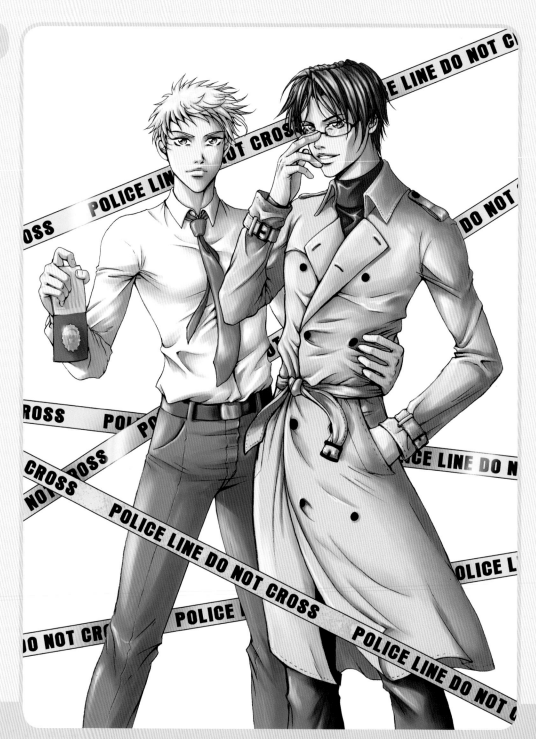

7.2. BACKGROUND

Behind the lines, we add a texture over a green background, leaving a faint white halo around the two detectives.

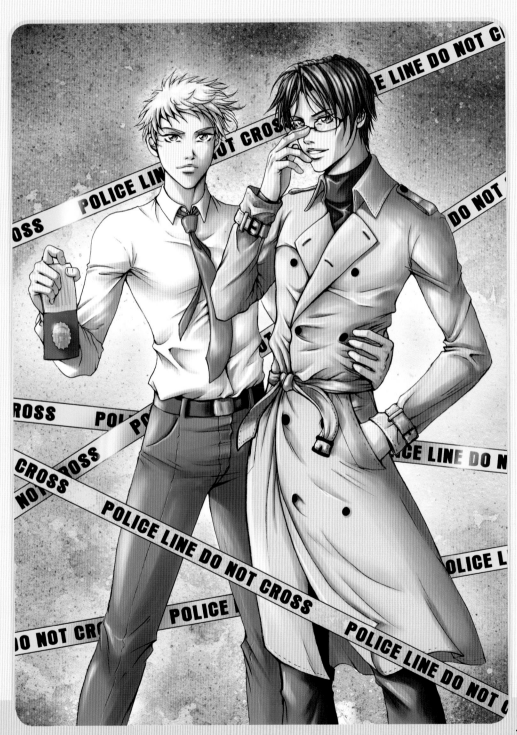

Finishing touches

- We darken the background slightly to make the main figures in the illustration stand out more.

- We apply a new gray scale watercolor paper texture with Overlay blending; we lower the opacity to 40% and allow it to affect both the characters and the background.

Tips & tricks

- By adding textures with Overlay blending over the final coloring, we make the illustration look more like a traditional painting, thus getting a warmer, more organic image.

- To achieve optimal results, we must try to make the textures complement the image, not mess it up. To make this happen, we experiment with different opacities and layer Masks so that the textures are visible only in the areas we want.

- We can create the textures ourselves scanning different papers or taking photographs of rocks or walls, but we can also design and manipulate them in the digital realm.

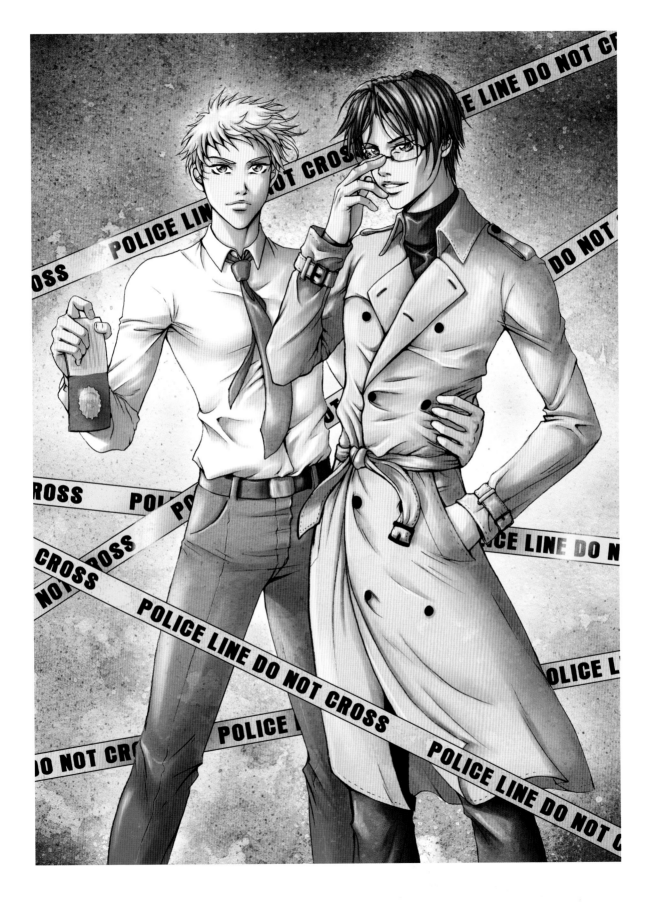

SURFER GIRL

The sun, the sand, the sea... Jewel roams the world seeking the best waves to surf with her van and her surf-board as her only companions. Perhaps somewhere along her journeys, she will find the cute surfer she met once before.

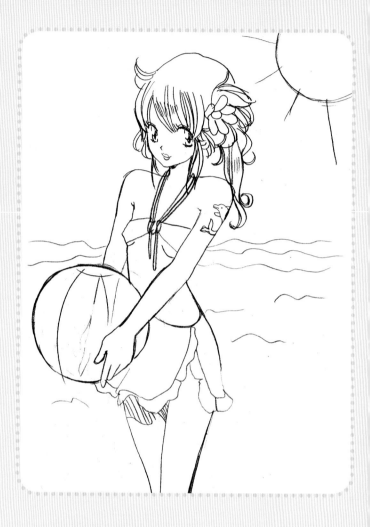

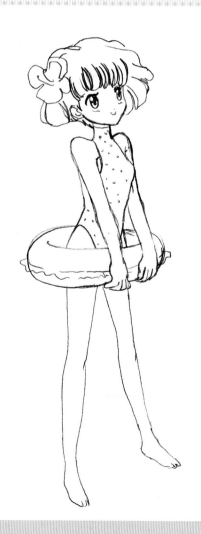

1. SKETCHES

There are many sport-themed series that star young troubled girls who push their limits to make their dreams come true. For this illustration we are looking for something less dramatic and more joyful, so we decide that a beach scene with a surfer girl will be original and fun.

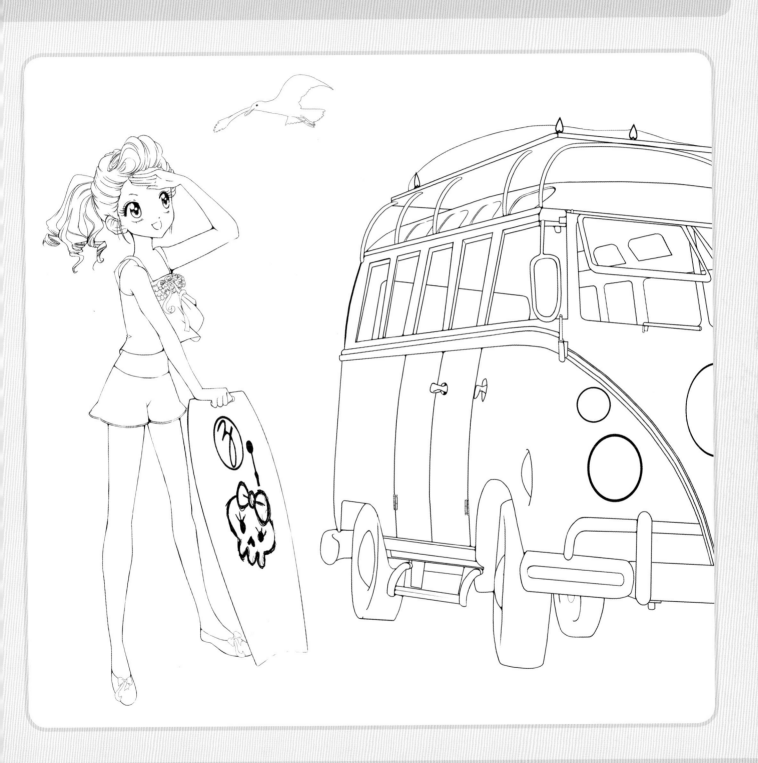

2. STRUCTURE

We lay out the basic structure that defines the pose of the girl, with one hand on her forehead and the other one placed as if it is holding a surf-board.

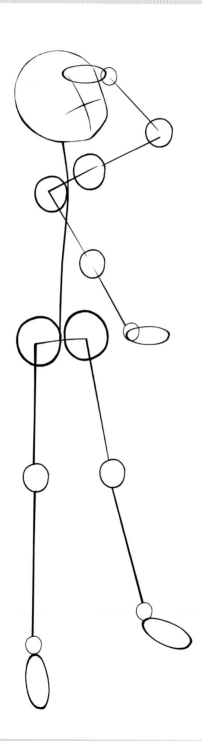

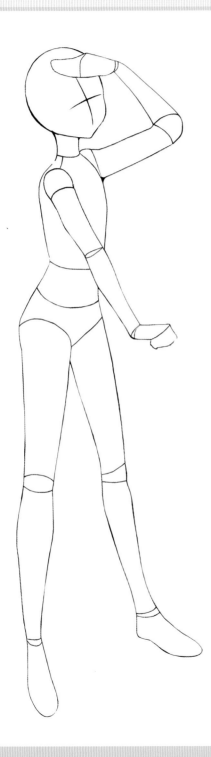

3. VOLUME

The torso is slightly twisted, which lends dynamism to a static pose.

4. ANATOMY

Being an athletic girl, Jewel's figure is agile and stylized. Her hair is tied up for comfort when she's in the water.

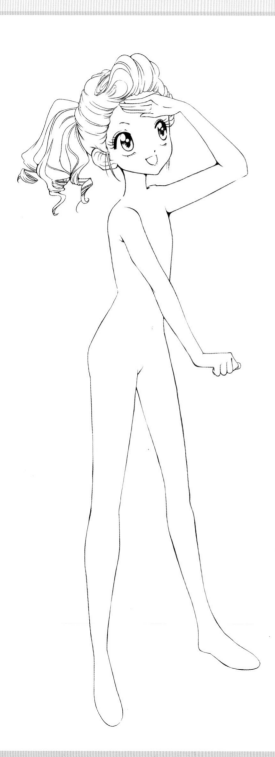

5. DETAILS

We dispensed with the bikini to have a more youthful image, something that is also more practical. The van has been drawn digitally, using a photograph as a reference.

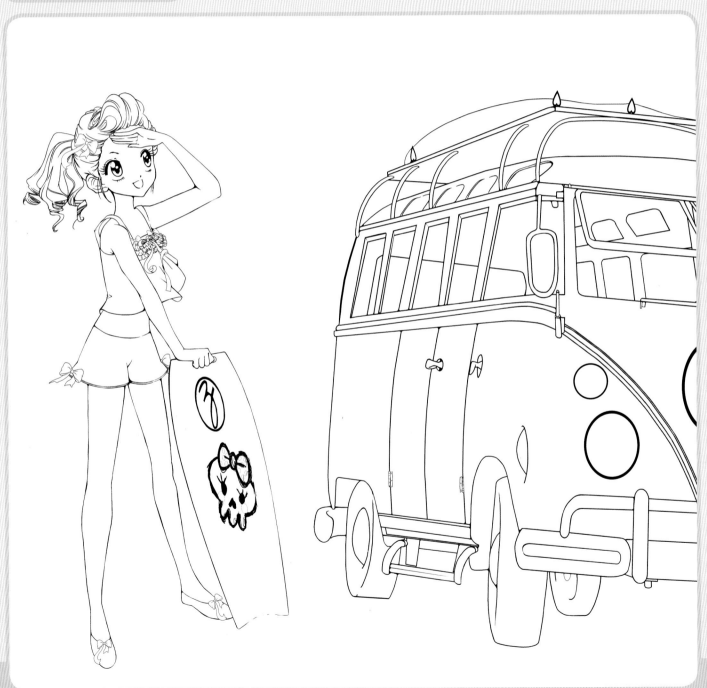

6.1. COLOR

Red and magenta will be predominant in the image, so we will use various green tones to complement them.

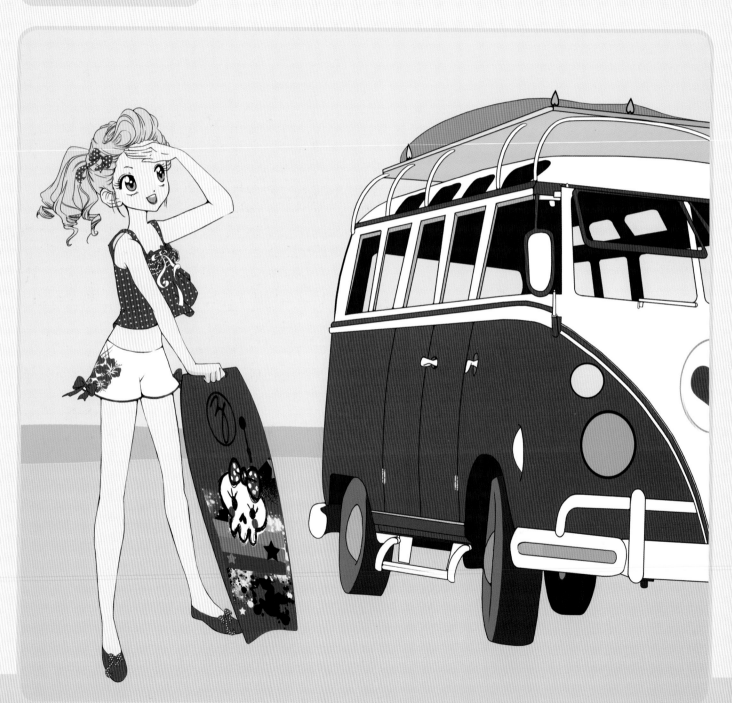

6.2. COLOR

We add decorative elements to the van. Its shadows are painted in lilac tones set to Multiply Blending. For the girl, we will use softened brush strokes to darker hen skin color.

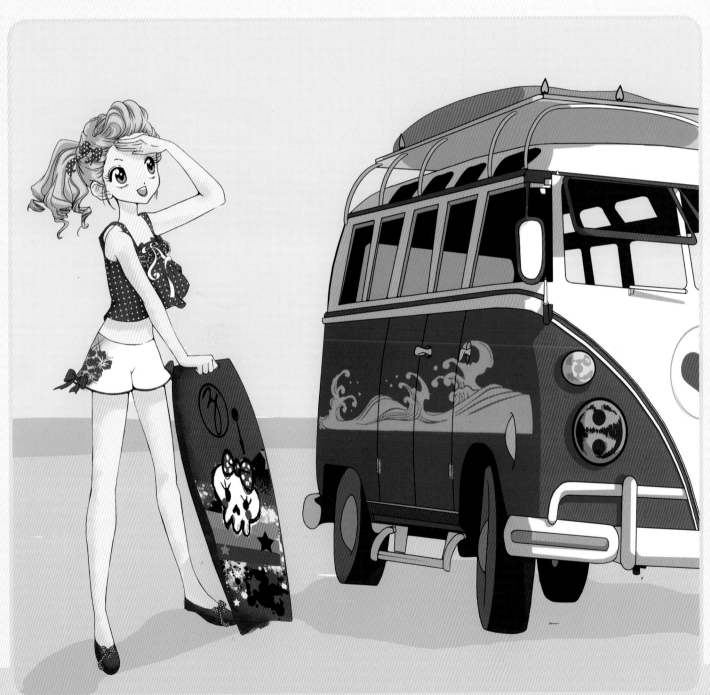

6.3. COLOR

We add the highlights and the clouds in the sky. A grainy texture is used for the sand and we draw the shadows on the ground on a new layer with its blending mode set to Multiply.

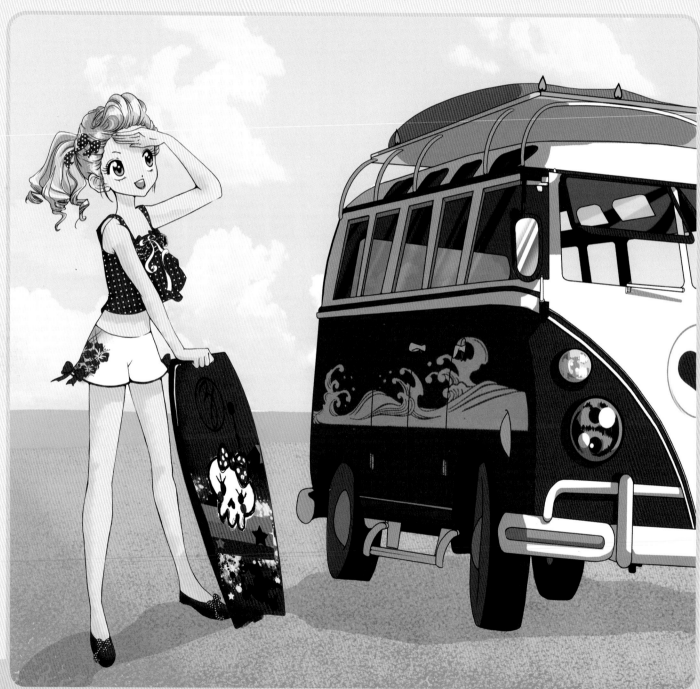

6.4. COLOR

We add a few more waves on the sand to make the elements in the picture look as if they are really sunk into sand.

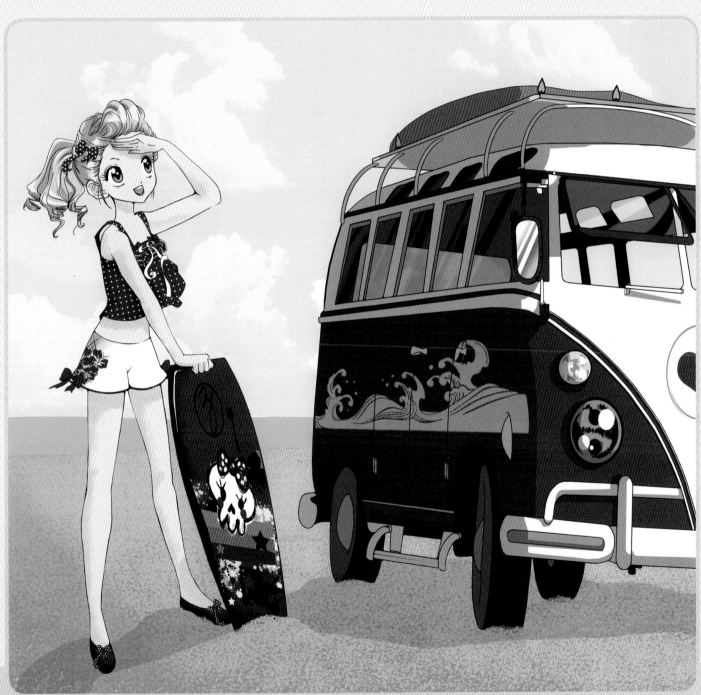

Finishing touches

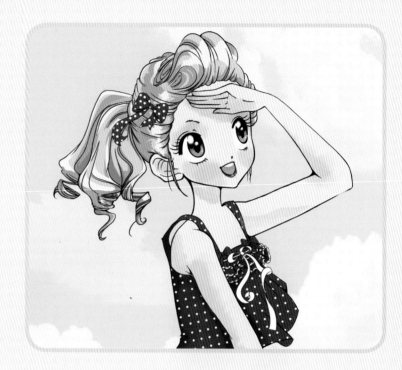

- We finish coloring the girl, painting the flush on her cheeks and eye shadow, and we add more highlights on her hair.

Tips & tricks

- We have combined several different coloring styles in this illustration: flat colors, gradients, textures and brush strokes, all of them aimed at achieving a pop look.

- For the background, we have used real clouds as a base to create our own by retouching and editing them digitally.

- To achieve that almost 3D-like finish for the van, in addition to having used a photograph as a base of reference, we outlined several color layers with blending properties we set to create a black Stroke. This effect helps us to emulate a one-color inking, something that reminds us of the finish achieved with felt-tip pens.

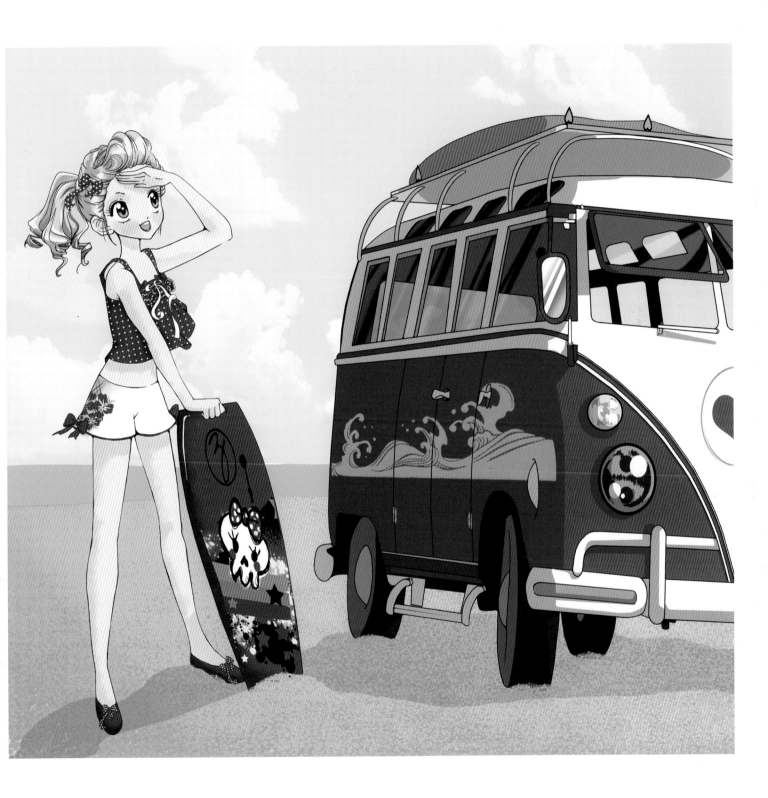

HIGH SCHOOL LOVE

With classes, grades and final exams, teenagers spend their best years in high school. There they meet their first love, experience their first relationships and also their first disappointments. Meiko is a cheerful and active girl, but her new boyfriend, Takeshi, seems more interested in books than in her. So Meiko has come up with the perfect plan: they will be studying together for their final exams, even if that means spending the night together at home.

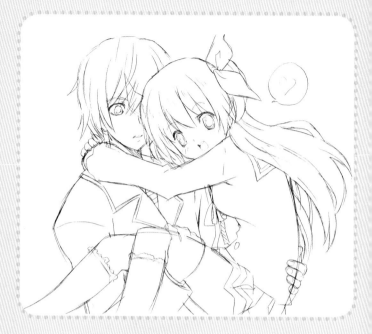

1. SKETCHES

Japanese *manga* teenagers often find themselves in love with boys who play hard to get or are just outside of their possibilities. That is why we thought it would be good to have a contrast between the boy, engrossed in his thoughts, and the girl, who is excited that they are returning home together after class.

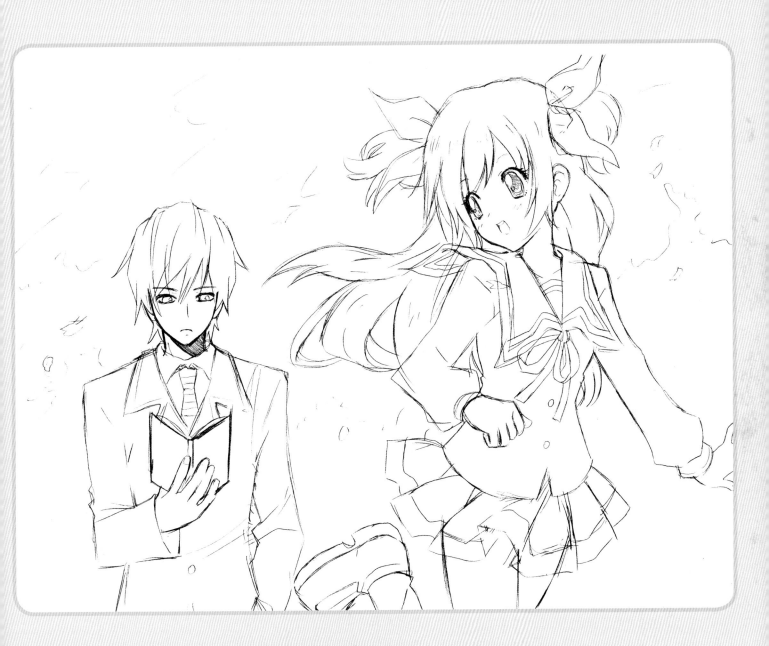

2. STRUCTURE

The boy walks upright while the girl has a more dynamic pose. Tilting her head backward balances her figure.

3. VOLUME

We sketch the outline of the characters, breaking up the limbs so they are easier to draw.

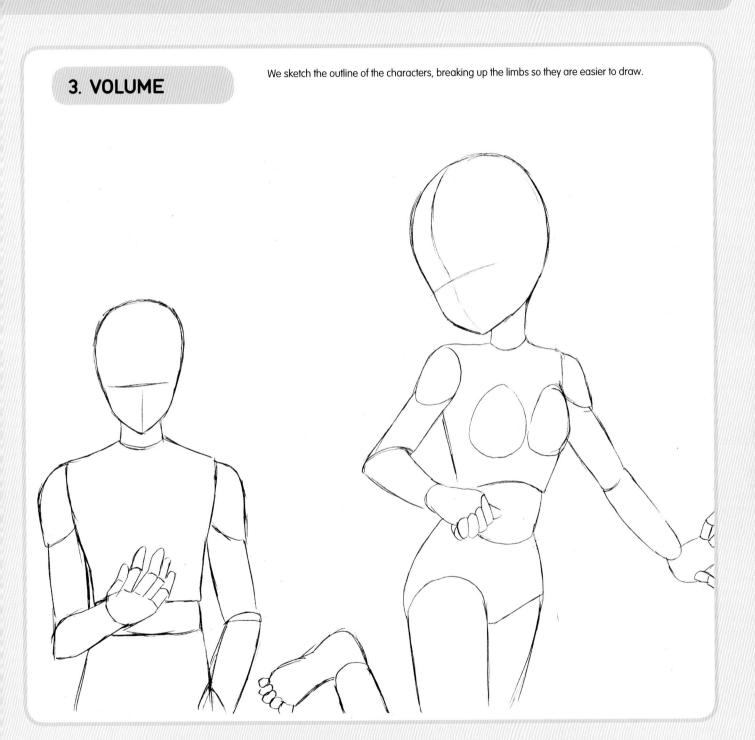

4. ANATOMY

We draw the hair and the remaining details of their bodies. The boy's neck has to be thicker than the girl's, maintaining a relative heftiness in the boy when compared to the delicacy of the female anatomy, whose shapes are softer and less pronounced.

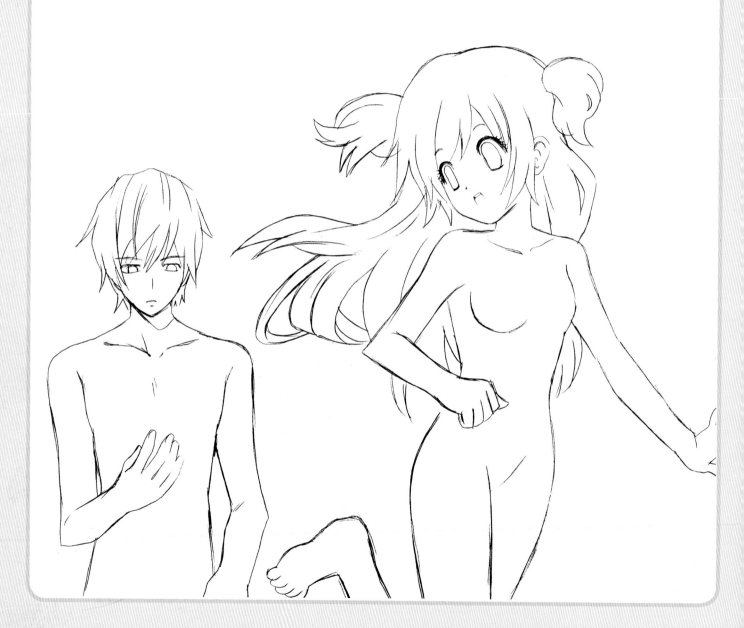

5. DETAILS

We dress them in their high school uniforms and then add sakura petals to enhance the mood of the scene. The flounces on the skirt are moved by an imaginary gust of wind.

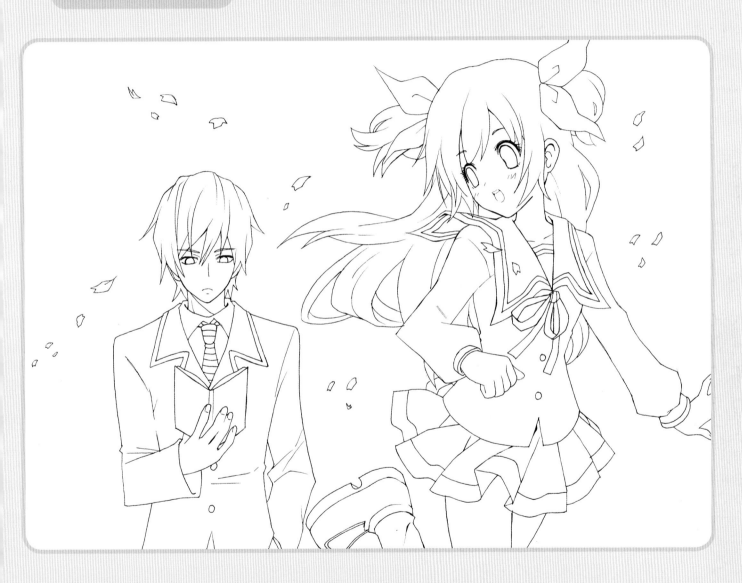

6.1. COLOR

The boy will have a range of cold colors, whereas the girl will be painted in warm and ocher tones. Considering that we are painting with flat colors and the lines are closed, we can use the Paint Bucket tool to fill the illustration with color on a different layer. If we enable the All Layers option, we can fill the different closed areas without having to make any selection.

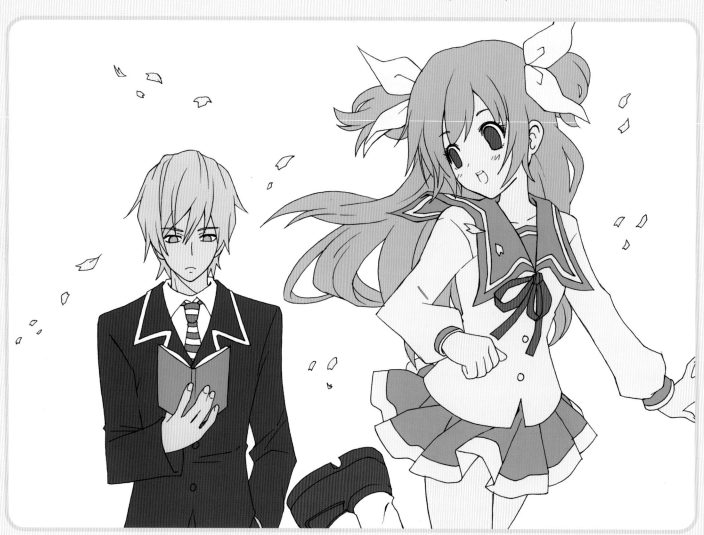

6.2. COLOR

We apply shadows and highlights using the Lasso tool to select the corresponding areas, and fill them in with color on another layer. We pay special attention to the details on the eyes using color gradients.

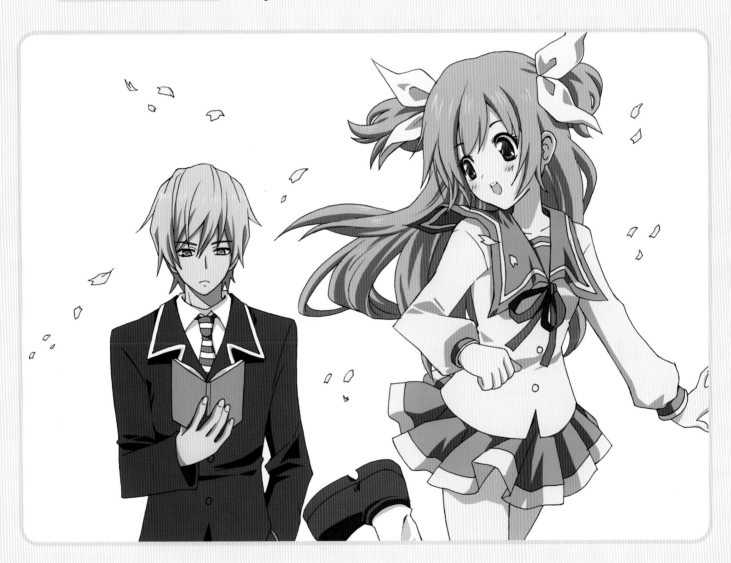

7. BACKGROUND

We create a vector drawing of the building in a separate file. We paint the blooming cherry trees using brush strokes of varying opacities.

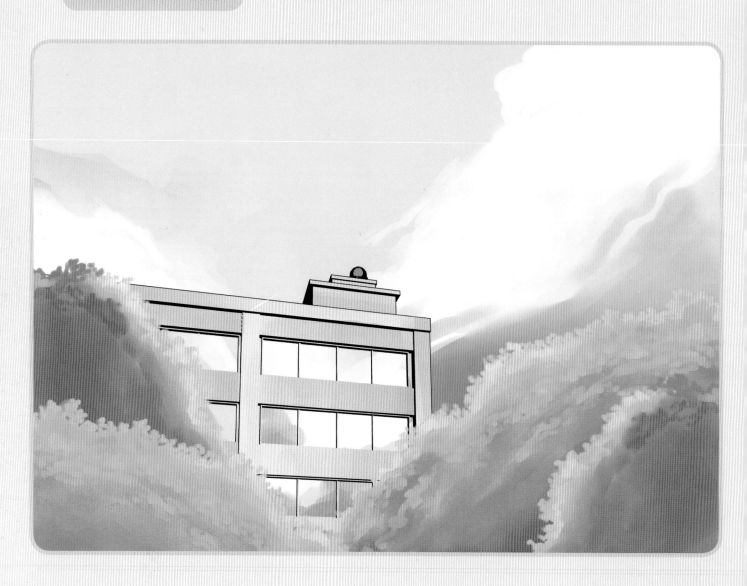

Finishing touches

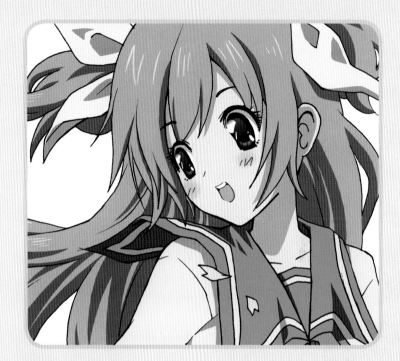

- We place the image of our two students over the background we have created.

- Working in this way allows us to create bigger images without slowing our process.

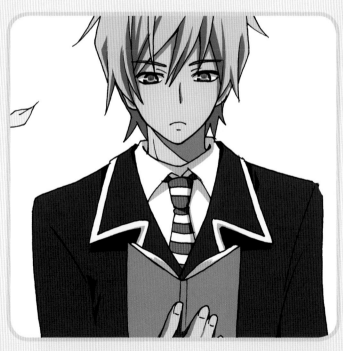

Tips & tricks

- We should never paint on the same layer that contains the original scanned drawing. We will always create new layers on which we will apply the various color areas.

- If you are new to digital coloring, it is a good idea to start to practice with flat colors and keep the base color, the shadows and the highlights on separate layers.

- If you still don't know how to take full advantage of your coloring software and are afraid of painting over the layer containing the original line drawing, you can lock it to avoid making mistakes when you are filling the rest of the image with color.

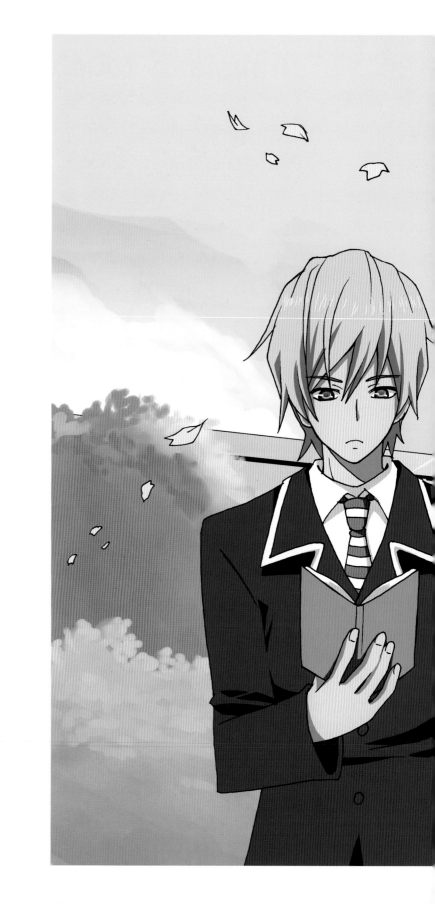

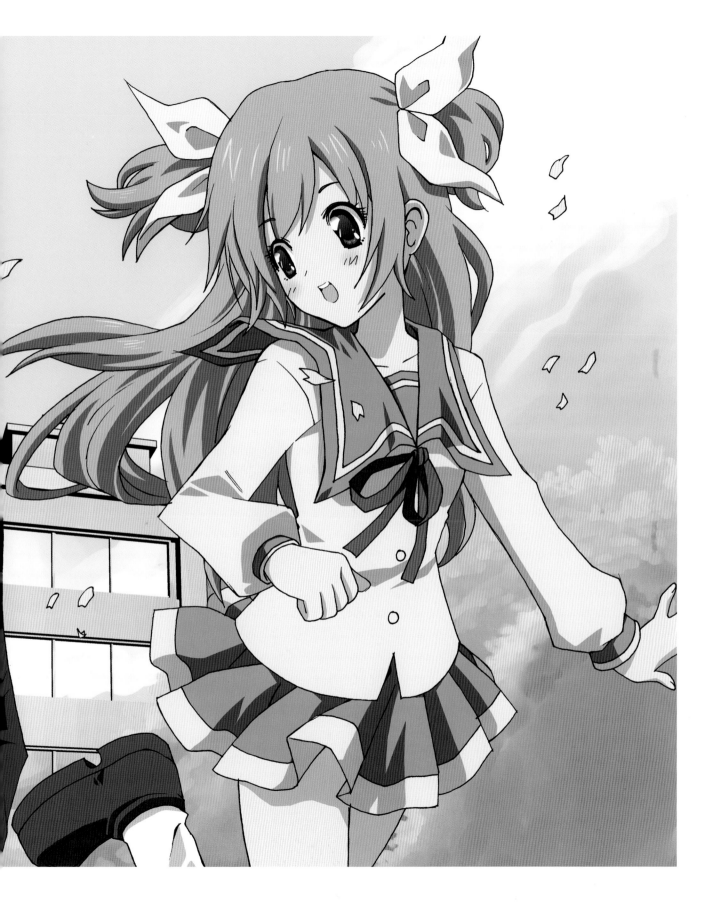

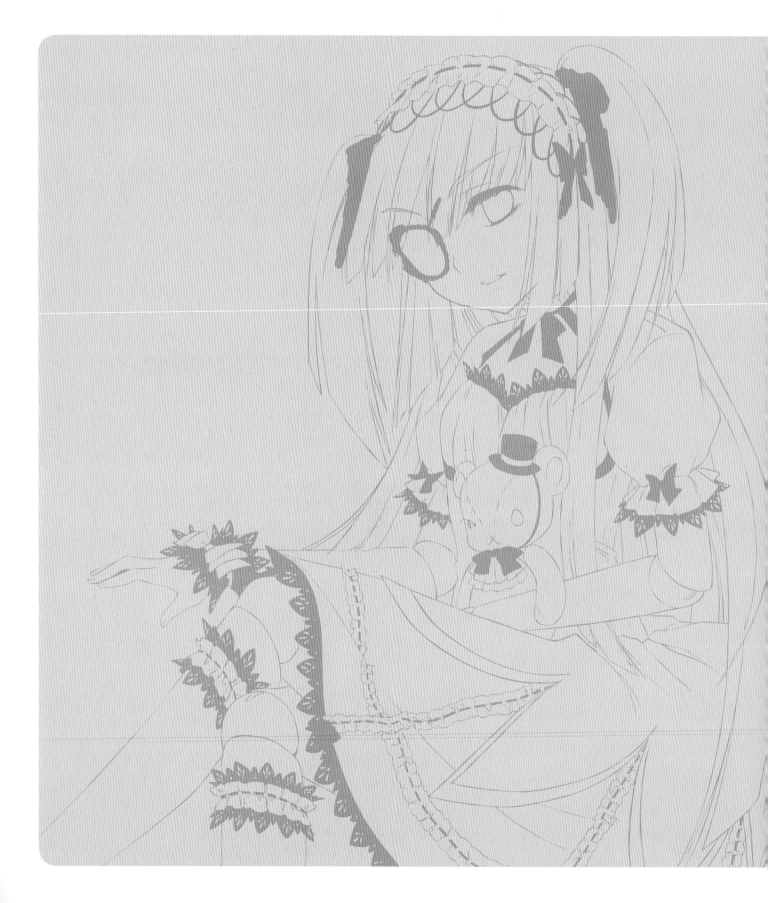

Gothic Zone

ROCKSTAR
MY GOTH DOLL
VAMPIRES

ROCKSTAR

Behind her defying look, her heartbreaking lyrics and her goth-punk getup, there's still a very tough girl you would be wise not to mess with. But to become a big rock star sometimes it is necessary to be patient and clever. An artist's life is very hard, and one has to be mature and level-headed to lead a smooth career.

1. SKETCHES

We want to steer away from the sweetened identity of Japanese idols, going for a darker, more American look. Although the girl's clothes were quite defined, we had some trouble finding the right pose and point of view.

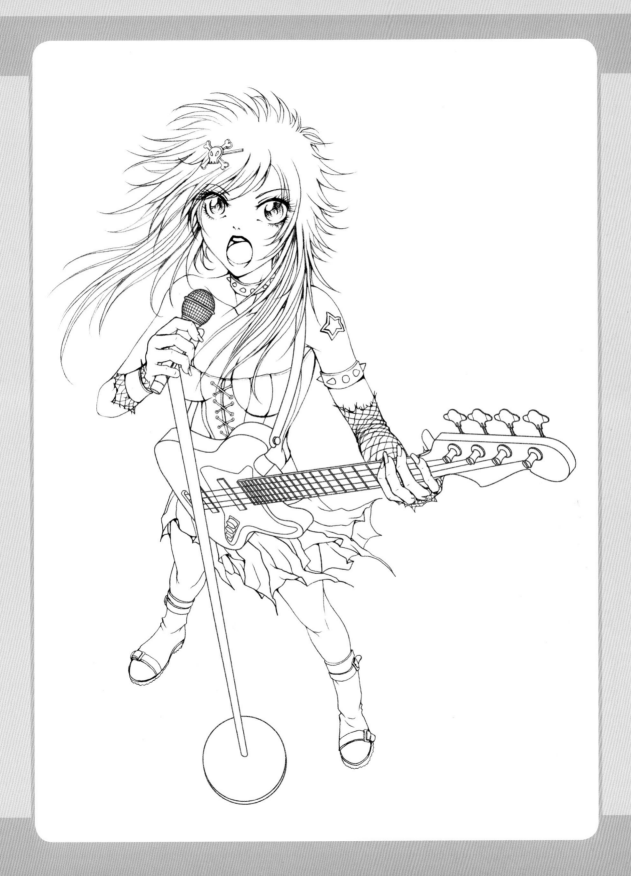

2. STRUCTURE

We lay out the image including the microphone and the guitar to make sure the body fits well in the pose, along with the elements with which she interacts.

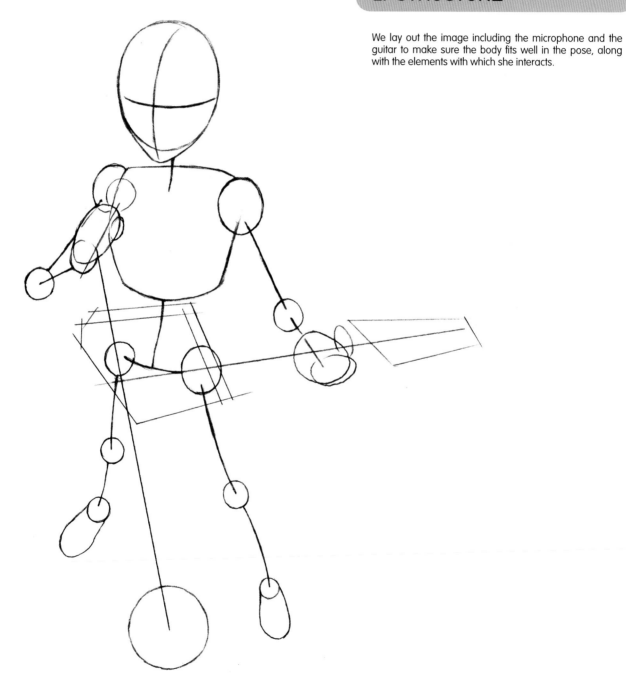

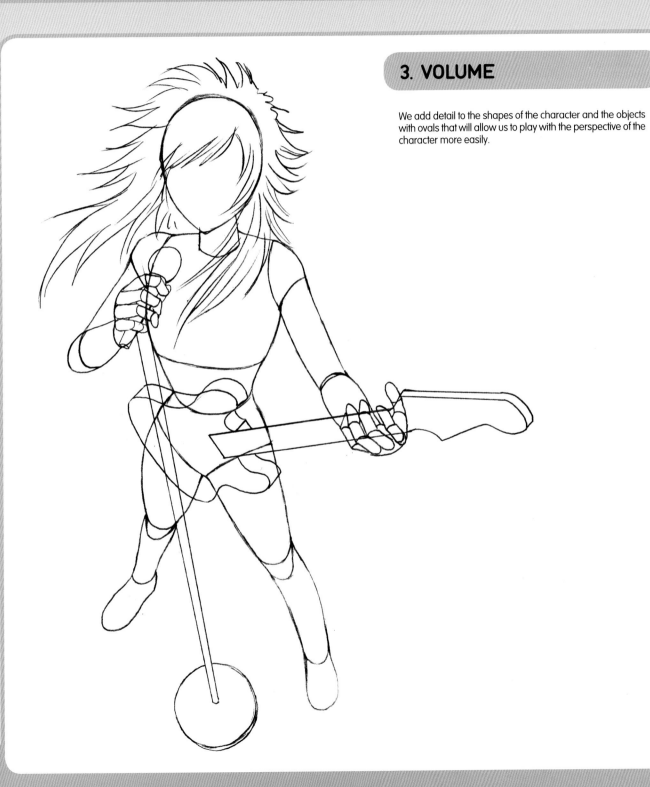

3. VOLUME

We add detail to the shapes of the character and the objects with ovals that will allow us to play with the perspective of the character more easily.

4. ANATOMY

Once we have the figure well defined according to the bird's eye view, we finish her facial expression.

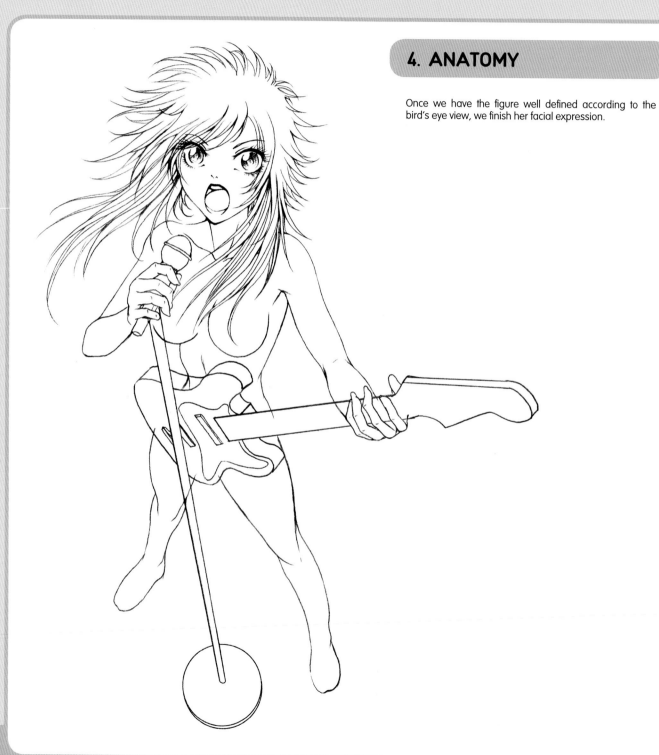

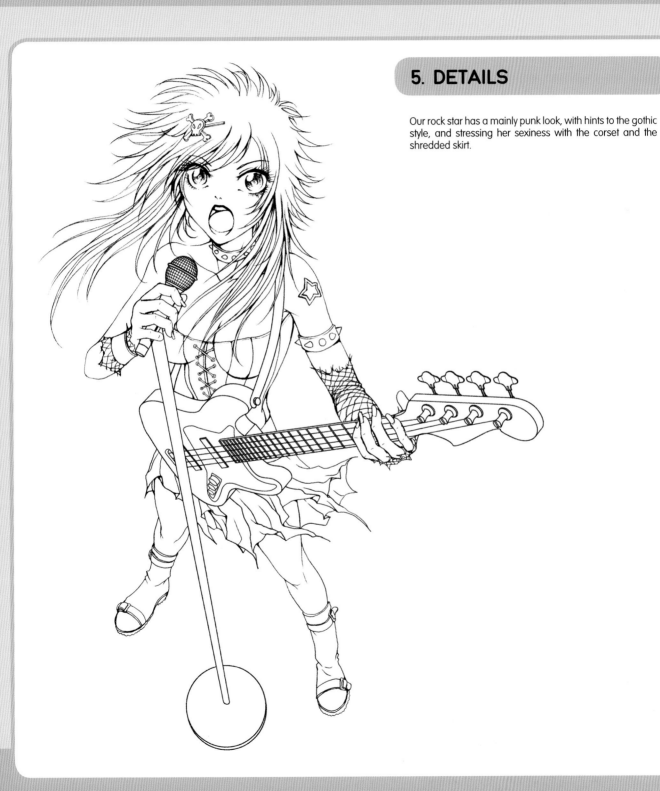

5. DETAILS

Our rock star has a mainly punk look, with hints to the gothic style, and stressing her sexiness with the corset and the shredded skirt.

6.1. COLOR

We color the line drawing and apply the first tones for the skin and eyes with softened watercolor brush strokes.

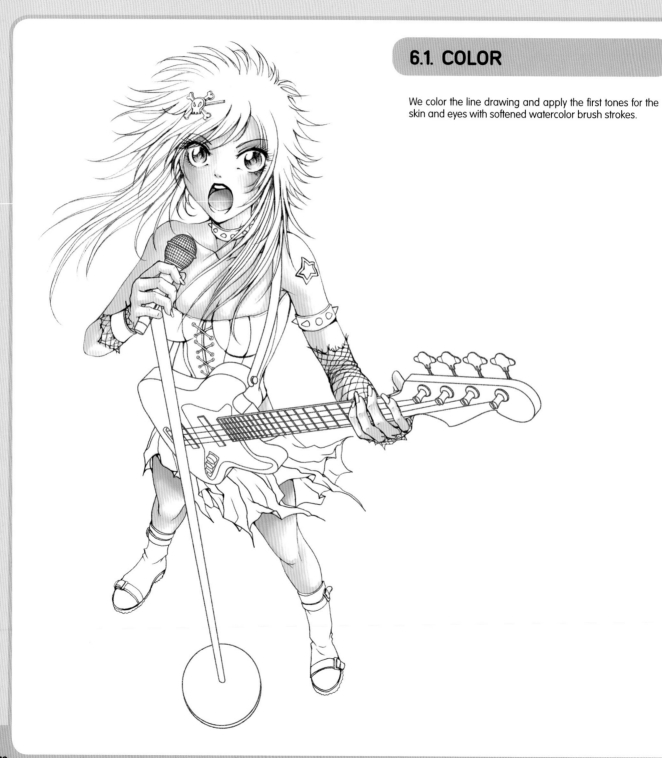

6.2. COLOR

We continue with the hair, leaving the middle part white to accentuate and mark the area lit by the spotlight.

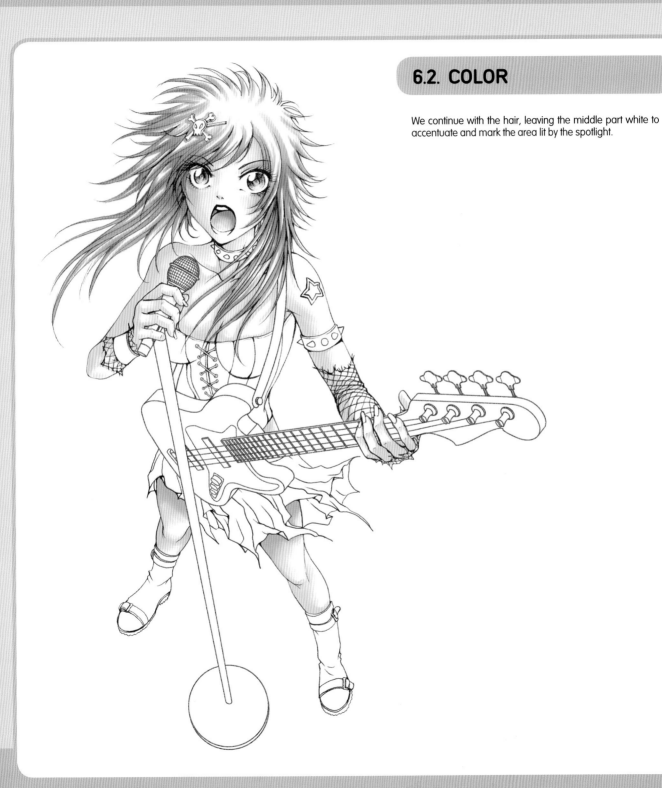

6.3. COLOR

We use brush strokes with different shades of black and lavender for the dress to create volume and texture like that of leather.

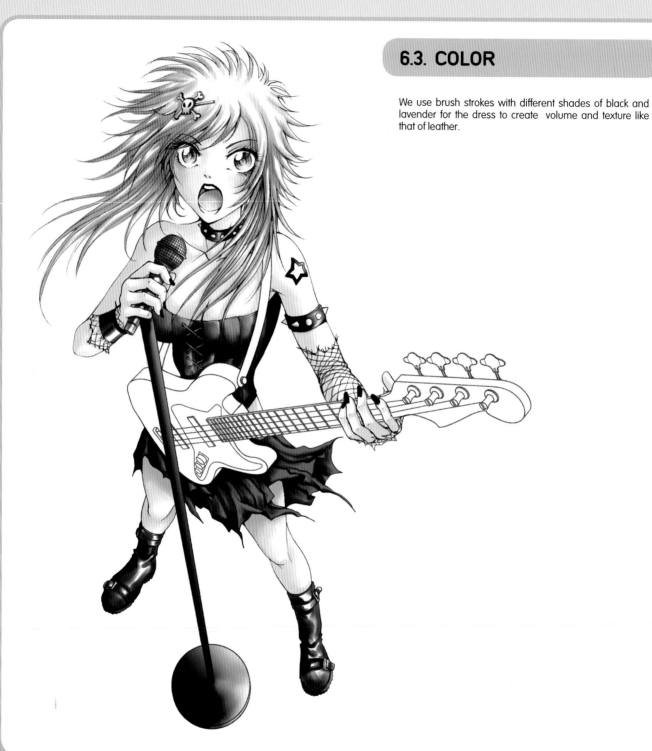

6.4. COLOR

After coloring the microphone, we finish the guitar by also using the Brush tool.

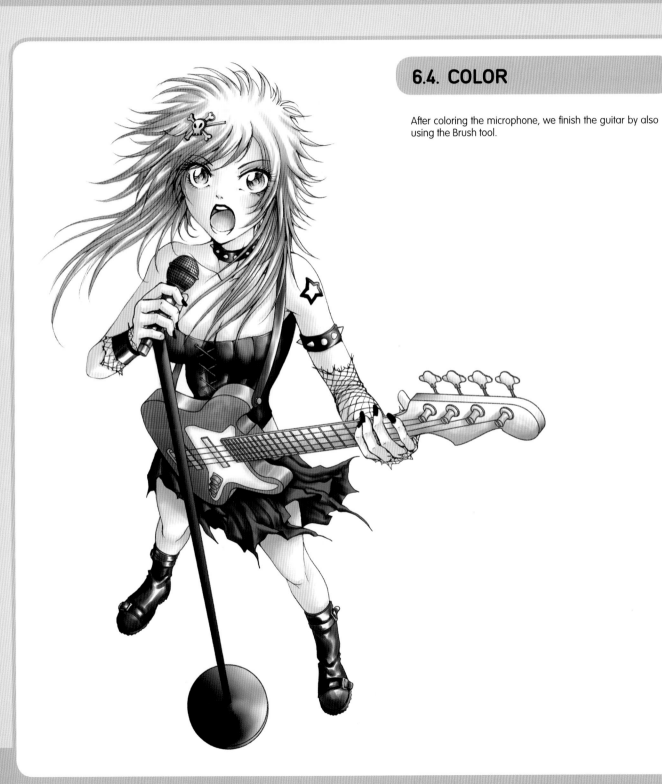

7.1. BACKGROUND

We create three spotlights over a textured background.

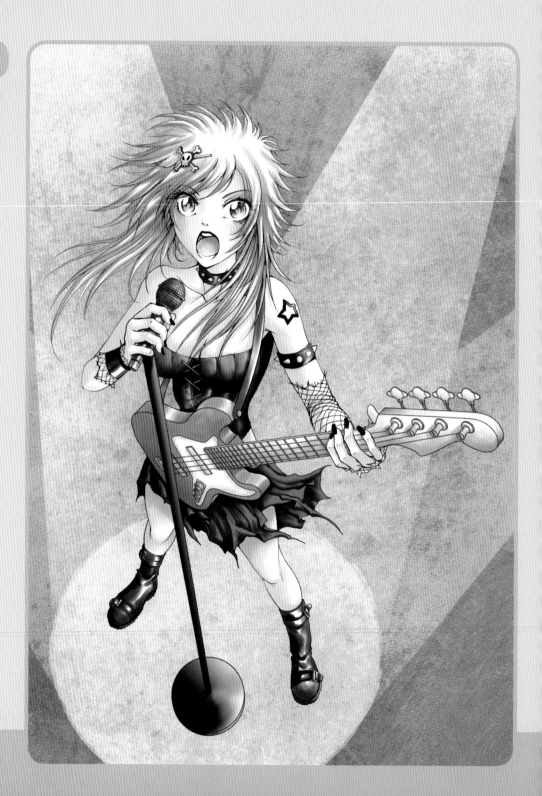

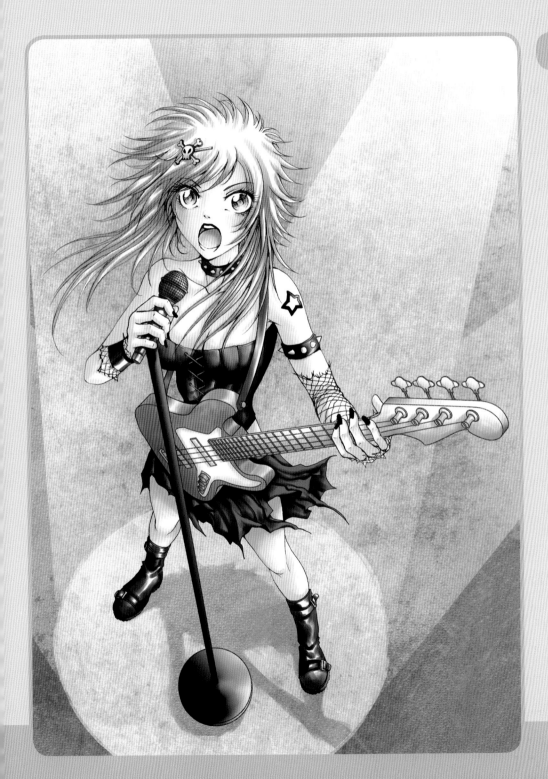

7.2. BACKGROUND

A white gradient is applied to the upper part of the image.

Finishing touches

- To strengthen the sensation of being on stage, we add more highlights and reflections, as well as paint spatters that match the textures background perfectly.

Tips & tricks

- This time we don't apply textures on the character, as that would detract from the volume and detail of the leather effect we achieved with the brush.

- Although tricky, bird's eye views add tremendous energy to an illustration. One has to be careful with vanishing points and the character's proportions according to the distance.

- Proper lighting is fundamental in this image; with highlights we get a three-dimensional look that completes the illustration perfectly.

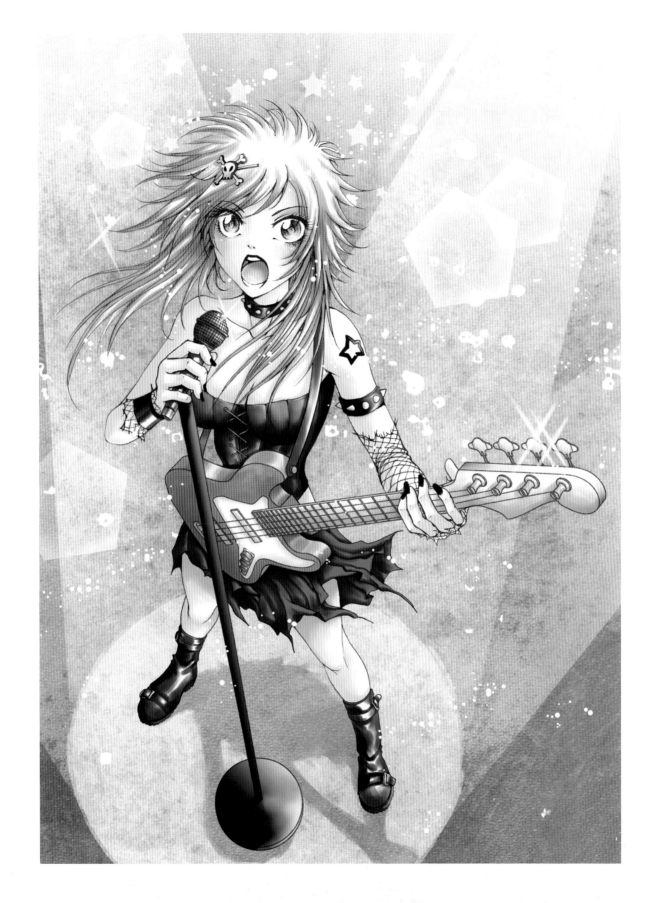

MY GOTH DOLL

Nobody knows how nor why, but my doll has a life of its own. She can move, she can speak, look and feel. The legend says that someone trapped a young girl's soul inside the doll and that she has been looking for a real body to escape to ever since. Me, I don't know whether that story is true or not. I found her one night in my attic. My doll is alive; my doll is my best friend.

1. SKETCHES

The look of the doll was pretty clear, but finding a convincing pose and composition implied more than one headache. The one we chose in the end seemed like the best choice.

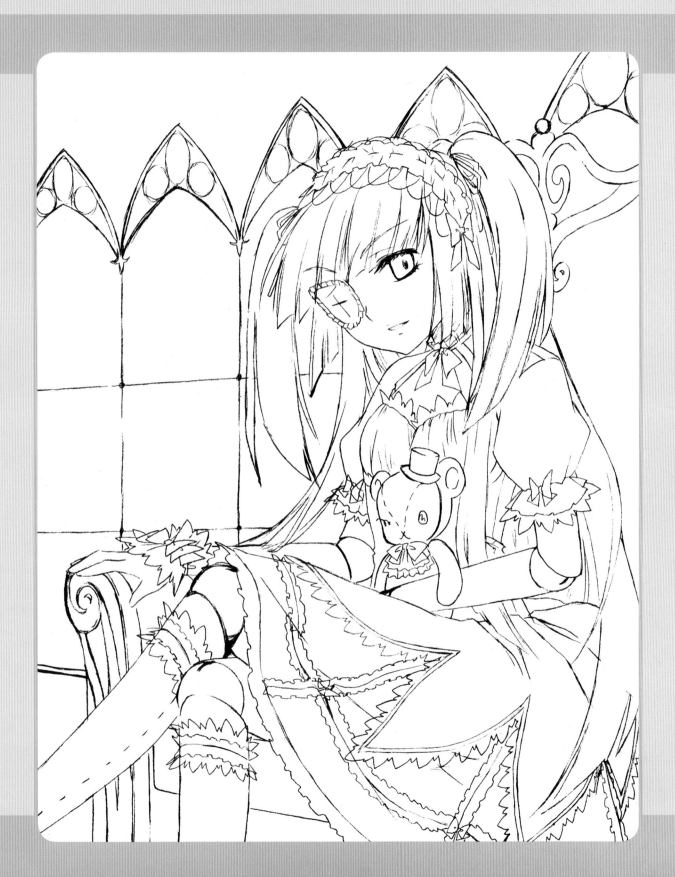

2. STRUCTURE

Her head is slightly tilted with a soft curve in her back to counter the stiffness of the seated pose.

3. VOLUME

We make use of ovals used as joints as a guide to include the actual joints of the doll.

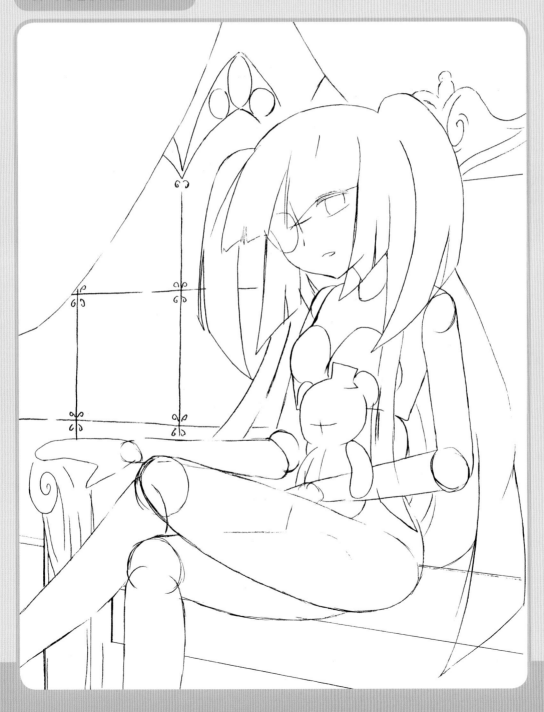

4. ANATOMY

We detail the facial features and clean the drawing of unnecessary lines. Her body is somewhat voluptuous as she is a large doll, not a real girl.

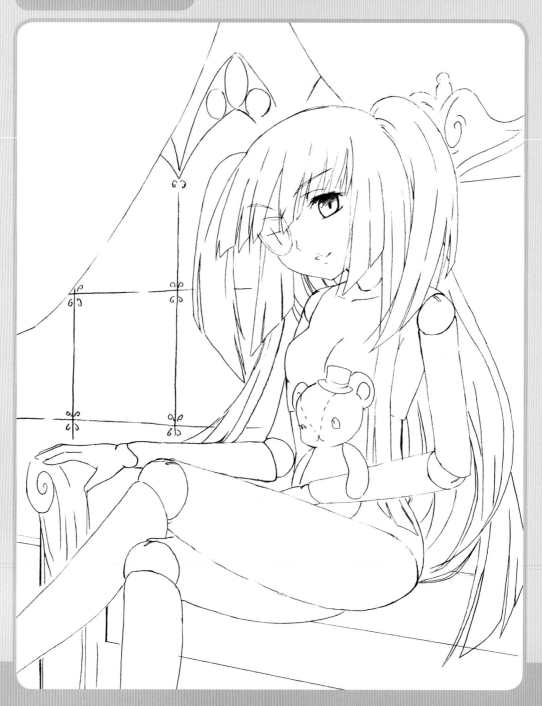

5. DETAILS

Her clothing is chosen to have a *gothic lolita* style, which combines Victorian elements with the look of classic maid uniforms.

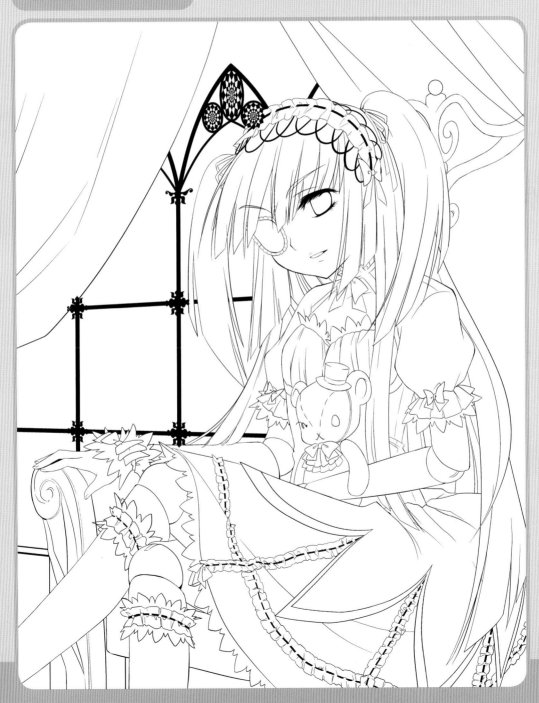

6.1. COLOR

We start with flat colors with low saturation, which we will gradually darken.

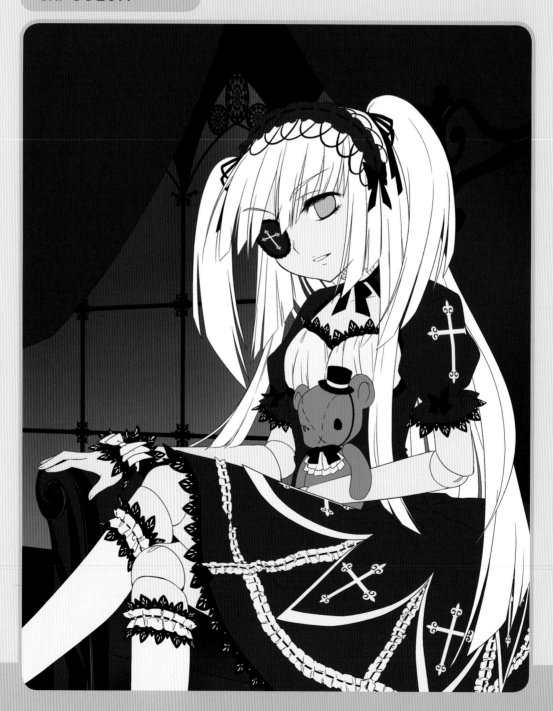

6.2. COLOR

We apply lighter shadow tones, and mark some of the hair locks with color. We detail the eyes and mouth and start shading the wrinkles and ornaments on her clothes.

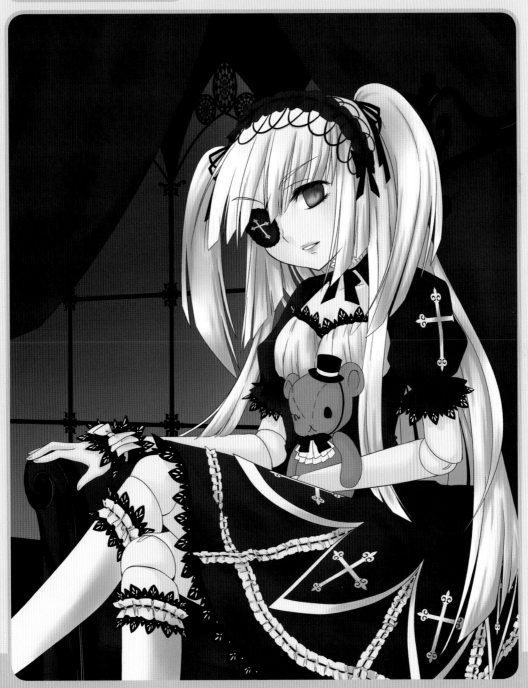

6.3. COLOR

We accentuate the shadows, adding darker tones on the deeper areas and those farthest from the light source. We add blusher to her face.

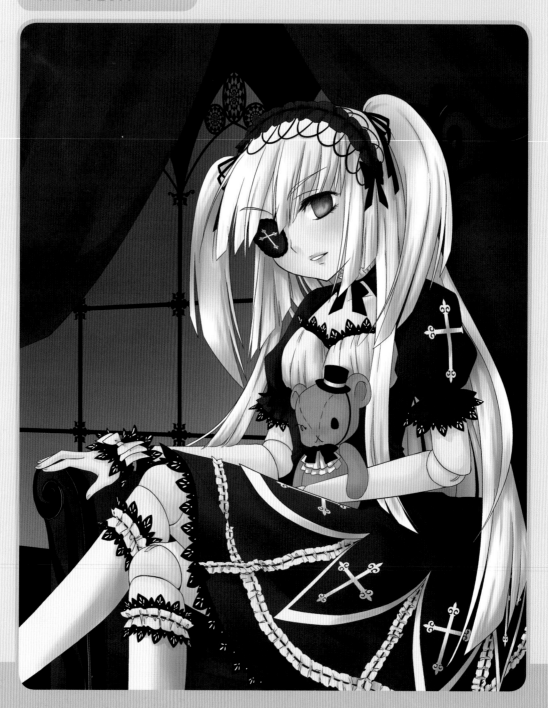

6.4. COLOR

We add highlights on the doll and the background; then we add the stars, drawing tiny white spots and blurring them. A faint white glow on the window simulates the reflection of real glass.

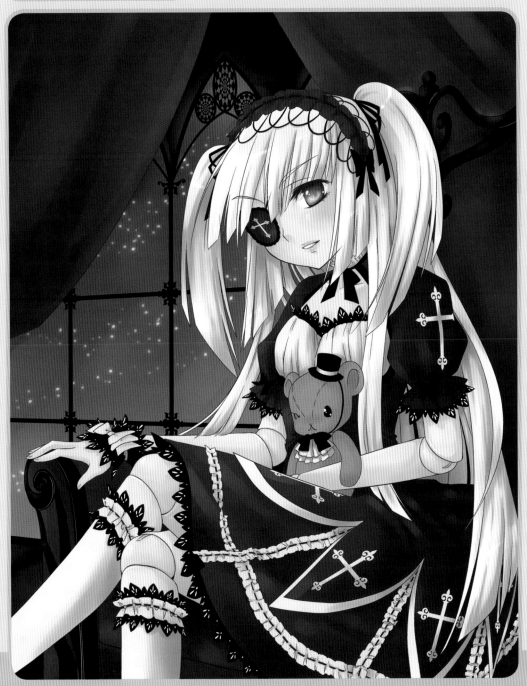

Finishing touches

- To finish the image, we add detail to the couch and drapes with a pattern. Around the doll, we add a glare with a bright color to make her stand out from the background as a result of the light coming in through the window.

- We apply to both the background and the doll a really soft diffuse glow. This way, we take some of the harshness away from the image, making it look gentler.

- Lastly, we place some butterflies in the upper left corner, finishing the dreamlike atmosphere we wanted to portray.

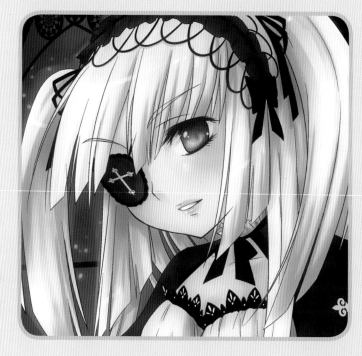

Tips & tricks

- To create a dark atmosphere, you don't need to darken the image, but make good use of light and shadow.

- This allows us to have a magical and dark atmosphere without sacrificing the details of the illustration.

- It is important to add always small areas of light that enhance the contrast between darker and brighter areas.

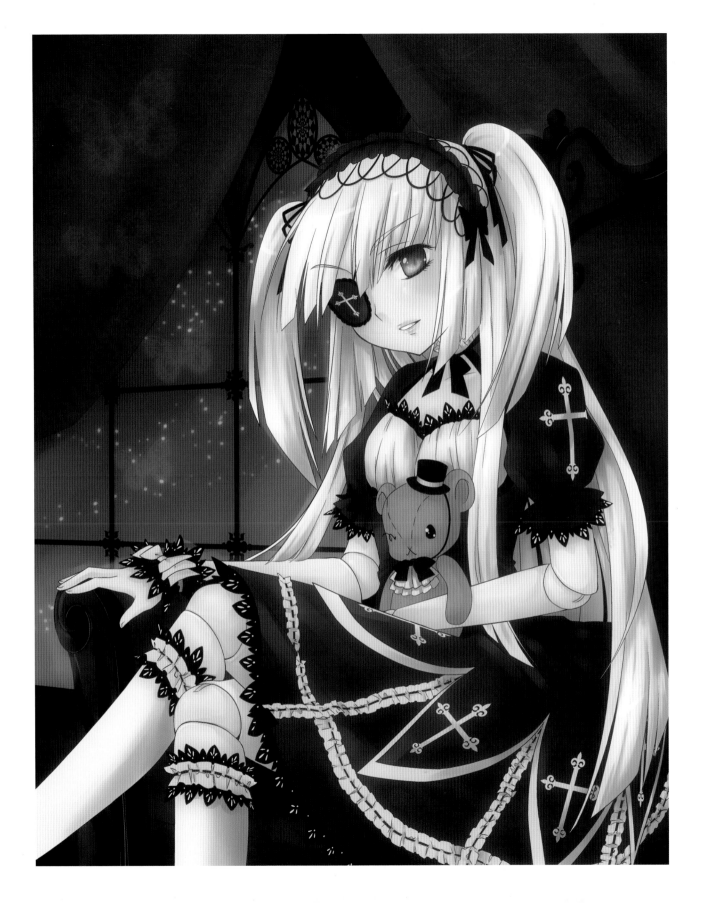

VAMPIRES

Every modern vampire has a mentor, a master or father figure. Beshia is a young vampire created by the old Koleh. Eager to enjoy his new condition, he doesn't hesitate to roam the city using his new supernatural abilities. Koleh, who is much more calm, must bear with his disciple's relentless spirit.

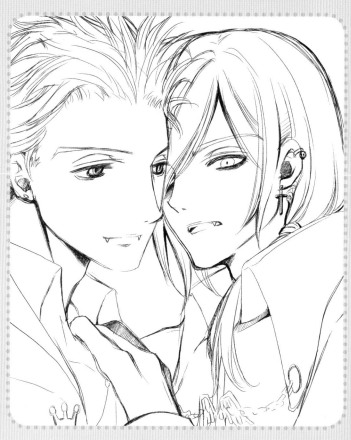

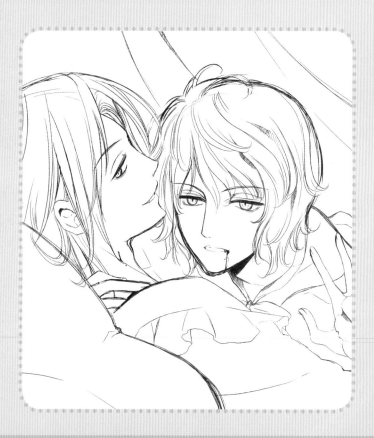

1. SKETCHES

Our first sketches were close-ups, however, our intention was to show a more open shot that would show the expressions of the vampires and also their clothes and environment.

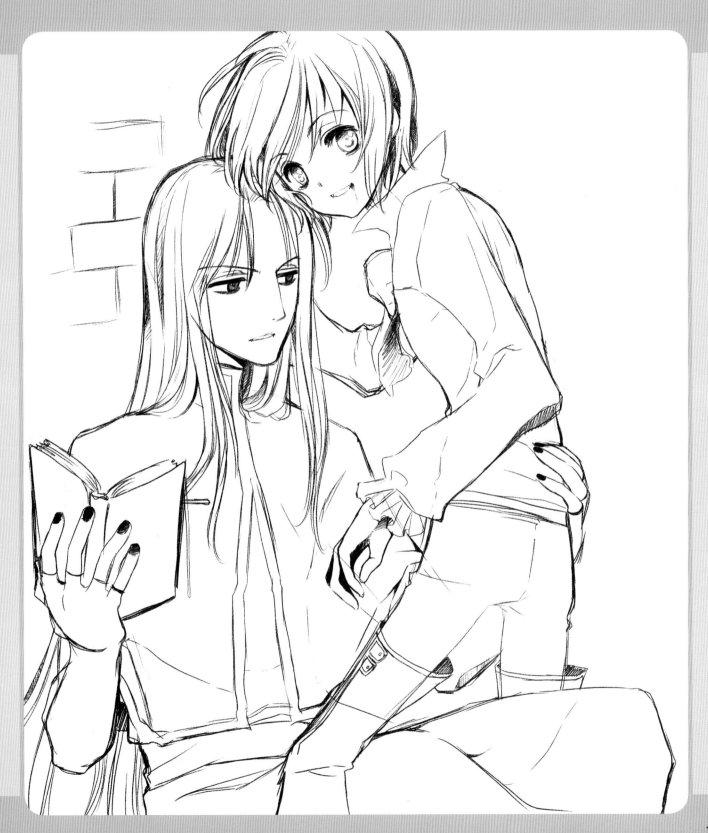

2. STRUCTURE

We outline the skeleton of the characters so that they fit naturally with each other.

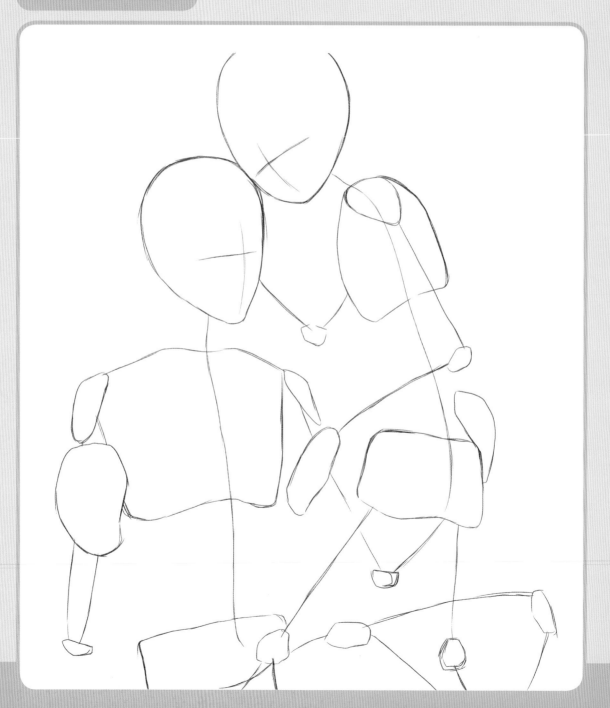

3. VOLUME

The younger character must look thinner and the older one must be heftier. We draw an approximation of the characters' hair.

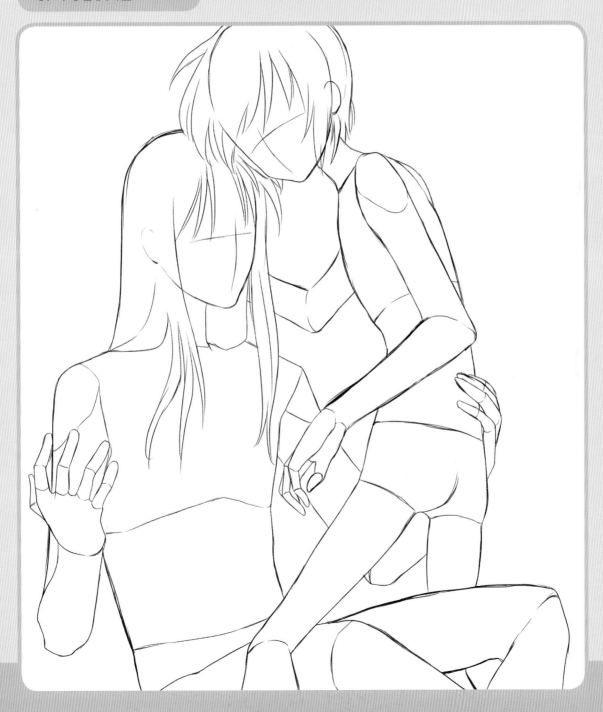

4. ANATOMY

The twisting of the younger vampire's torso is quite forced, but this makes the scene less static.

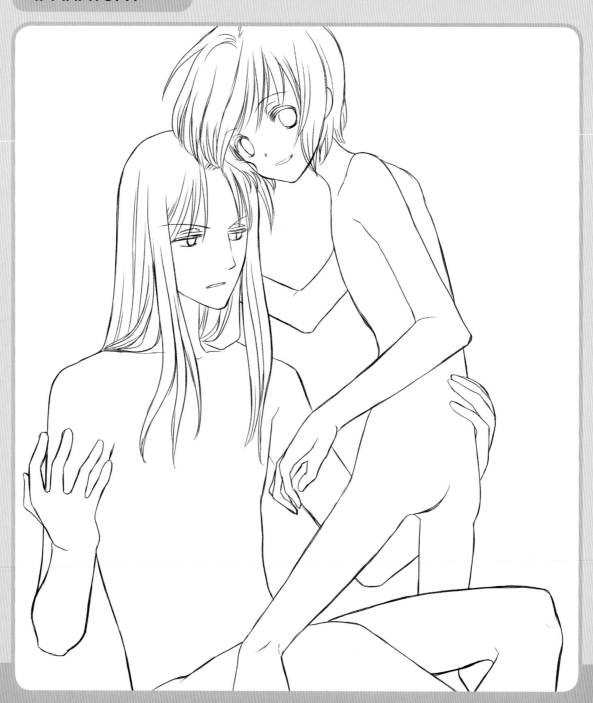

5. DETAILS

The drawing is completed by adding clothes and the bricks in the background. The older vampire dresses in a more sober and medieval style, whereas the clothes on the younger one have a more romantic appearance.

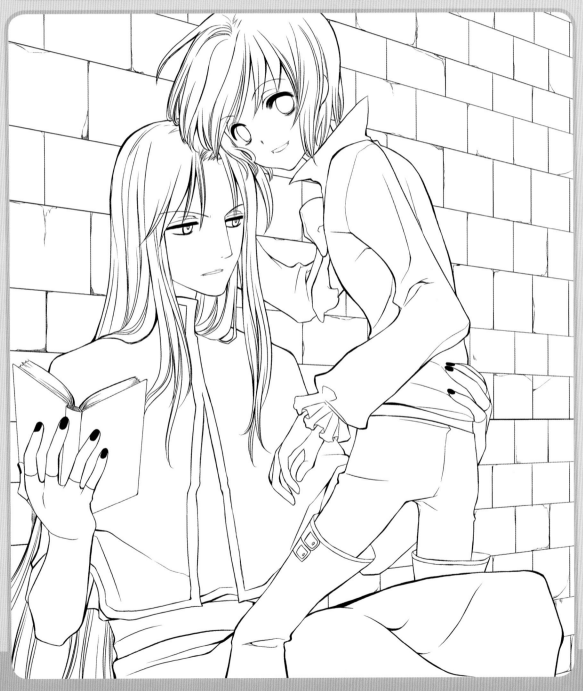

6.1. COLOR

We apply basic colors: yellow, ocher, lavender and green tones. They are all complementary colors. Although we are creating a night scene, we always start with bright and soft tones.

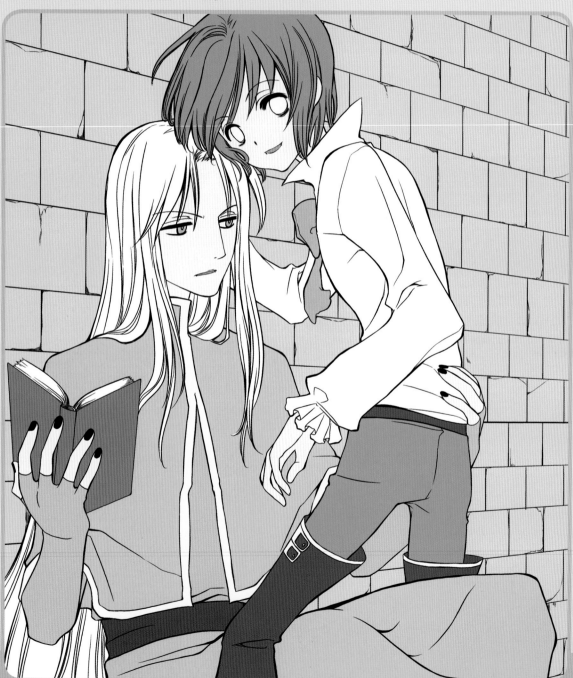

6.2. COLOR

For the shading, we start by marking the contrast and darkness. We define the main lit and dark areas using the brush; we will calibrate and add detail to the image at a later stage.

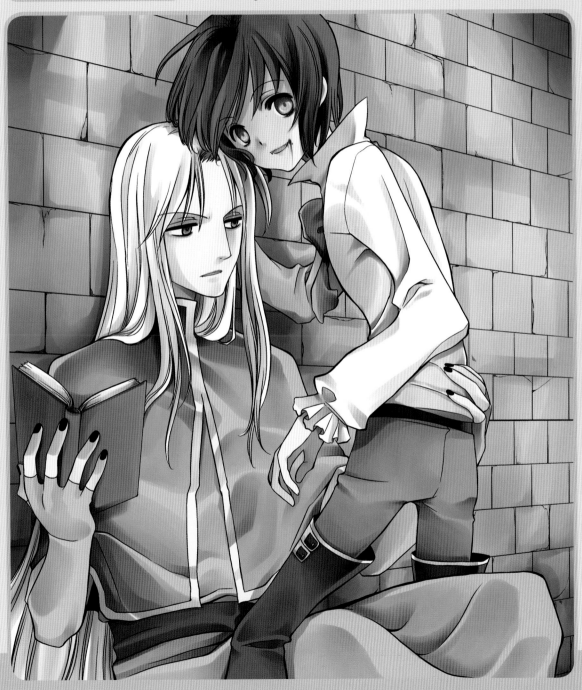

6.3. COLOR

We change the tone of the picture to make it look more sepia, after which we add more highlights and other details like the stains on the wall.

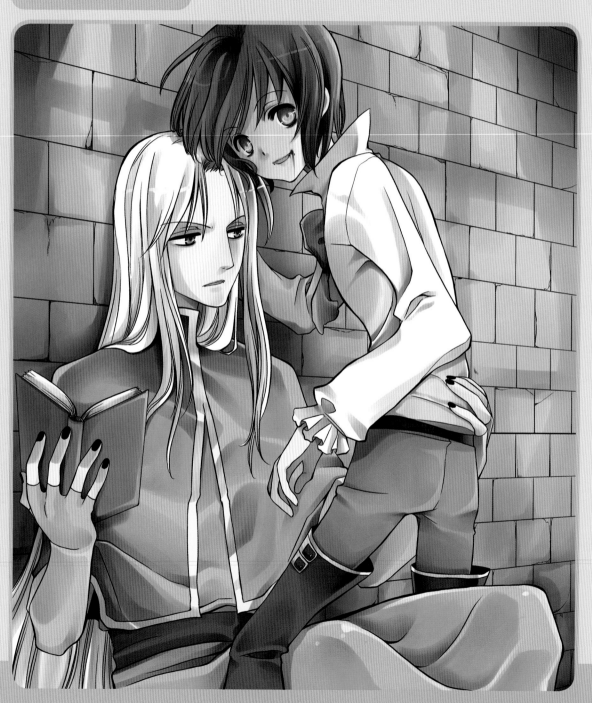

6.4. COLOR

We add depth to the background by adding new lit areas that complete the reflection on the wall of the light coming from a window.

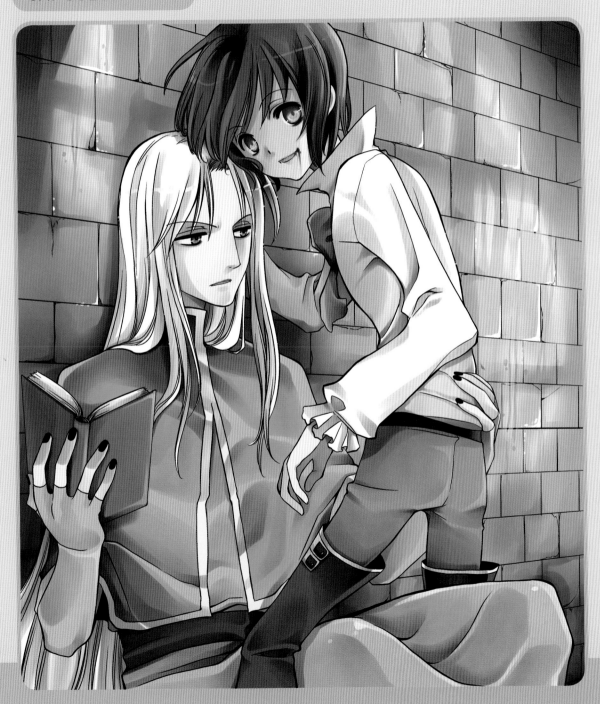

Finishing touches

- We darken the two vampires because they are backlit and make them have more contrast with the background.

- We add some final highlights to the outer contour of the characters, simulating the moonlight hitting their bodies.

- We also add brush strokes on the vampires' hair to make some of it white.

Tips & tricks

- To draw the wall we have used as a base the Vantage Point tool available in the software program Manga Studio. However, other programs have their own tools that can help you get the same effect.

- The creator of this illustration used two coloring techniques. With one of them, she shaded the brighter parts first, after which she added the darker shadows.

- The other technique is to use the Smudge tool in Photoshop (or an equivalent tool) on a dark brush stroke to blend it with the brighter color, creating a gradient.

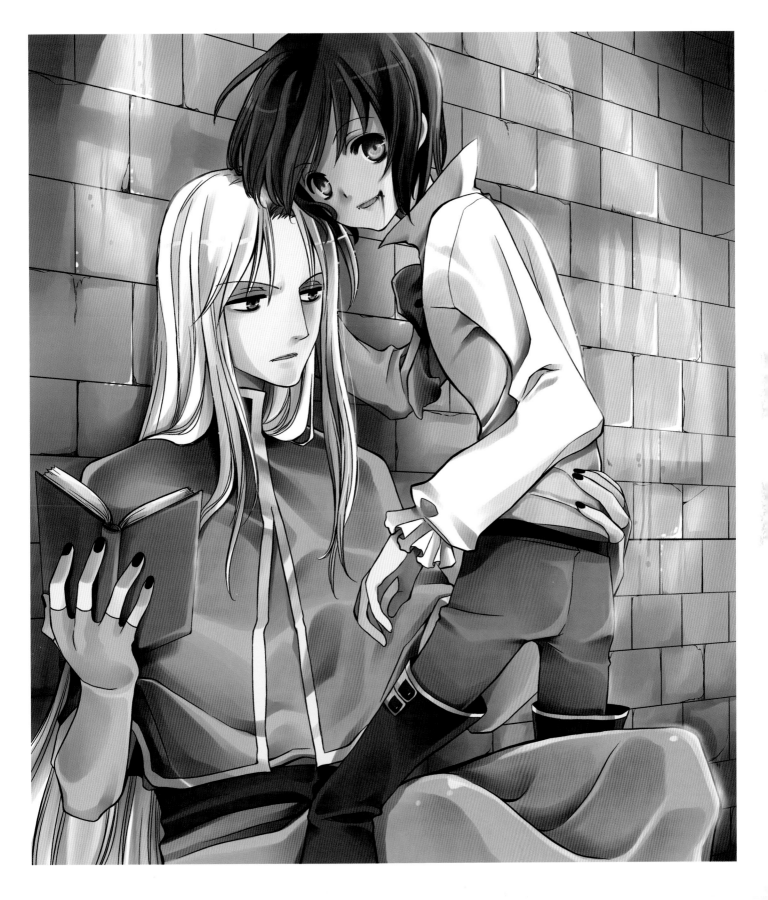

Magic Lovers

MAJOKKO CELESTINE
LITTLE WITCHES
PUPPIES
ARCHANGEL & DEMON GIRL

MAJOKKO CELESTINE

Love is disappearing from the world and that has caused angels to be weaker when confronting demons. Thankfully, Majokko Celestine, with the aid of the little Kuore, a cherub of the QPi2 agency, fights for true love and helps to ease the pain of broken hearts.

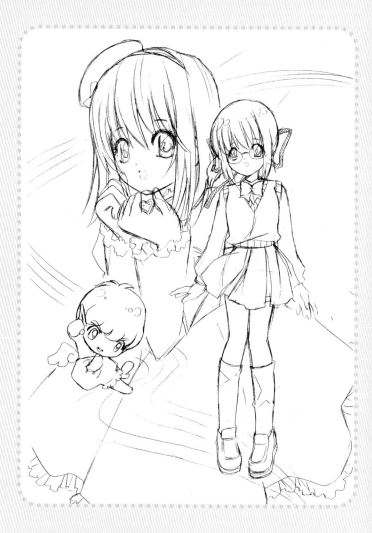

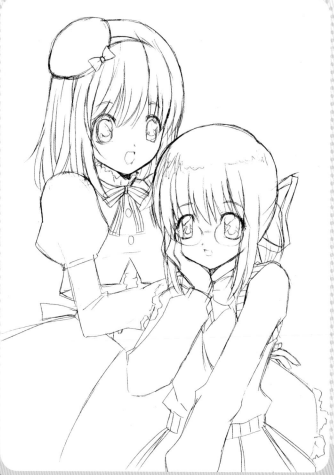

1. SKETCHES

The concept for this illustration was to show the duality of Celestine as a shy and insecure girl on the one hand, and as her alter ego: Majokko Celestine on the other. The scene we finally completed was the most compelling and energetic of the three proposed ones.

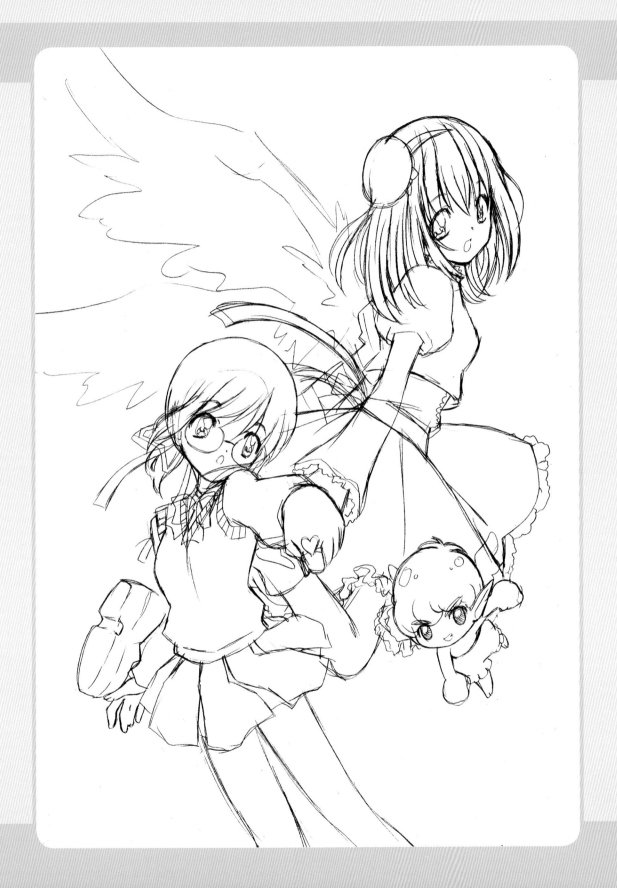

2. STRUCTURE

We create a triangular composition laying out the three characters that will appear in the final illustration. We use a curve for the central axis of the characters, which makes their underlying structures more fluid.

3. VOLUME

We fill in the structure of the characters, being especially careful with the foreshortened hand.

4. ANATOMY

We finish drawing the bodies, the hair and the facial features. We simplify the body of the little angel character as if it were a doll.

5. DETAILS

We differentiate Celestine's two personalities making them wear clothes of very different styles. On the one hand we have her magical side, wearing a flashier dress, typical of *magical girls*, and then, on the other, we have her other personality, much more formal and serious, wearing a school uniform.

6.1. COLOR

The main tones of the girls are defined with magenta, blue and brown. We add a warm touch to the cherub's hair.

6.2. COLOR

We draw the shadows on a new layer using the Lasso tool.
The sole of the shoe is painted with a gradient.

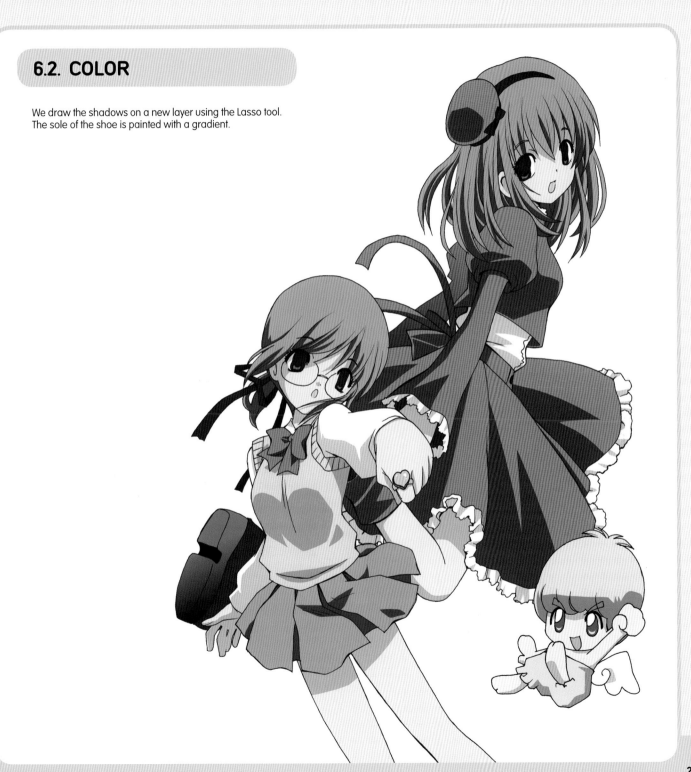

6.3. COLOR

We add some round-shaped lit areas to mark the high-lights. For the hair, we use a white-to-transparent gradient.

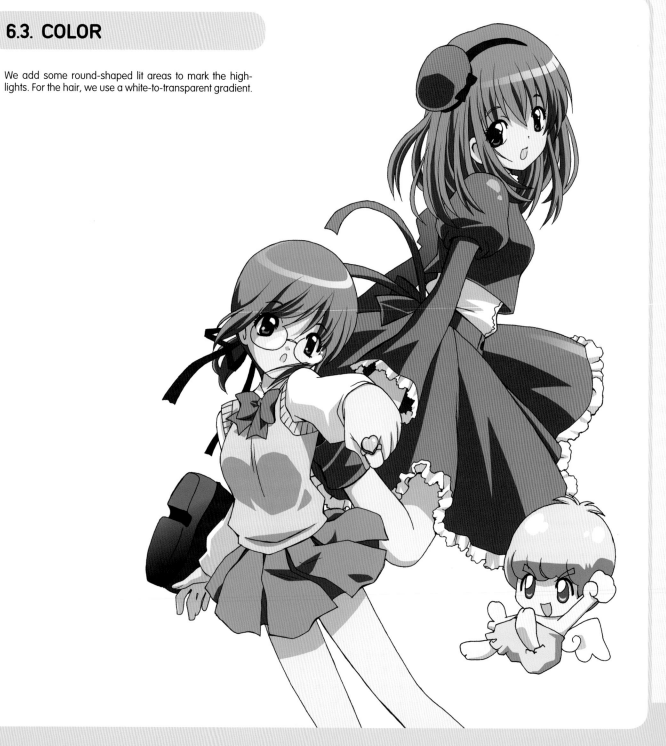

7.1. BACKGROUND

We fill in the background with magenta; we will use this as a base to add the remaining elements. Using the layer options to create a White Stroke we will outline the characters and detach them from the background.

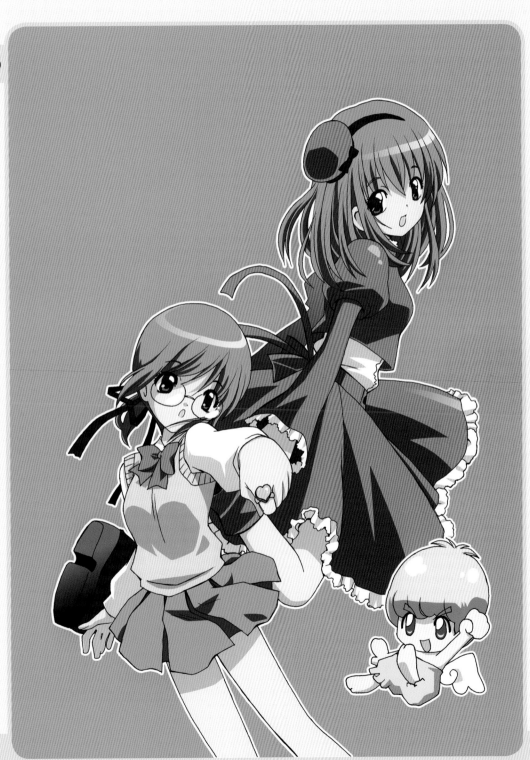

7.2. BACKGROUND

We paint on a new layer applying oblique orange brush strokes of varying opacity.

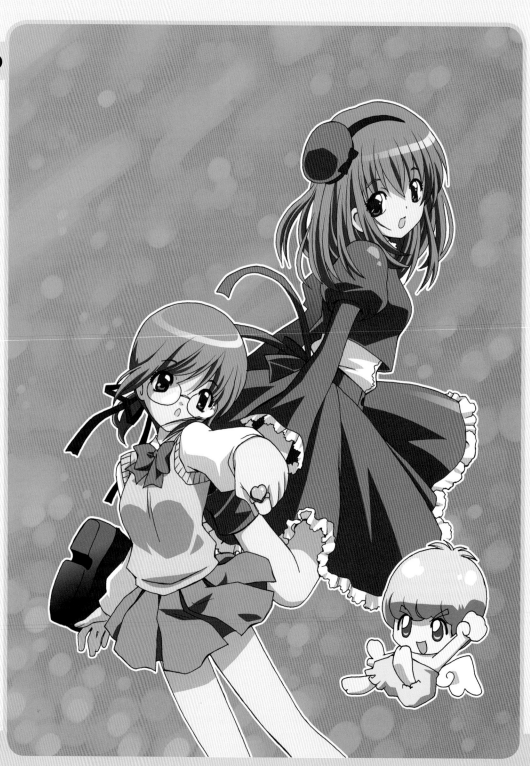

7.3. BACKGROUND

We add a myriad of white sparkles to stress the magical aspect of the characters in the illustration.

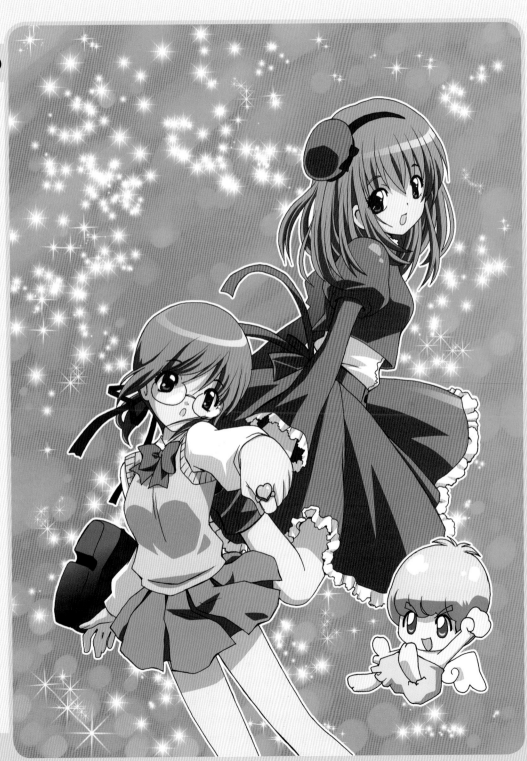

Finishing touches

- We finish by adding magical wings to the second Celestine, making them transparent where they meet her back.

Tips & tricks

- Creating partially transparent fills is as easy as editing one of the color points of the fill and decreasing its opacity to zero.

- If we want to do it with brush strokes, once we have the flat color filled in we can lower the opacity of the Eraser tool and then gradually erase the desired parts.

- There are many types of brushes to create lighting effects; they come in different shapes, such as stars and blurred points. We can also create them ourselves or search for brush packages on the internet.

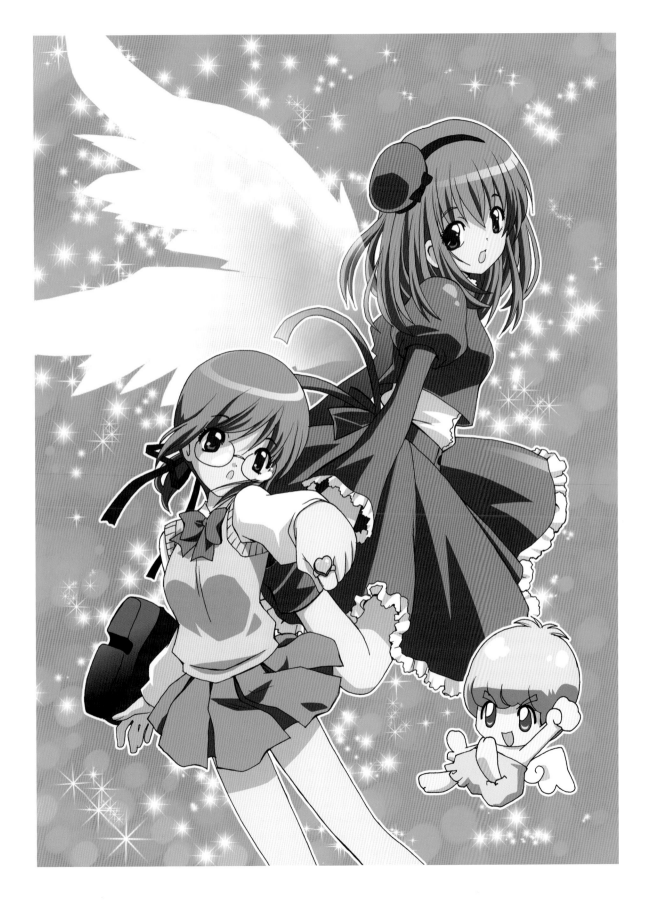

MAJOKKO CELESTINE: Bonus!

MANGA

Majokko Celestine has her own comic version. Here is a sample page from the original *manga*, drawn by Alicia Ruiz, aka "Akane", and written by Rubén García for Kamikaze Factory Studio.

WOW, WHAT HAP-PENED!?

GREAT! THE TRANSFOR-MATION WAS SUCCESS-FUL!

SAY, DON'T YOU HAVE A SUMMER DRESS?

gosh, I'm roasting...

WE'RE **NOT** A FASHION BOUTIQUE, DEAR.

LITTLE WITCHES

Love spells, truth potions, magic enchantments. Everything is possible in the world of witches. But some rules must never be broken. Mary and Kristen are two young apprentices studying magic at the high school of witchcraft, who just love to experiment and get in trouble.

1. SKETCHES

We prepared several scenes where our little witches had a great intimacy. We chose the one that shows one of them trying to make a potion while her friend is pestering her playfully.

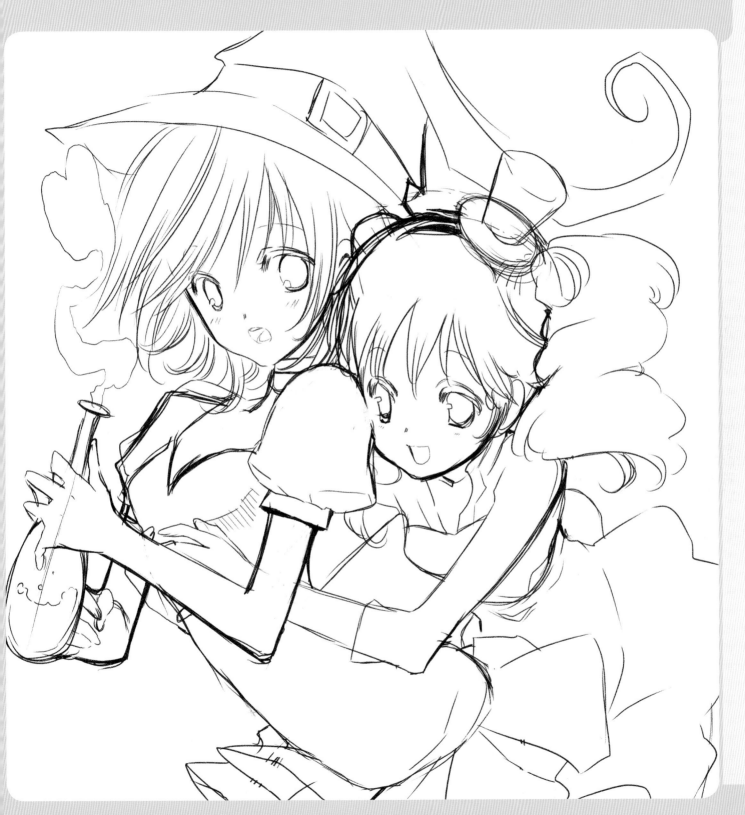

2. STRUCTURE

We place the two little witches leaning, with central axes perpendicular to the legs and a slight twist in their spines and necks.

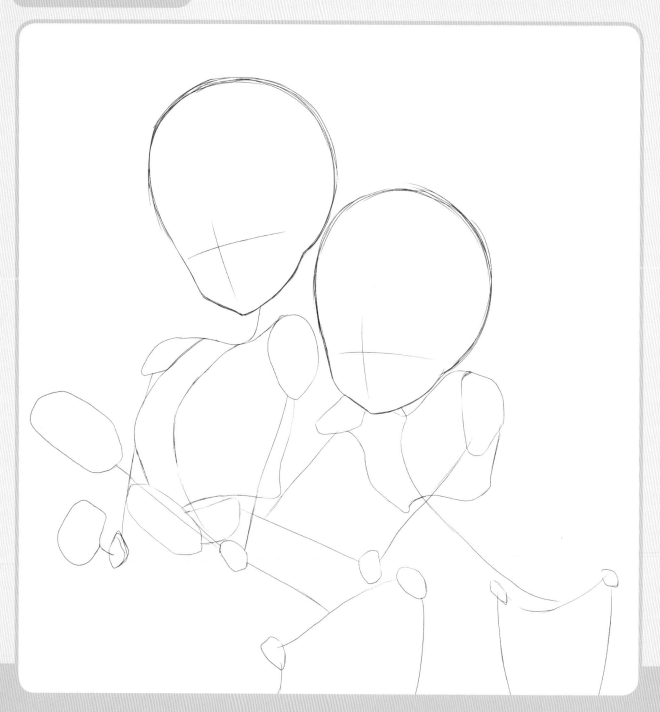

3. VOLUME

Their bodies must have winding shapes in order to convey a sense of motion.

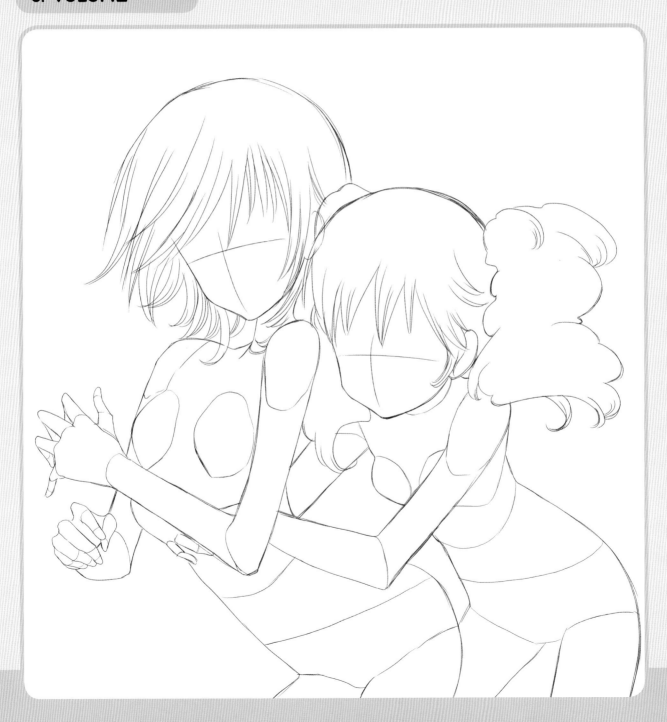

4. ANATOMY

In illustrations like this one, anatomy doesn't have to be realistic; instead, it is drawn as stylized as possible.

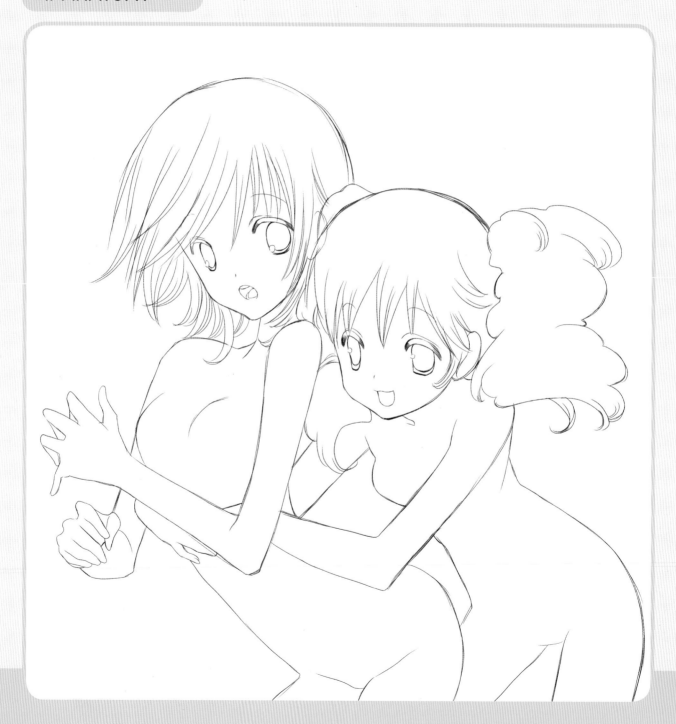

5. DETAILS

We play with two different clothing styles. On the one hand, we have a more classical dress, with the typical hat of a witch, while on the other hand, the other girl's dress has touches like those of lolitas, crowned with a small hat resting on her hair.

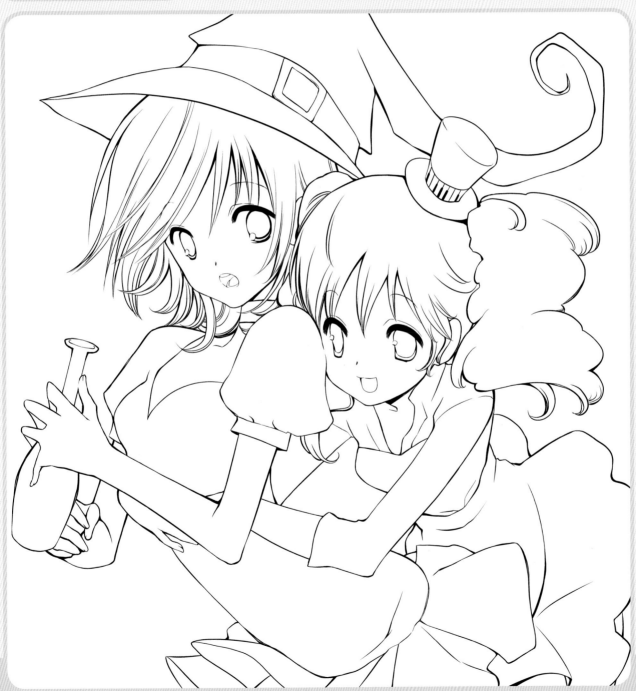

6.1. COLOR

We start with a set of flat colors that are very different for each of the girls. One of them has cooler tones with hints of yellow, while the other one uses a range of purple tones.

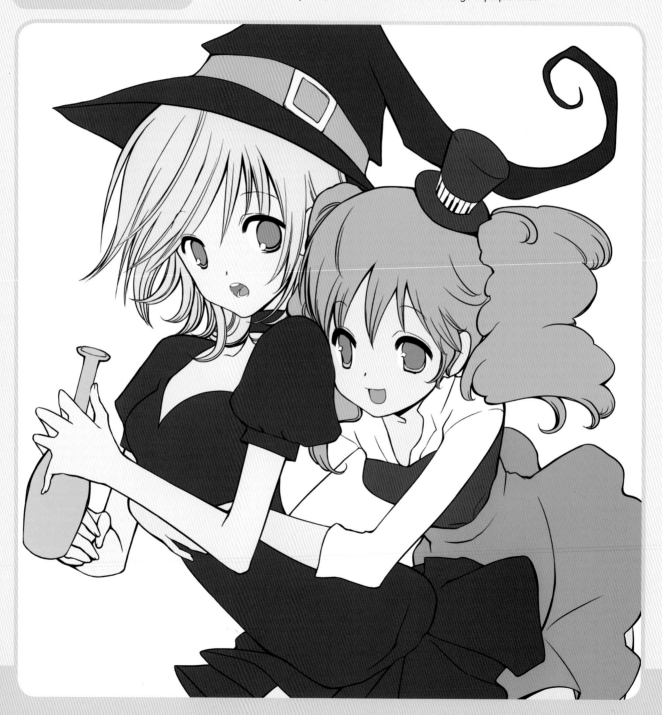

6.2. COLOR

We paint the shadows with a watercolor brush until we get a soft gradient look that softens the shapes. For their cheeks, we use a soft brush with its blending mode set to Multiply.

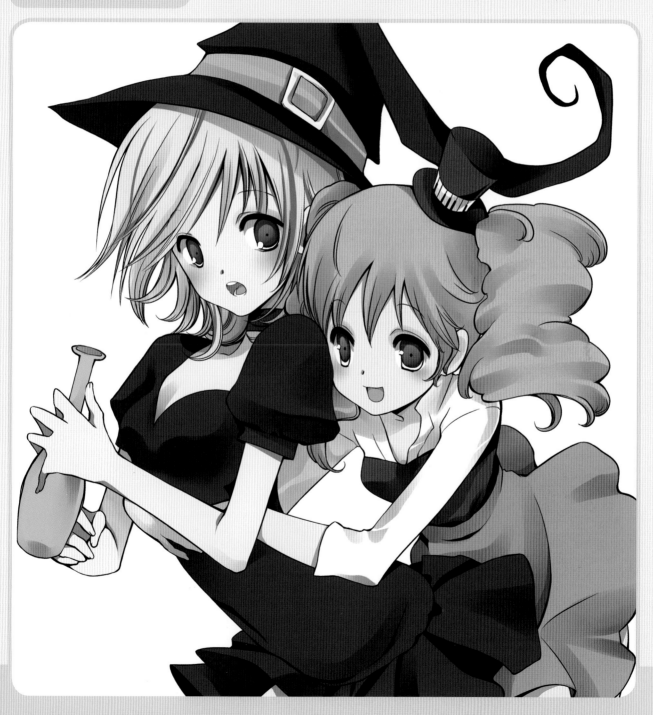

6.3. COLOR

We apply the highlights on a new layer with small strokes of irregular width and several spots that give the image a more magical look.

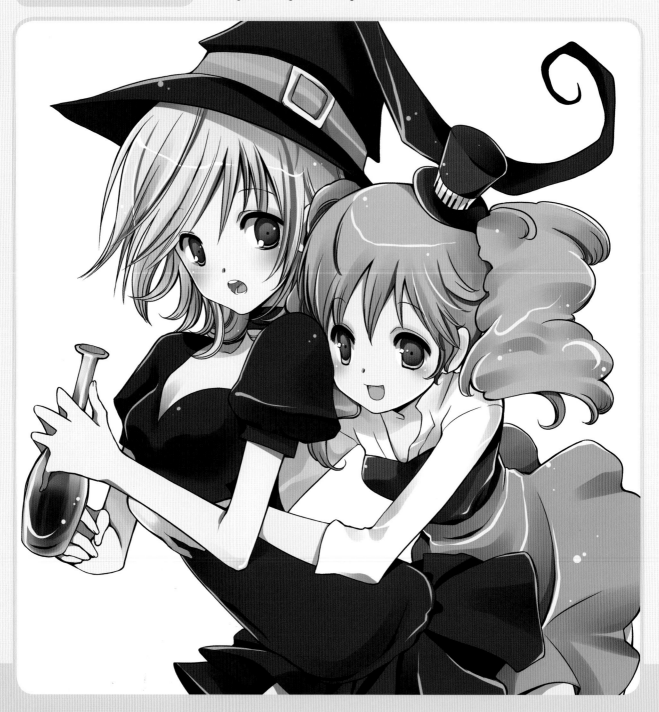

7.1. BACKGROUND

We paint the background with a dark-to-bright green gradient; the explosion and the smoke effect of the potion are created with various soft brush strokes.

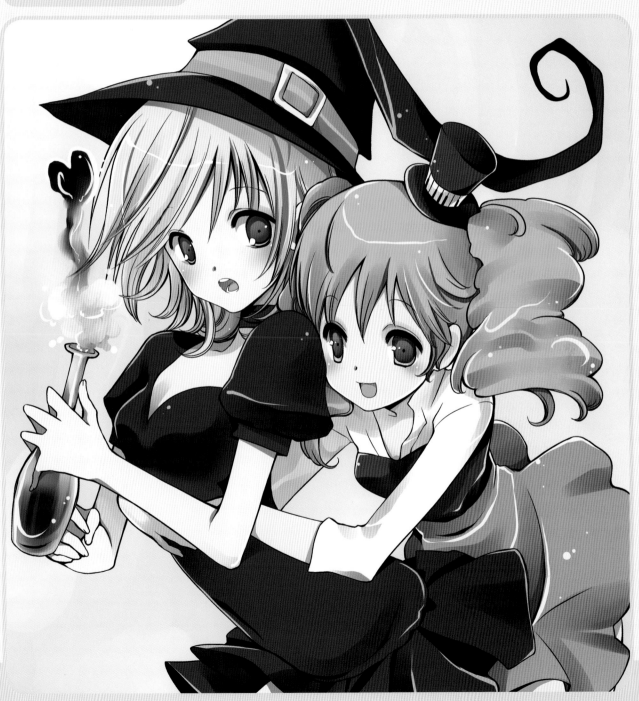

Finishing touches

- To give more complexity to the background, we apply additional brush strokes on top of the overall gradient, defining areas of light and shadow.

- As a final touch, we paint more spots of glitter in the background.

Tips & tricks

- To create the smoke, first we draw the outline with a flat color. Then we use a watercolor brush with a darker color to apply the shadows while smudging the border at the same time.

- The secret is to achieve a frothy look, using different brush opacities, darker tones in the center and some highlights and lit areas. The technique is similar to painting clouds. The inner region will be more compact and the outer borders will have softer, less opaque strokes.

- The cheeks are done with a soft brush set to Multiply; the rest of the shading has been done with a watercolor brush. These brushes are very different: while a regular soft brush only adds color, a watercolor brush not only adds color, but it also absorbs the underlying color, which allows you to make short gradients.

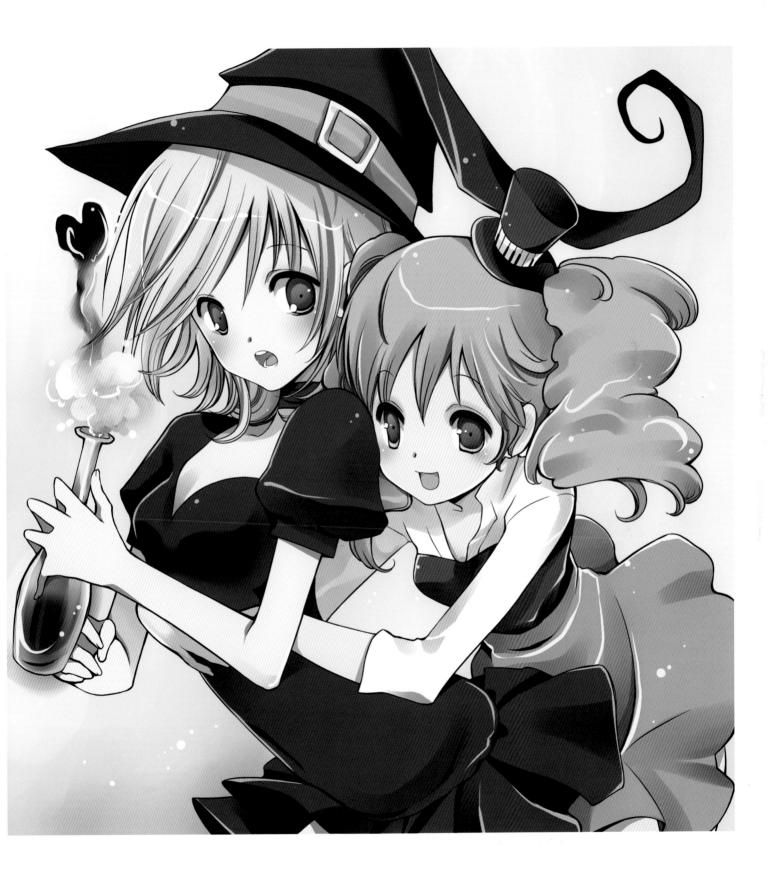

PUPPIES

Puppies like to play, have fun and run up and down the street. But they also enjoy lying down on the bed after a long day. Pit, the older one with dark hair, is always ready to get in trouble, while little Koe, who has brown hair, is much more innocent and cautious. Adorable as they seem, they are fierce when provoked. So it's better not to bother them.

1. SKETCHES

The illustration we chose has that touch of camaraderie, sensuality, mischief and innocence that were only partially present in the other two sketches.

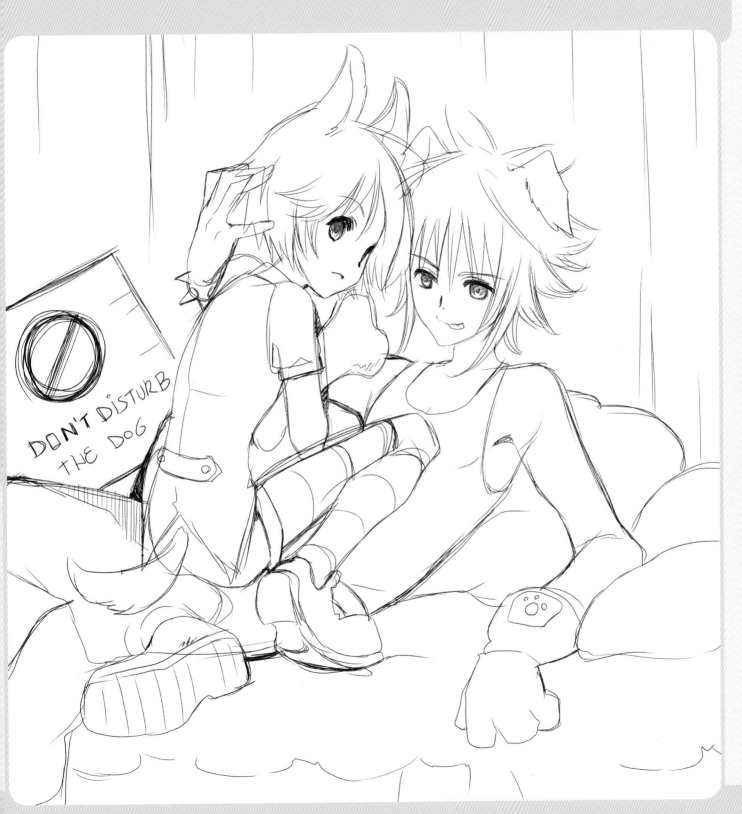

2. STRUCTURE

Starting from a triangular composition, we place the characters making sure their limbs are properly adapted to the perspective.

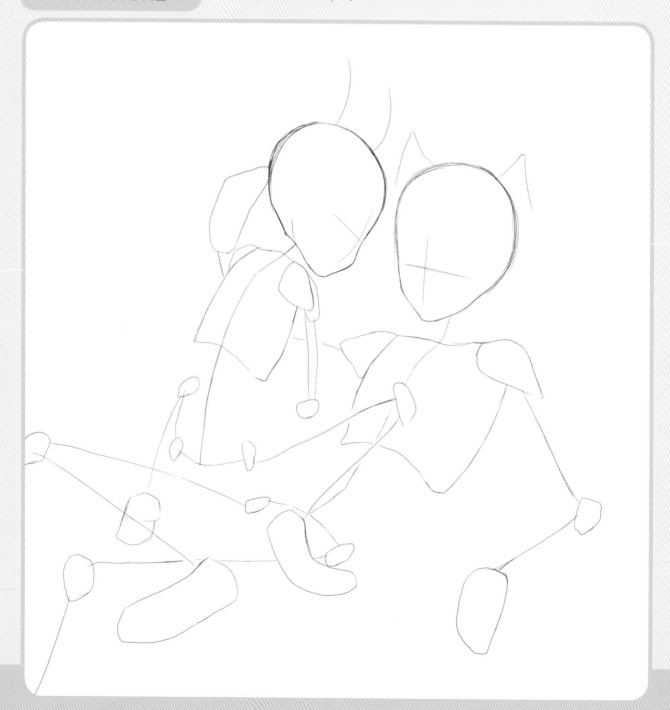

3. VOLUME

We break up the joints to facilitate the process of drawing the limbs.

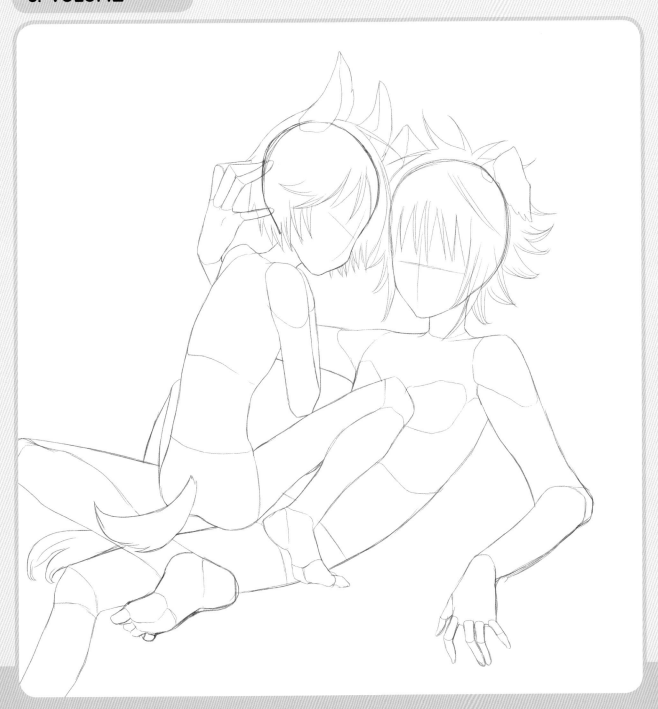

4. ANATOMY

Although they are puppies, they look like young humans. We avoid a hefty look and thus make them softer, more delicate.

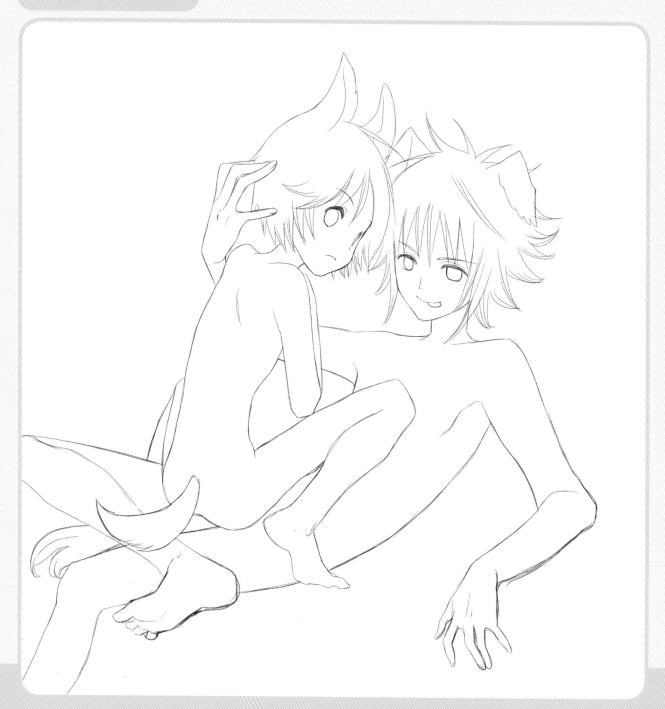

5. DETAILS

We dress them in plain, comfortable clothes with some hints to their canine nature. For the background, we draw some lines that simulate wood and add a sign.

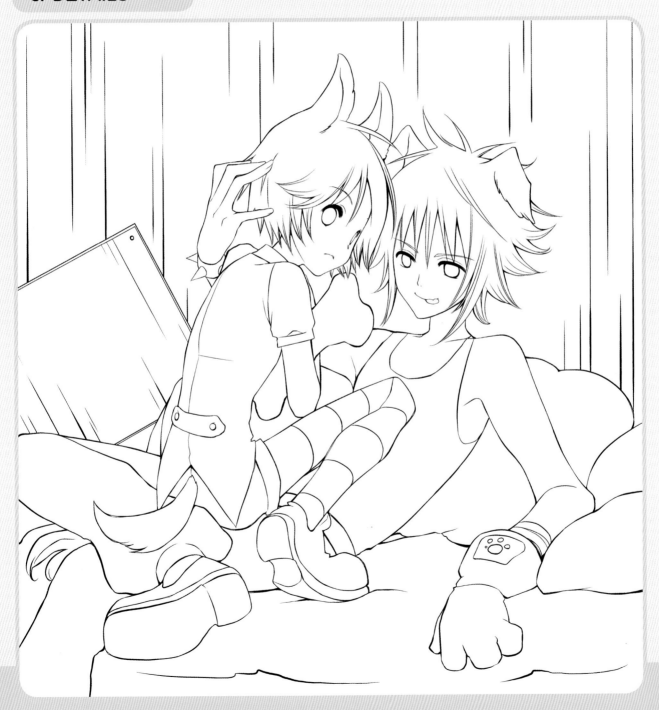

6.1. COLOR

Ocher tones are predominant in the chromatic range of this illustration, having a contrast in the blue tones used for Pit's hair and trousers.

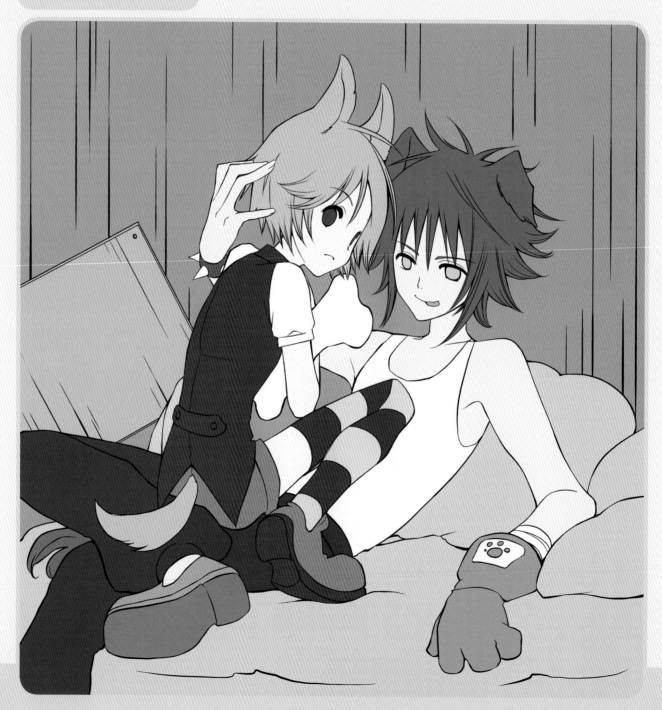

6.2. COLOR

We apply shadows with a soft brush, defining the volumes with small blurred gradients. We hide the layer with the background colors to focus on the characters.

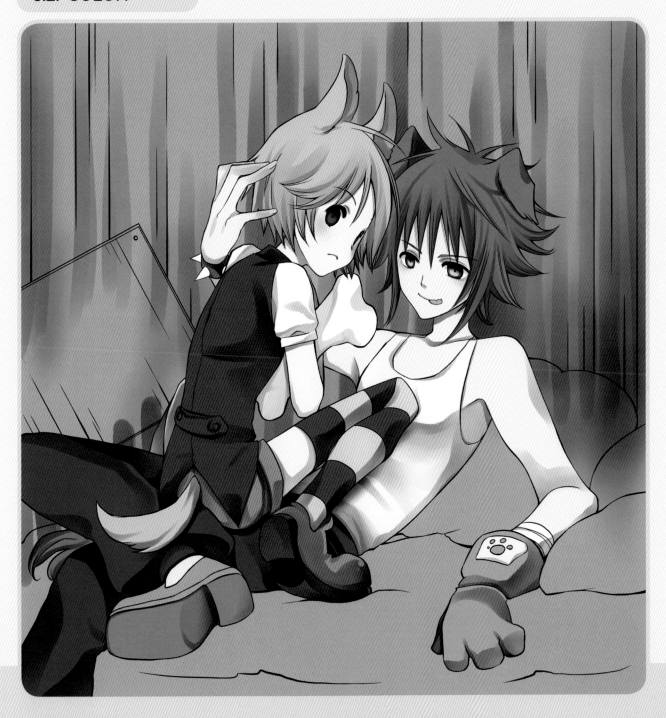

6.3. COLOR

We make the background layer visible again, draw the "do not disturb the dog" sign and paint the shadows and volumes of the couch.

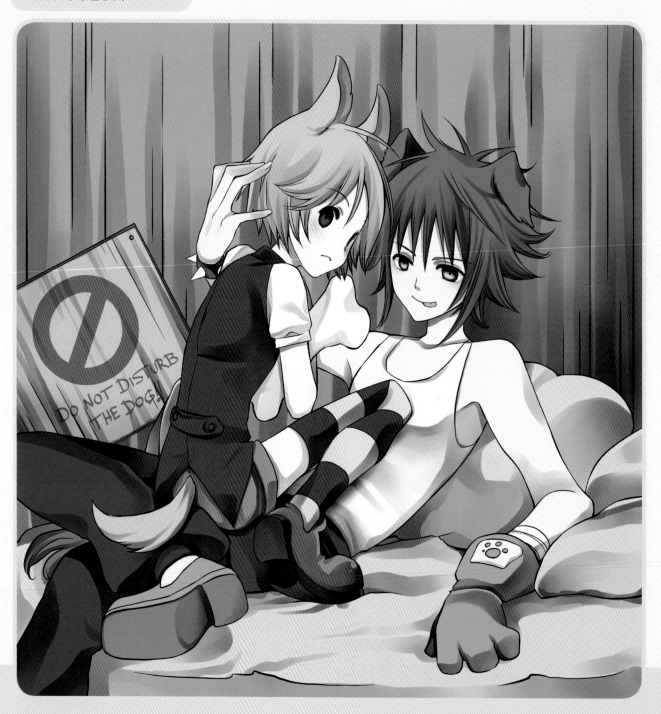

6.4. COLOR

We paint soft highlights with brush strokes, without too much contrast, to recreate a more diffuse lighting.

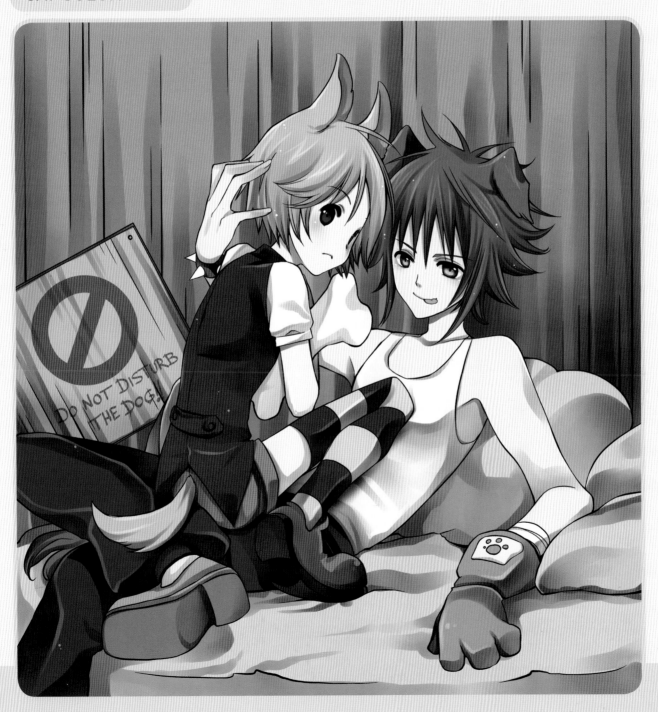

Finishing touches

- We finish with a single source of light marking the light direction on the characters with an oblique shadow at the top.

- To make it more realistic, we use a gradient with its layer blending mode set to Multiply, but we also complement the effect erasing, with the brush, parts of the gradient on the heads of the characters to strengthen the lighting effect.

Tips & tricks

- The symbol on the sign has been drawn separately. It was later imported in the illustration on a new layer with its blending mode set to Multiply so that it would show the shadows on the wood.

- Adding highlights after the shadows have been applied (see the socks) can create an interesting metallic look.

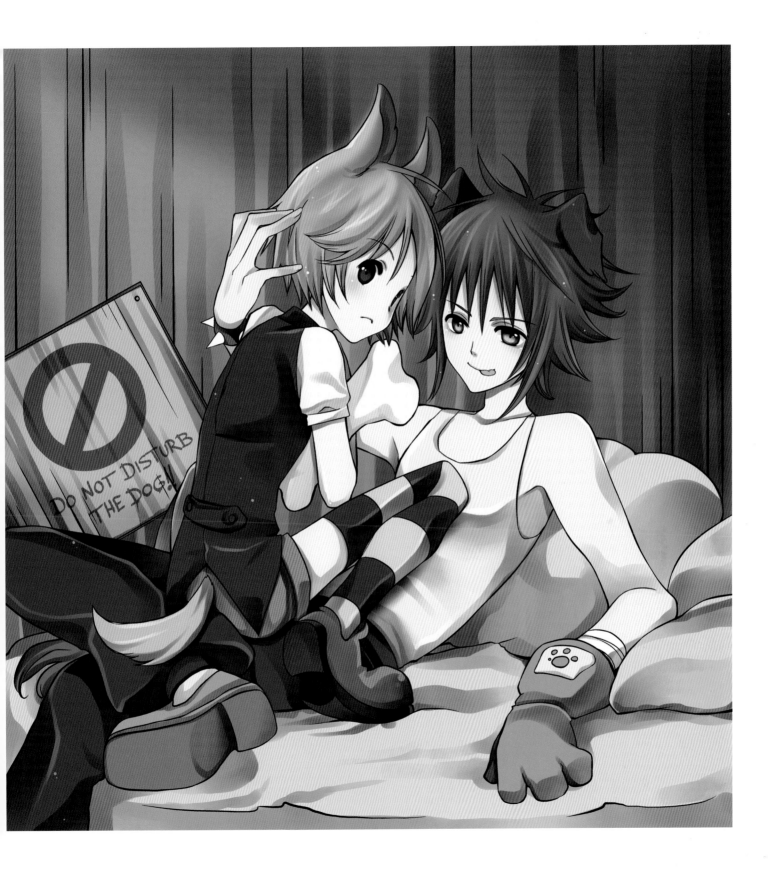

ARCHANGEL & DEMON GIRL

Since time immemorial, angels and demons have engaged in a fierce battle to win as many human souls as possible for their own sides. Angels try to save us, to take us to the light, while demons tempt people to attract them to darkness. But occasionally, amongst so much fighting between good and evil, an unexpected relationship is born, a relationship between irreconcilable rivals.

1. SKETCHES

We wanted to have a great contrast between the she-devil, who is more decisive, provocative and sensuous, and the archangel, shier and more timid and emotional. They are a conflicting couple united by powerful feelings.

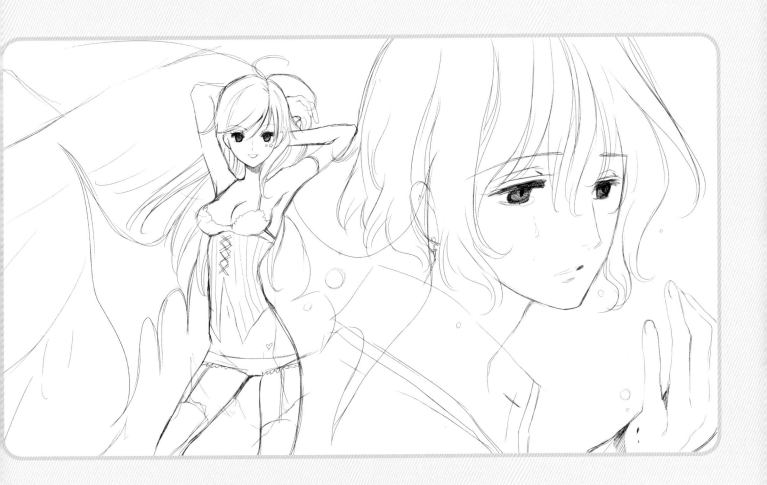

2. STRUCTURE

For the she-devil, we make her skeleton have a dynamic pose, arching the central axis to force the pose a bit. For the angel, although it is a close-up, we emphasize the pose twisting the neck and the back slightly.

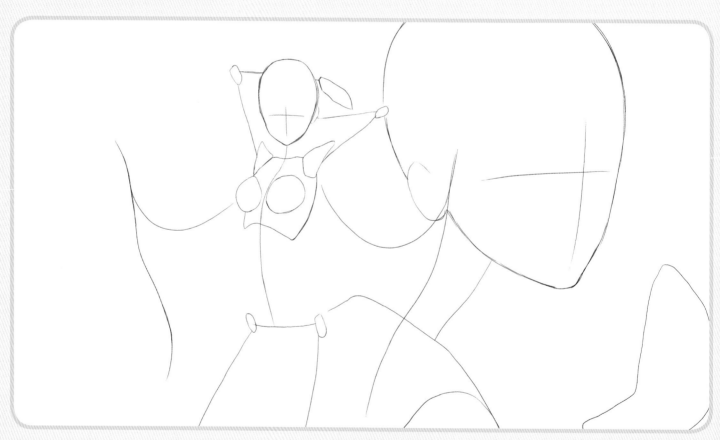

3. VOLUME

In this step, we will need to make sure that the overlapping characters do not occlude important elements of each other's anatomy.

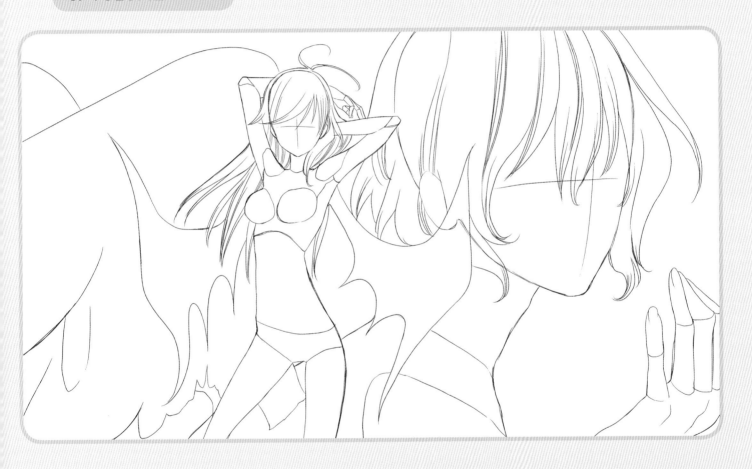

4. ANATOMY

Although the she-devil must be very striking, *shôjo manga* girls are always very stylized.

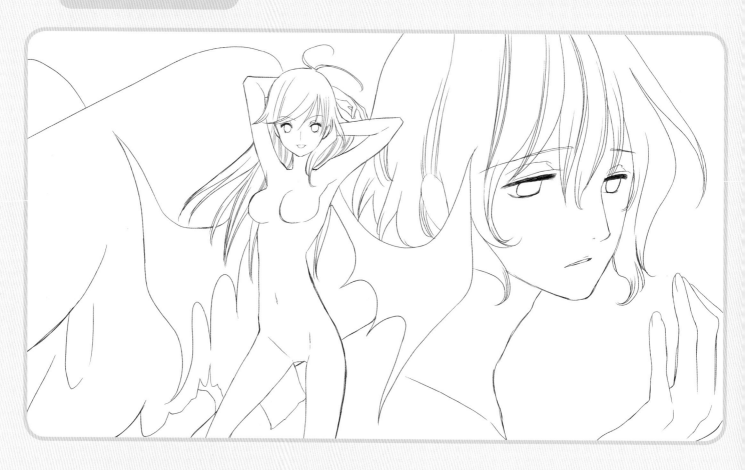

5. DETAILS

To make the she-devil look sensual, we dress her with a lingerie outfit. The archangel wears a shirt with religious motifs.

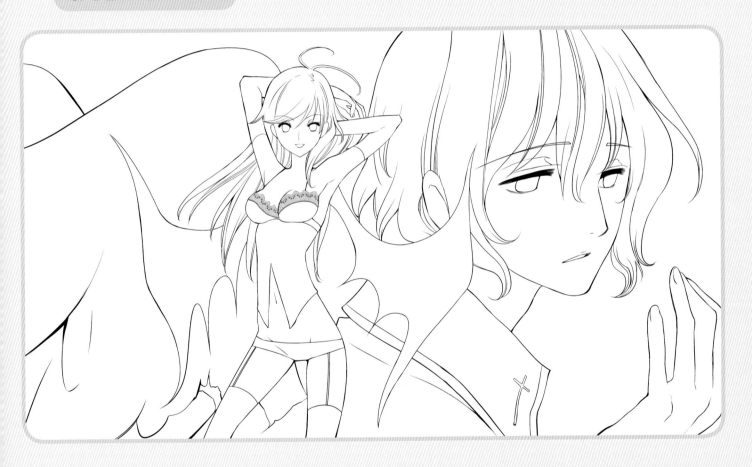

6.1. COLOR

Colors always help us to differentiate characters with opposing personalities. For the she-devil we use purple tones and for the archangel we use blue and yellow as well as purple for the eyes to get an otherworldly look.

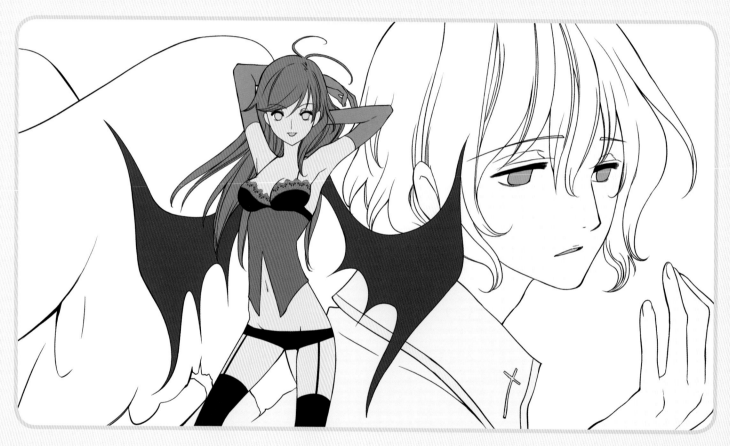

6.2. COLOR

We use the watercolor brush to paint the shadows, applying less pressure on the areas that receive more light.

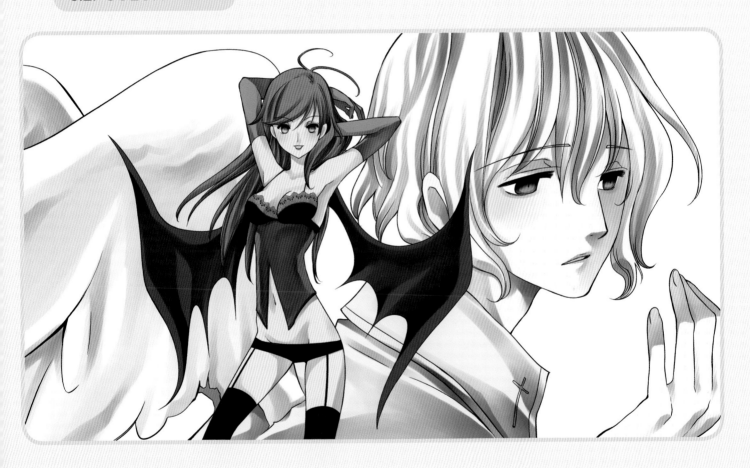

6.3. COLOR

We paint small lines and spots as highlights, as the base color we applied is already bright.

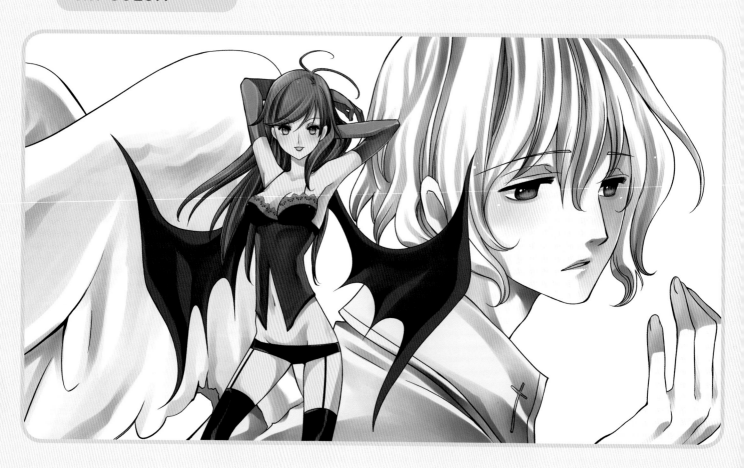

6.4. COLOR

Now we add more details, such as tears on the archangel and details on the corset the she-devil is wearing.

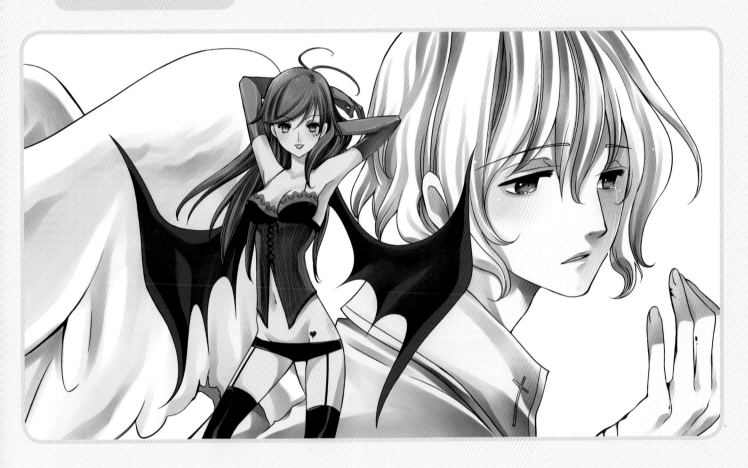

7.1. BACKGROUND

We create the background by applying strokes with pink tones and small white spots. We create another layer to draw the white cracks with a hard-edged brush. Around the she-devil we add a white outline, setting the layer options to apply a white Stroke effect, 16 pixels in size.

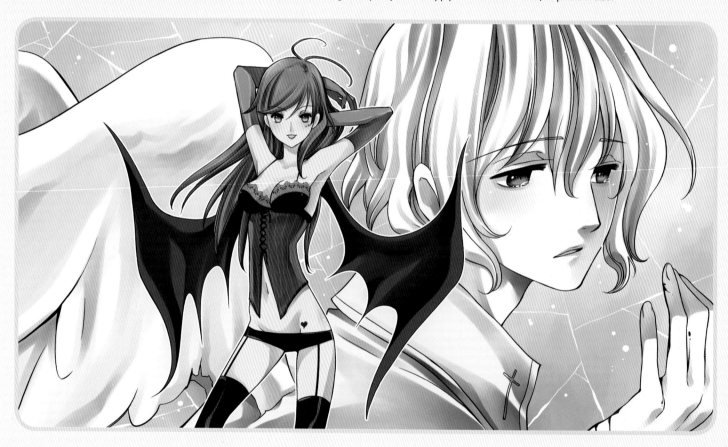

Finishing touches

- We apply a slight lavender satin finish; to achieve this we take a flattened layer with the coloring of the angel and set its layer blending mode to Multiply and its opacity to 18%.

- We add transparent feathers as an ornament; its layer options are set to create a white Outer Glow effect.

- We draw additional highlights on the characters to finish the illustration.

Tips & tricks

- When working with images of this size, it is advisable to split them up in various separate parts to facilitate and speed up the work process.

- We color each character in different files and use separate layers.

- Then we create a new file where we will paste the characters with their layers flattened (or organized in a group or a smart object) and we create the background on a new layer.

- If we don't want to flatten the layers in case we have to make final adjustments, we can organize the file using Layer Groups or the Smart Object feature in Adobe Photoshop CS4.

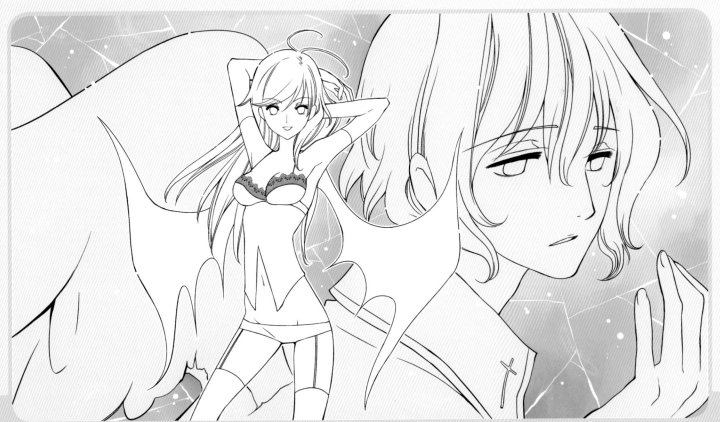

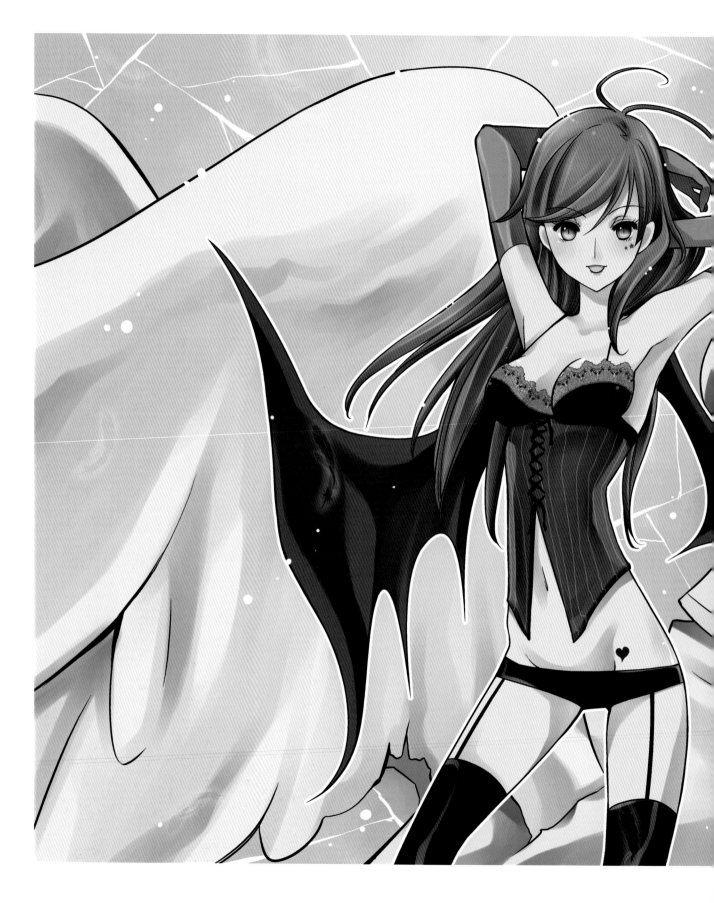

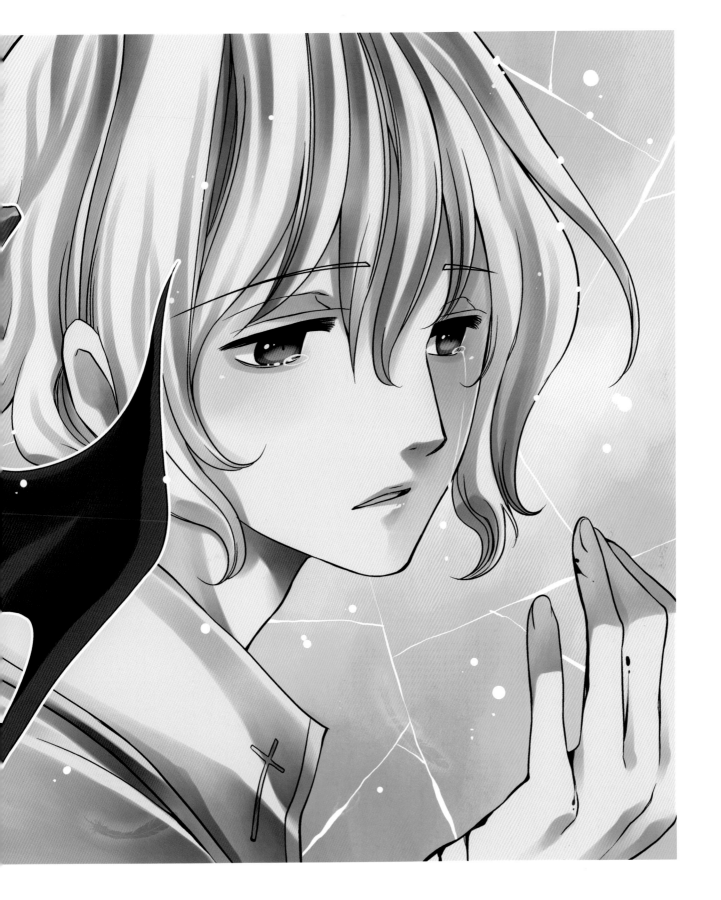

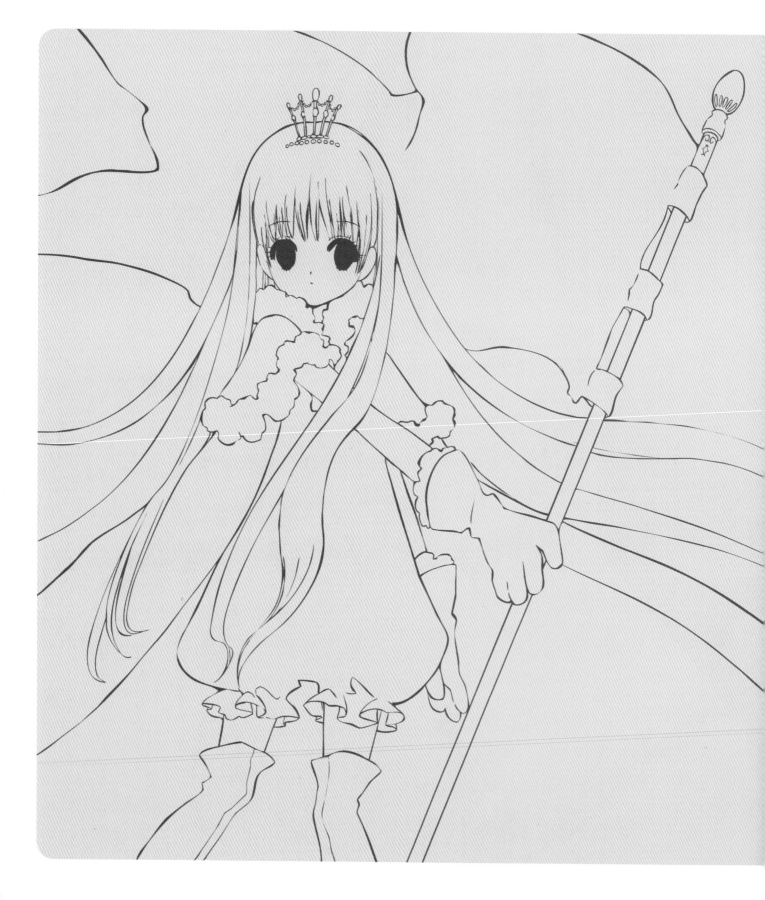

Legends

GODS OF OLYMPUS
WARRIOR ELF
SNOW PRINCESS
KINGDOM OF THE ROSES

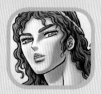

GODS OF OLYMPUS

Siblings Apollo and Artemis, children of Zeus and Leto, are resting on the rocks of one of the slopes of Mount Olympus after a long evening of hunting. Even the gods make the most of peaceful times to revel in their favorite pastimes, as it is impossible to foresee when the skies will turn dark with clouds of misfortune.

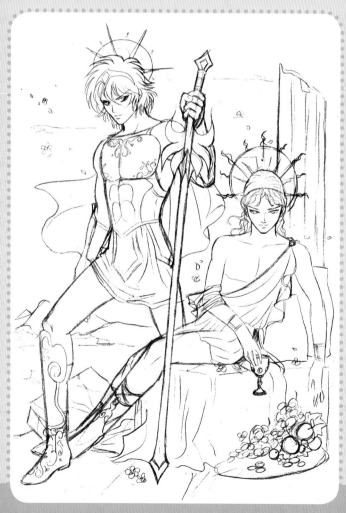

1. SKETCHES

Greco-Roman references frequently occur in *manga*, so we laid out some scenes that showed various gods of Olympus. We choose the one showing the hunter gods that represent the sun and the moon.

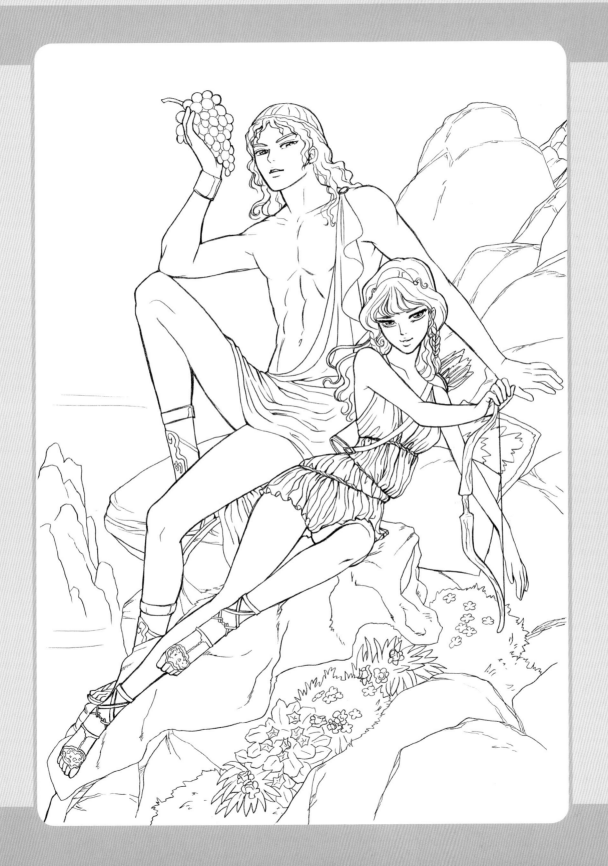

2. STRUCTURE

We combine straight limbs that support the weight of the characters with curves in their spines to achieve a dynamic pose despite their seated positions.

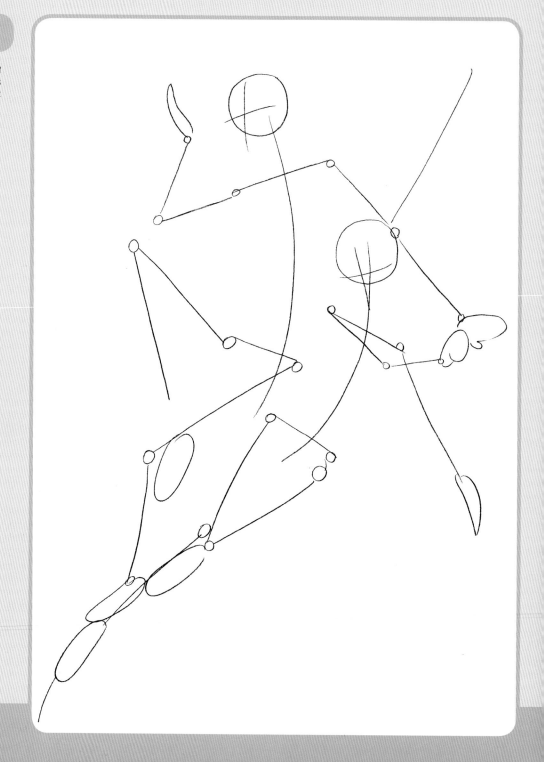

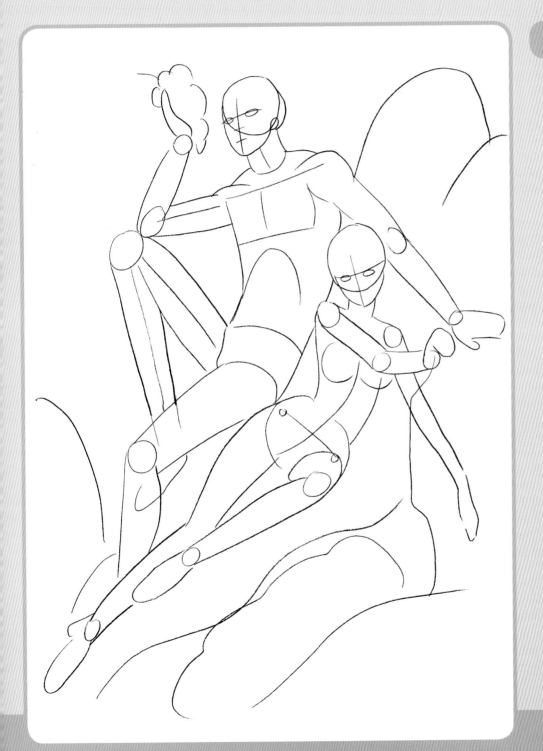

3. VOLUME

Given that we're dealing with a realistic-looking drawing, we make the proportions less stylized and closer to the normal.

4. ANATOMY

The bodies of both characters must be aesthetically pleasing without losing their voluptuousness.

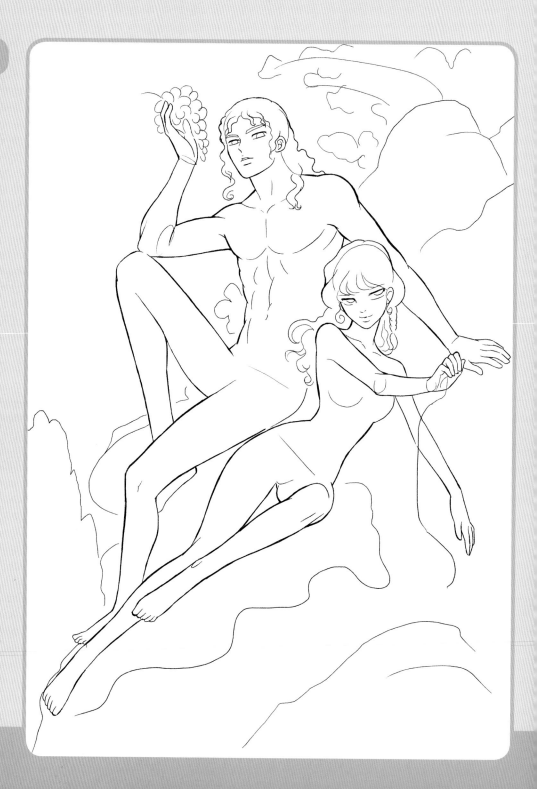

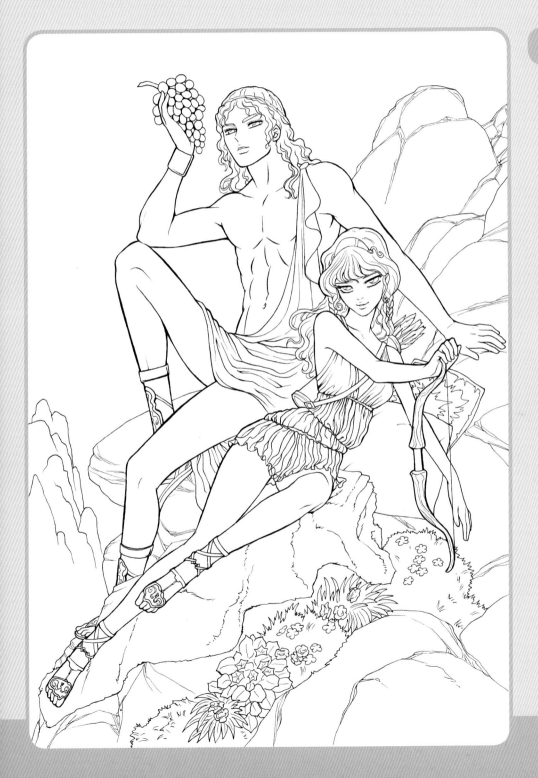

5. DETAILS

We draw their robes and sandals, and finish detailing the rest of the elements in the illustration: the bow, the leopard skin, the grapes and the rocks.

6.1. COLOR

We use a very soft brush to paint a color base that will define each color area and set the main tones of the drawing.

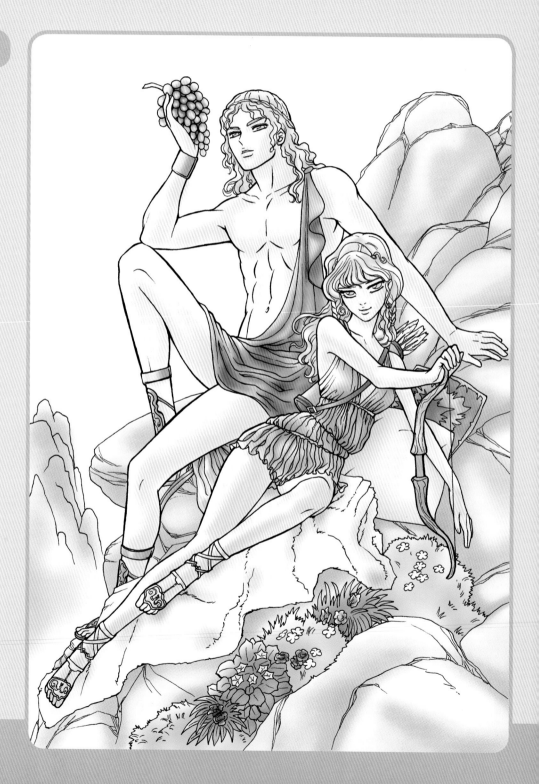

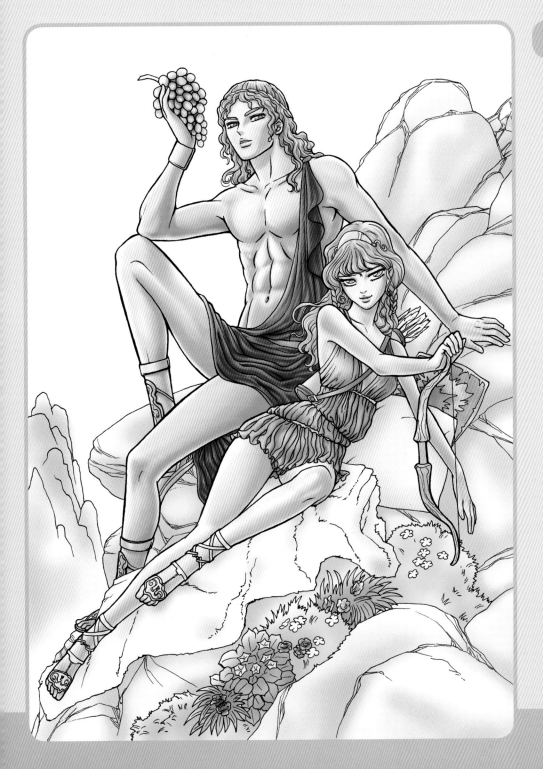

6.2. COLOR

We apply the shadows with a watercolor brush over the base color layer.

6.3. COLOR

We apply an intermediate color between the shadows and the base color, and start adding volume to the elements in the background.

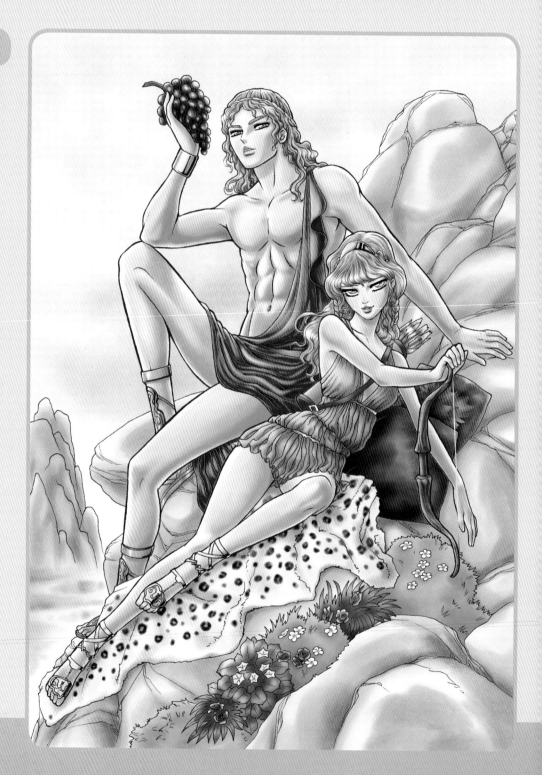

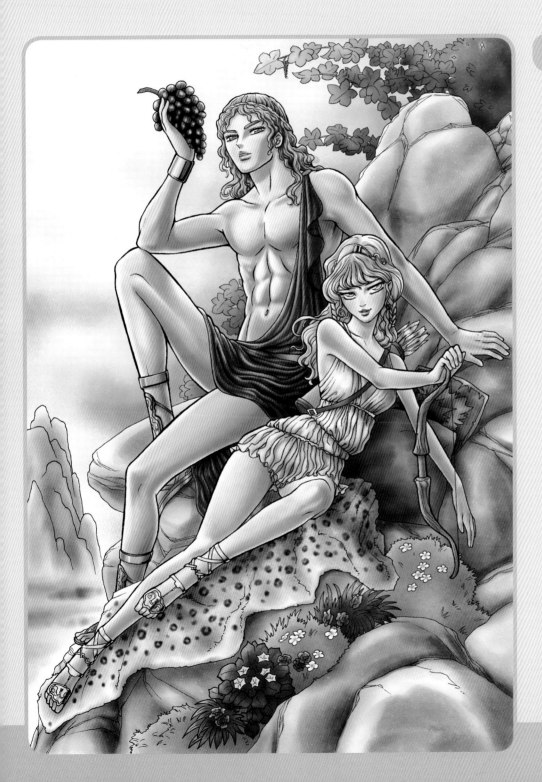

6.4. COLOR

We balance the color adjusting the overall tones and then add various elements, such as the shrubs in the upper part of the illustration.

6.5 COLOR

We apply texture to the background with its blending mode set to Soft Light and 57% opacity, and brighten the image a little.

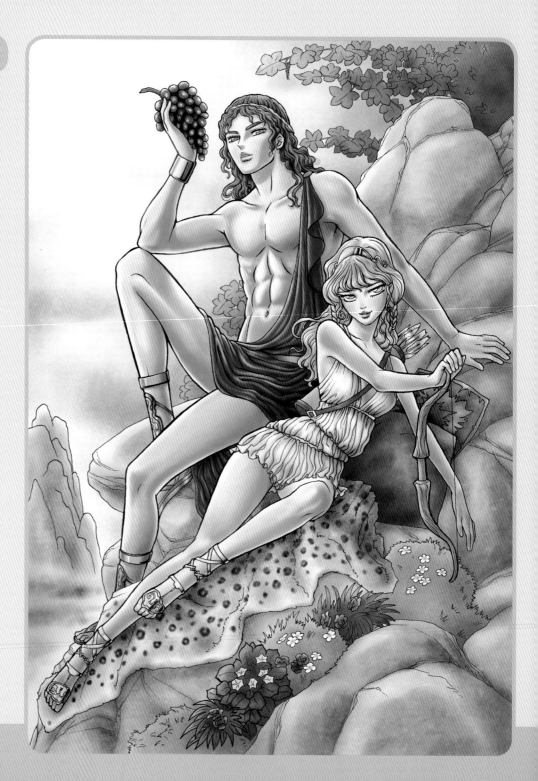

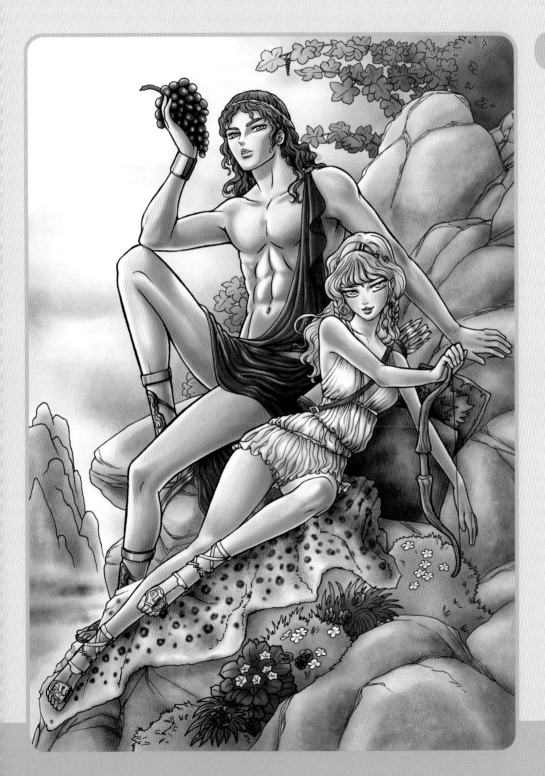

6.6. COLOR

We add more textures on the rocks and adjust the colors again, enhancing the light of the final image.

Finishing touches

- We add a frame to the image with a blank layer to which we apply two Blending Options, effects set to 61% Multiply.

- First, we apply a dark brown Inner Shadow effect set to Multiply and with 38% opacity; we set global light angle to 30°, a distance of 5 pixels and a size of 196 pixels.

- Second, we apply a Gradient Overlay effect with its blending mode set to Hue, 23% opacity, radial style, 90° angle and enable the Align with Layer feature.

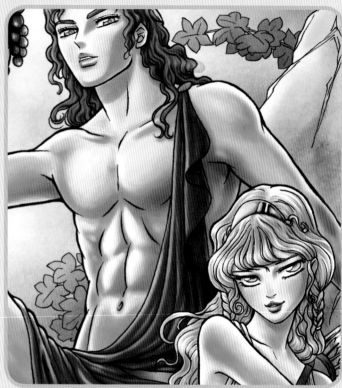

Tips & tricks

- Once we have the color base, with shadows and highlights applied on various layers, then we can adjust the colors and perform the appropriate corrections.

- The use of textures with different layer blending modes gives illustrations a more organic feel, simulating traditional coloring.

- Layer masks make it easier to apply textures only on desired areas.

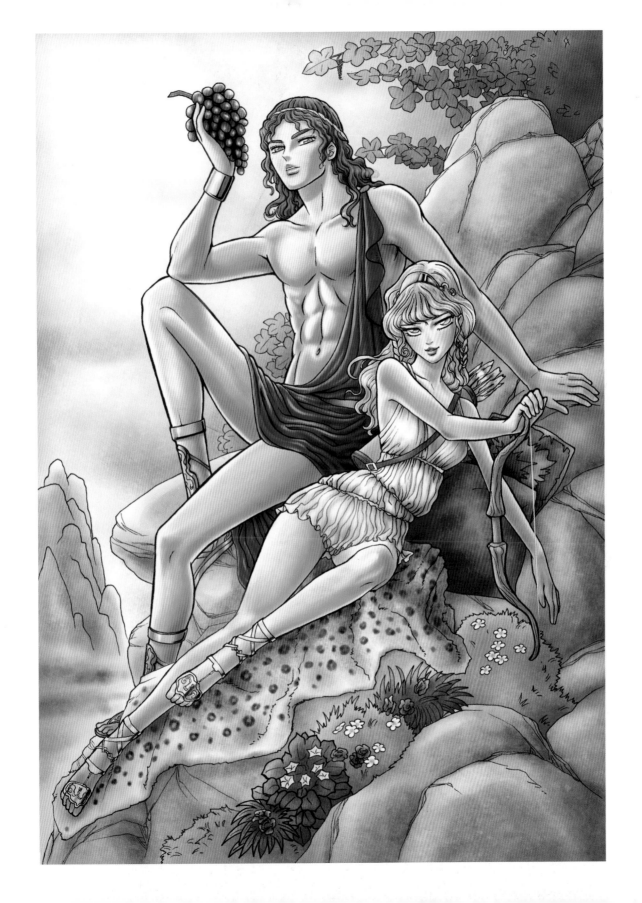

WARRIOR ELF

Merilwen is a young elf warrior of the Rosvhaar clan. Her people have been attacked by fearsome and cruel orcs bent on destroying their cherished thousand-year-old forest by cutting down the trees to use the wood to build a new base of operations in the valley. But she, along with the other elves of the clan, are not going to allow such barbarity. Especially because the sap of one of the oldest trees is what has given the elves the gift of immortality, generation after generation.

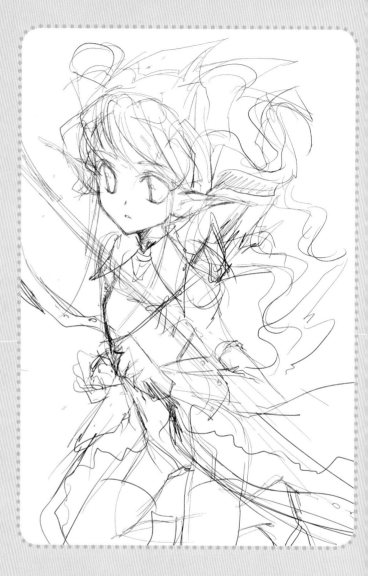

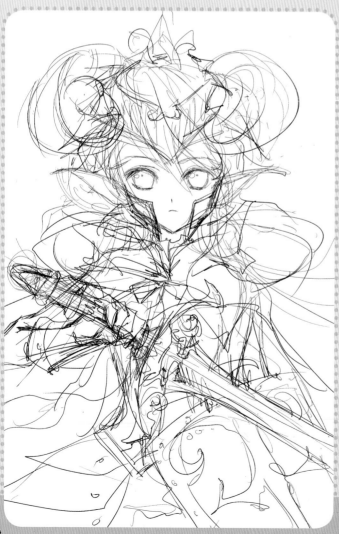

1. SKETCHES

We try different points of view with the elf: a frontal composition, a three-quarter portrait, and a profile portrait. The profile portrait had a more epic look, so that is the one we chose for completion.

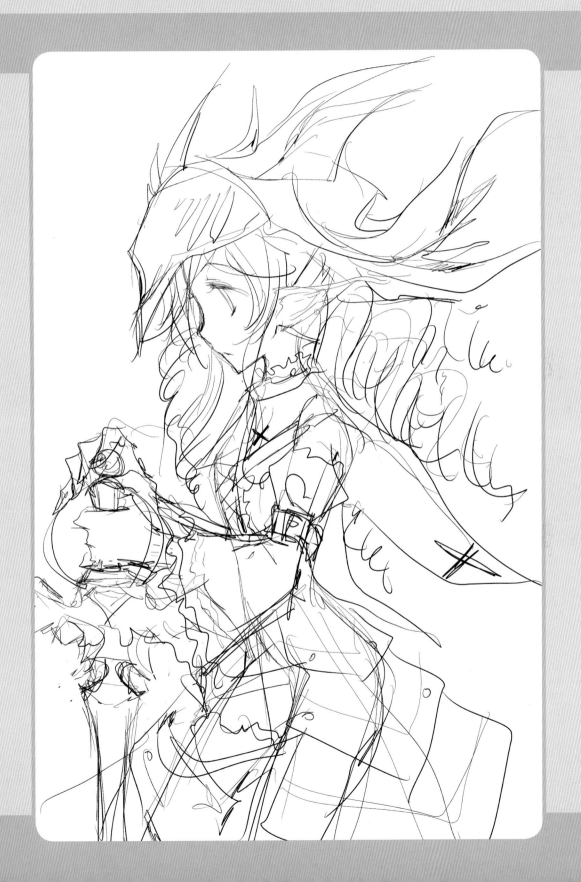

2. STRUCTURE

Although the head is seen from the side, the body is slightly turned towards the viewer, showing three quarters of it. It is common to draw bodies completely seen from one side, but that makes the illustration less natural.

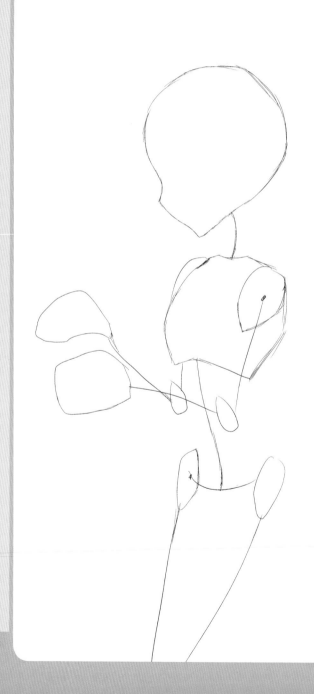

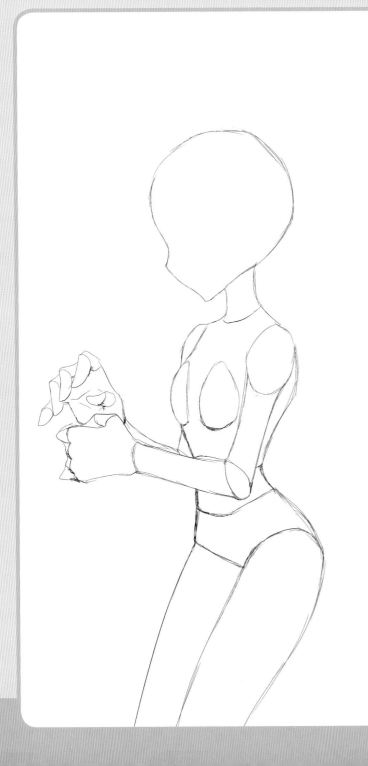

3. VOLUME

We fill the structural lines drawn in the previous step with stylized shapes crowned by big hands, characteristic of a warrior.

4. ANATOMY

Since we are drawing a female elf in *shôjo* style, the body must not be too thick. However, we can accentuate her warrior aspect with some details, such as the thickness of her fingers.

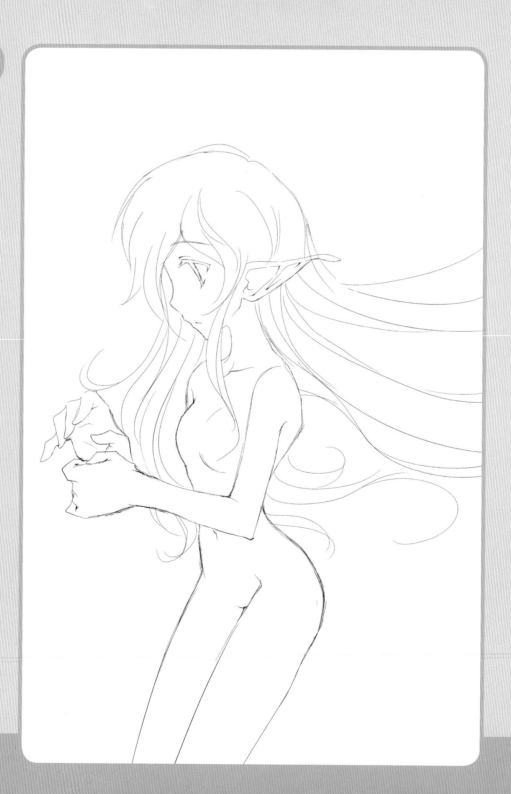

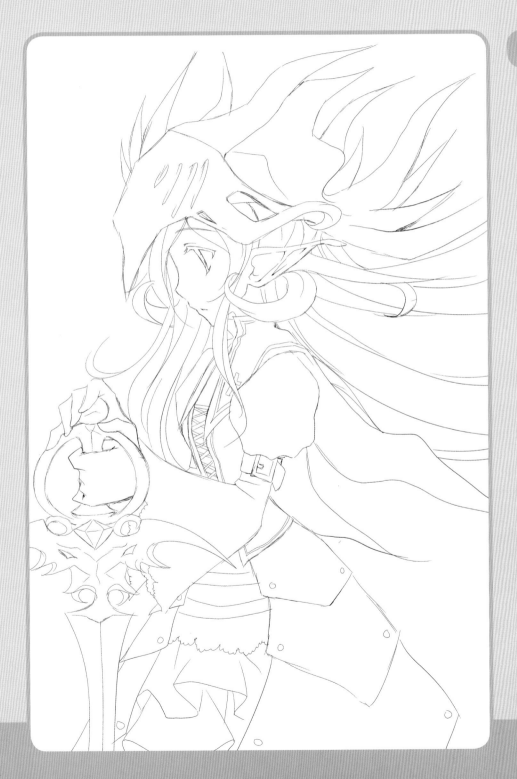

5. DETAILS

The bulky armor and sword are the final touch to the warrior-like appearance of the elf, although we have also included some female touches like the corset and the petticoat.

6.1. COLOR

We start painting the skin of the character, using the brushes to shape the volume of her features. This time we start with a black color base for the background, over which we will continue the painting process. That is why the line drawing is now white, in order to visualize it easily.

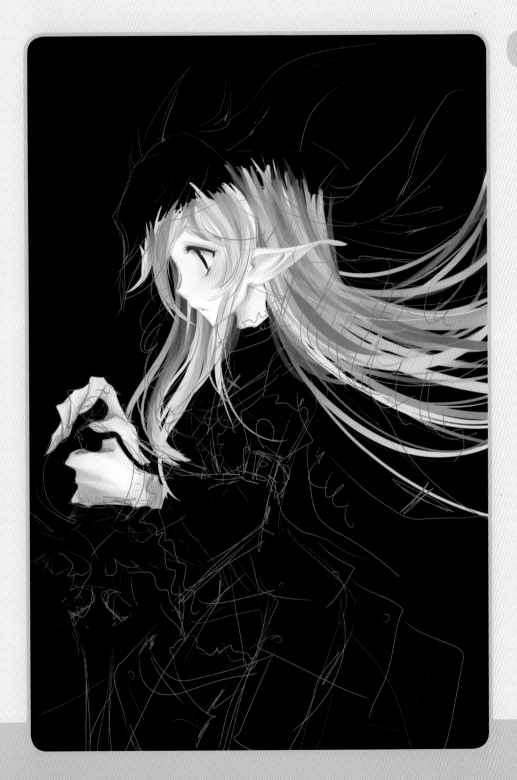

6.2. COLOR

We continue applying more brush strokes to draw the hair. First, we apply a medium tone to define the shape and size of the hair locks. After, we paint areas of light and shadow on them.

6.3. COLOR

Now we work on the outer parts of the clothing, using varying degrees of paint.

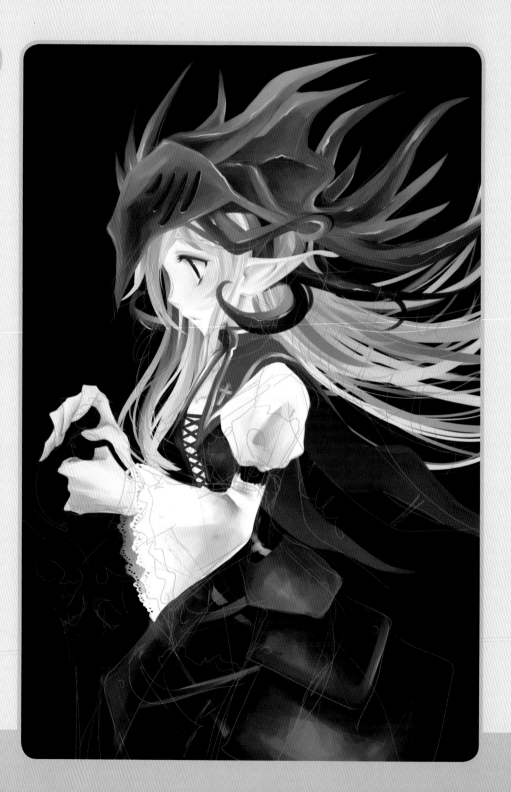

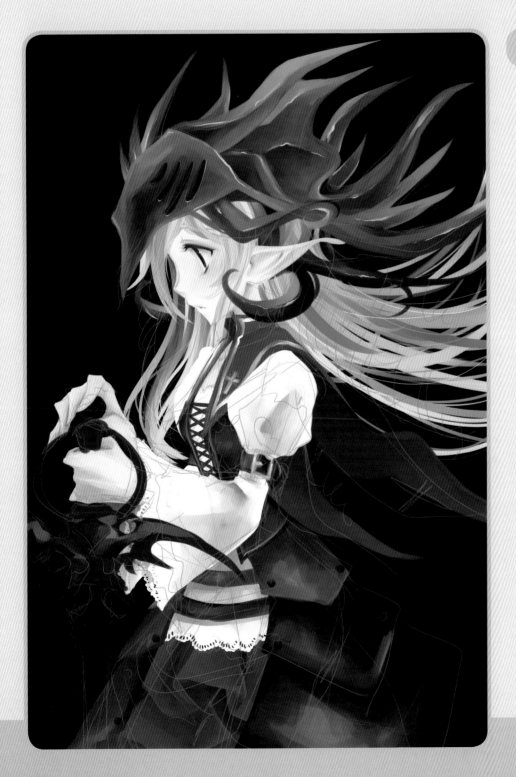

6.4. COLOR

We continue coloring the rest of the elements of the clothing, trying to create volume using shadows and highlights.

6.5 COLOR

Now that the clothes and the sword are completed, we can work on the background decoration adding brush strokes in the background as well as roses and petals surrounding the elf.

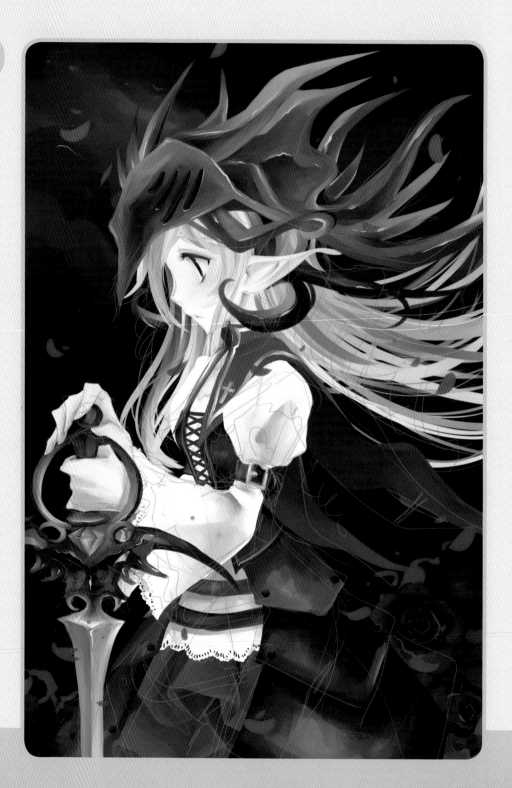

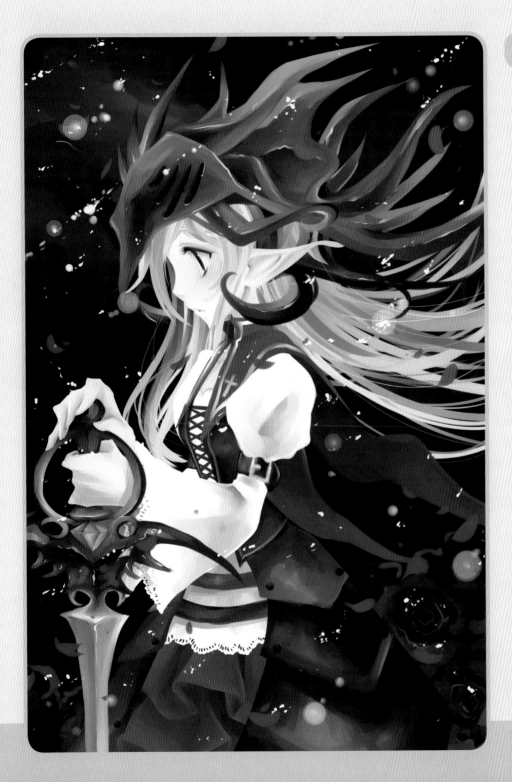

6.6. COLOR

We remove the white line drawing that we had used as a guide to do the coloring process, and finish the illustration adding light flares and small white spots.

Finishing touches

- We finish the illustration applying a vintage paper texture with its blending mode set to Overlay, placing it on top of all the layers of the illustration.

- To prevent changes in the color hues of the illustration, the texture must be a grayscale image.

Tips & tricks

- This illustration has been colored using PaintTool SAI software, except for the final texture, which was inserted using Photoshop.

- However, this type of coloring process can also be done with other programs; what's important is finding the right brushes and learning to use the graphic tablet.

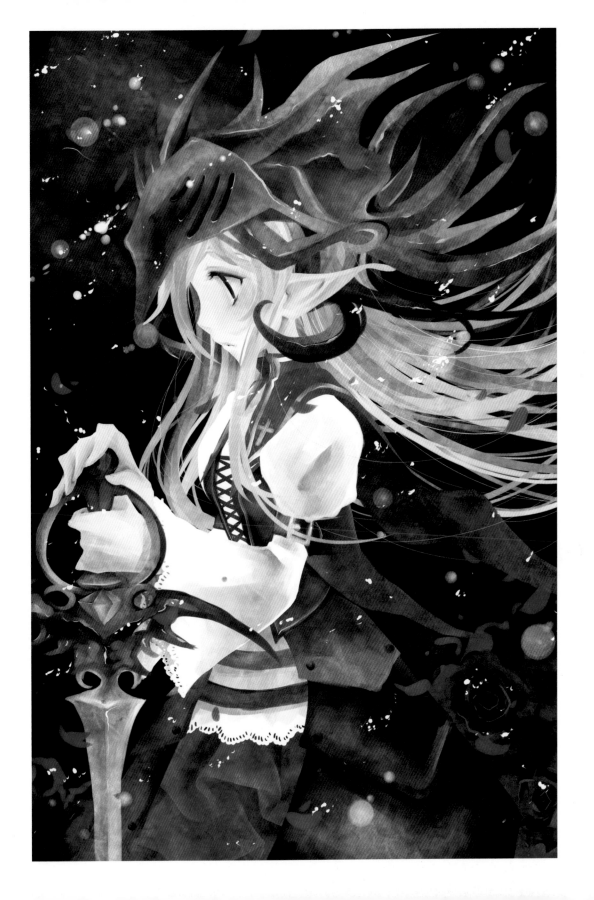

SNOW PRINCESS

Beyond the rivers and the mountainsides, atop the highest peak of Mount Northmun, is the palace of Princess Sneeuw. It is a cold, isolated place protected by the incessant snow and the constant blizzards lashing the place. But inside, magic allows a warm home where the whole royal family and court reside. Suddenly, however, many of the palace inhabitants start to fall ill, as if a lethal cold had seized them. Sneeuw resolves to leave the palace and try to find an antidote for this strange ailment that threatens to end the quiet life of her kingdom.

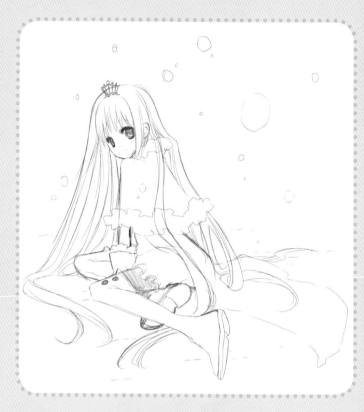

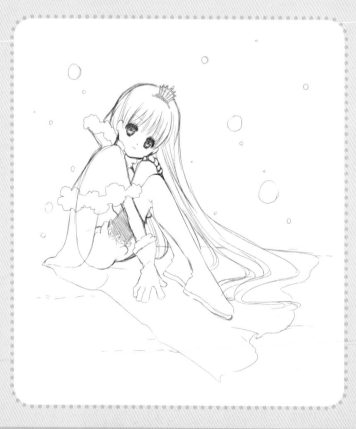

1. SKETCHES

A candid and resolute child princess has to show strength, as well as naïvety. Thus we choose to finish the sketch that shows her standing with the flag in her hand while it flutters in the wind.

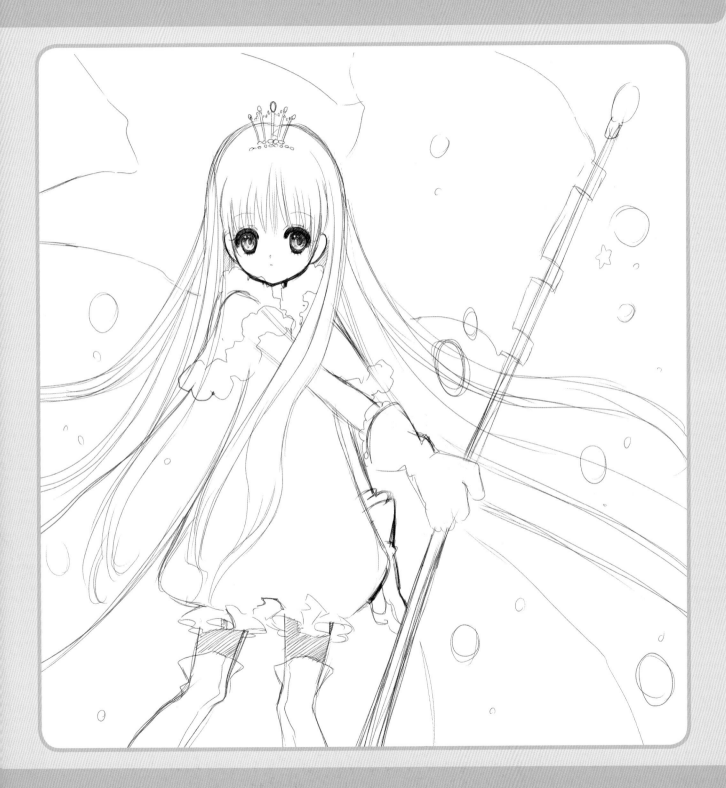

2. STRUCTURE

We create a 45° angle between the central axis of the figure and the flagpole. To avoid making the princess look inscrutable, we flex her spine slightly as well as her torso and knees.

3. VOLUME

We complete the construction of the character, stylizing the figure as much as we can. We also draw the hair, which is an essential part of this illustration.

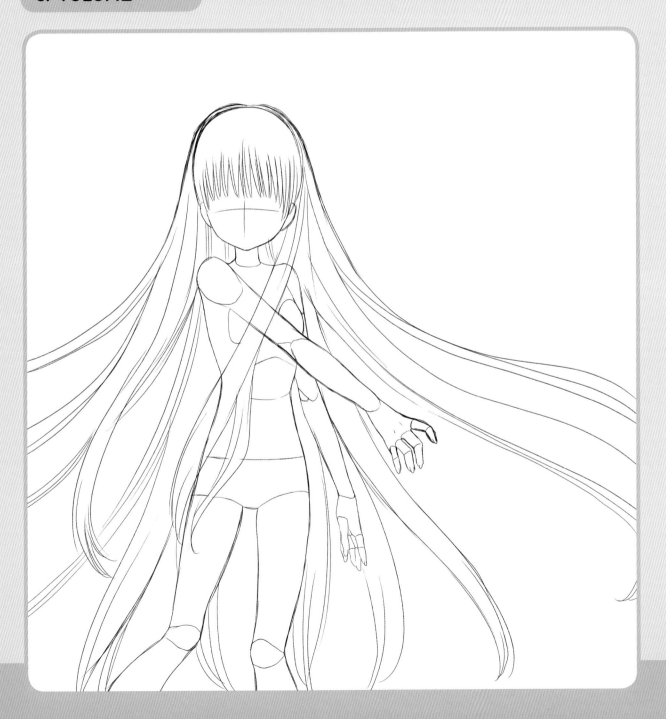

4. ANATOMY

We clean the drawing and include the facial features, giving the princess an innocent expression. Since we're drawing a girl, her hips cannot be too wide, they have to be just visible enough to accentuate her femininity.

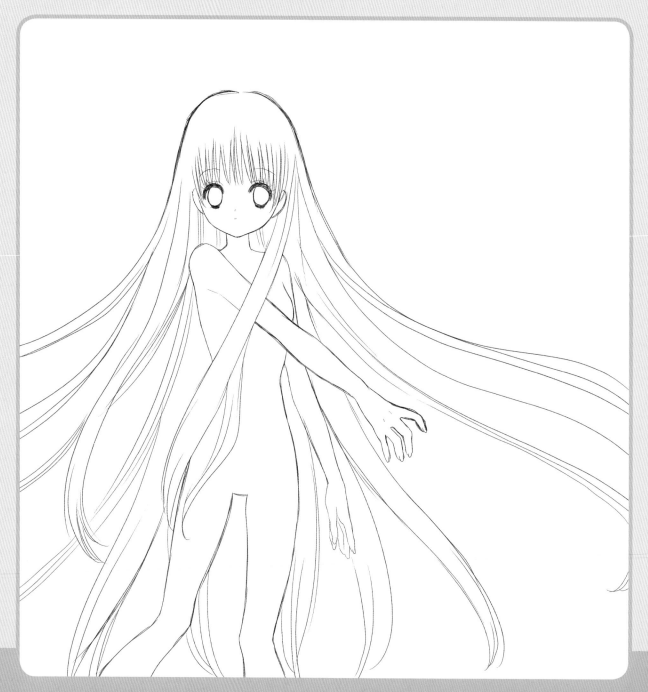

5. DETAILS

Her clothing is designed to withstand the extreme cold of the mountain, but we must remember to include details that visually covey that she is a princess, such as her crown. We also draw the flag she is carrying, which is the banner representing her kingdom.

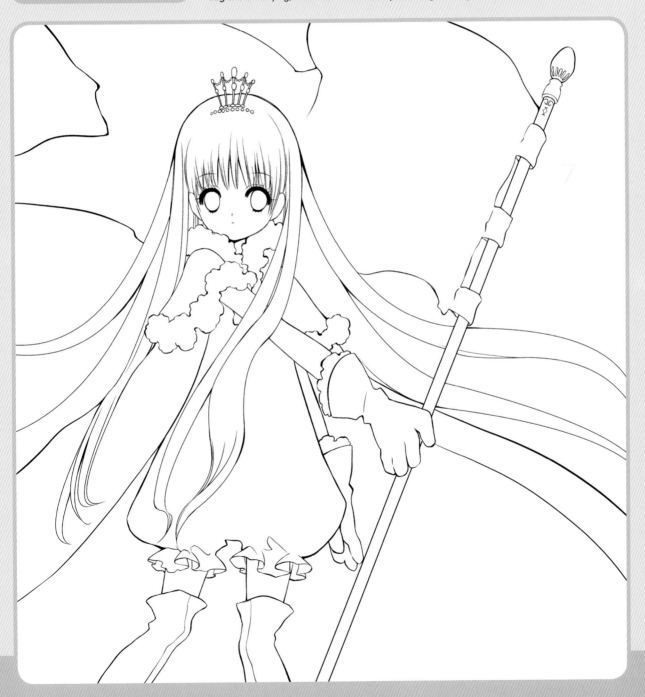

6.1. COLOR

We fill the drawing using base colors that have a low saturation, but are dark enough so that we are be able to apply highlights to them.

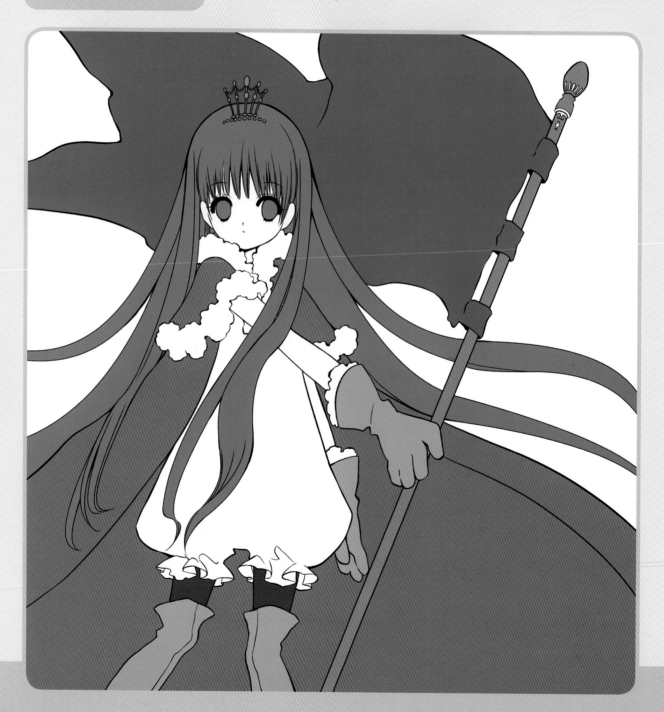

6.2. COLOR

We apply the shadows with a watercolor brush on all the elements except the hair, where we will paint highlights over the dark base color we applied earlier. The shadow projected by the flagpole on the cape has an irregular shape to simulate the visual effect of it being projected on a piece of cloth.

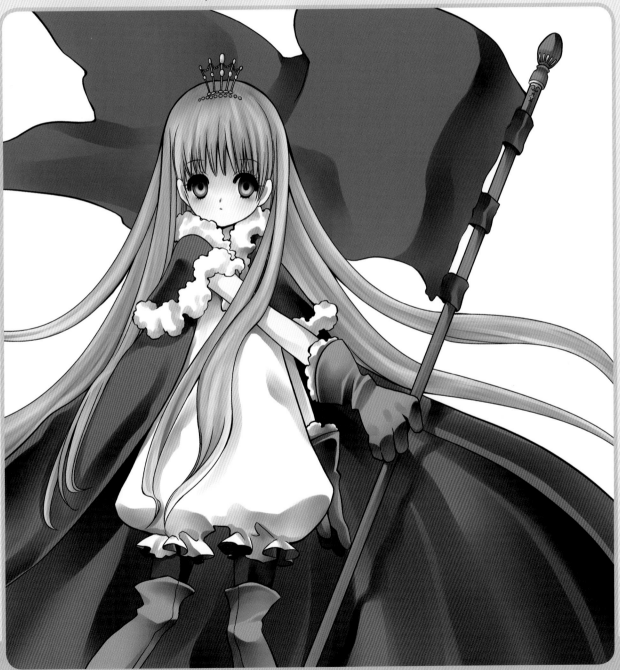

6.3. COLOR

The highlights have been applied with a soft brush, which works really well when used on a layer above the whole illustration to make it cover the colors and the line drawing, thus achieving a more defined effect.

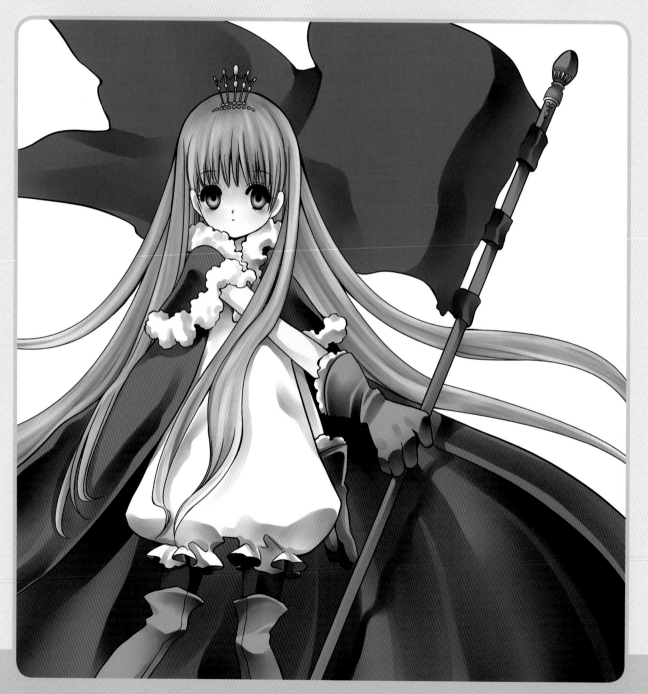

6.4. COLOR

The darkest area in the eyes is painted with Multiply blending mode using the same soft brush we used for the highlights, although this time it has been applied on the same layer containing all the coloring of the eyes (locking it to avoid painting outside the line).

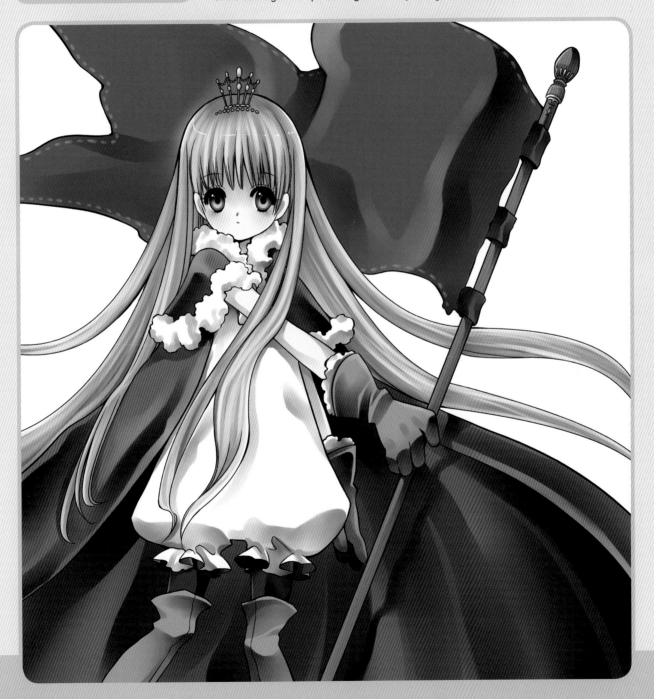

7.1. BACKGROUND

We apply several brush strokes with dark blue on the existing bright blue color base we had painted in the background. This way, we will create an effect that loosely resembles clouds. Starting from a general color tone we have been able to homogenize the tones in the image.

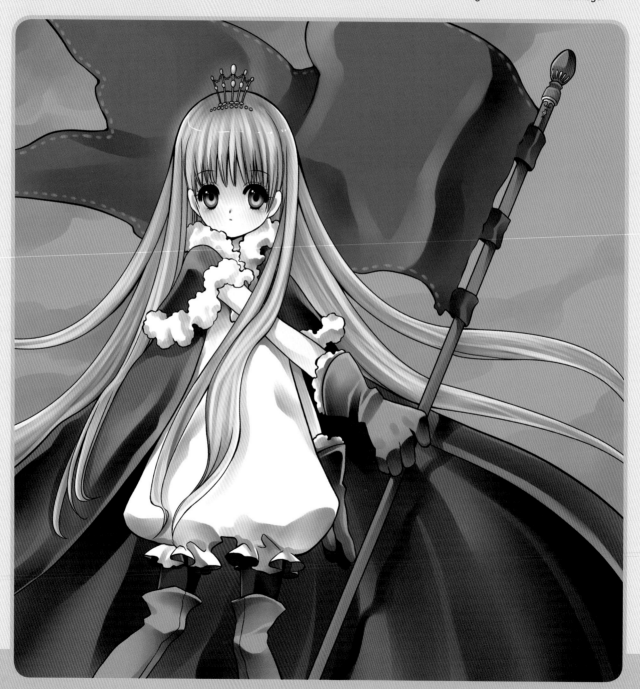

7.2. BACKGROUND

We paint over the image adding white brush strokes with varying opacities: more opaque for the snowflakes and more transparent for the clouds in the background.

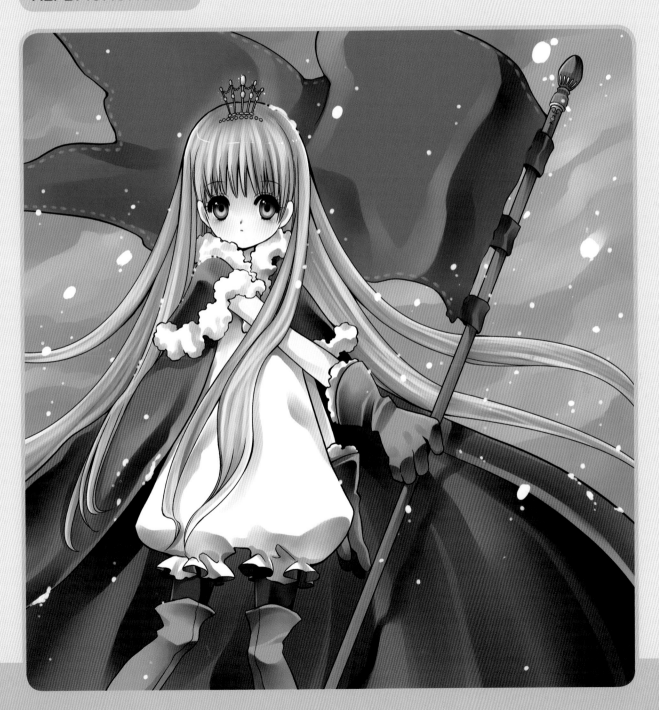

Finishing touches

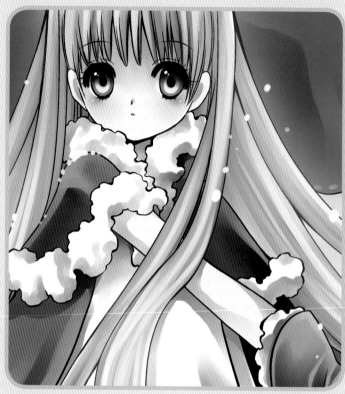

- We lighten the background with white brush strokes, trying to achieve a cloudy-looking gradient effect.

- We paint over the eyes, using the Overlay blending mode, adding a really bright spot to the iris.

- We apply glittering specks with more brush strokes around the princess to make the image brighter.

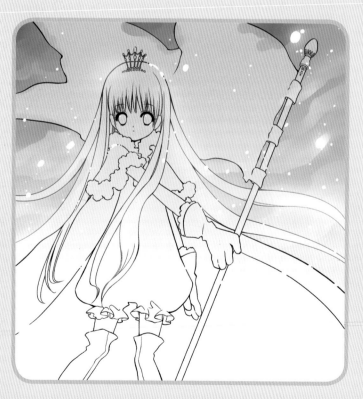

Tips & tricks

- The specks, when they are well distributed and balanced, make the image stand out and help complete the mood.

- Shadowy areas have to be especially dark, just to simulate the contrast produced by the light reflection on the snow.

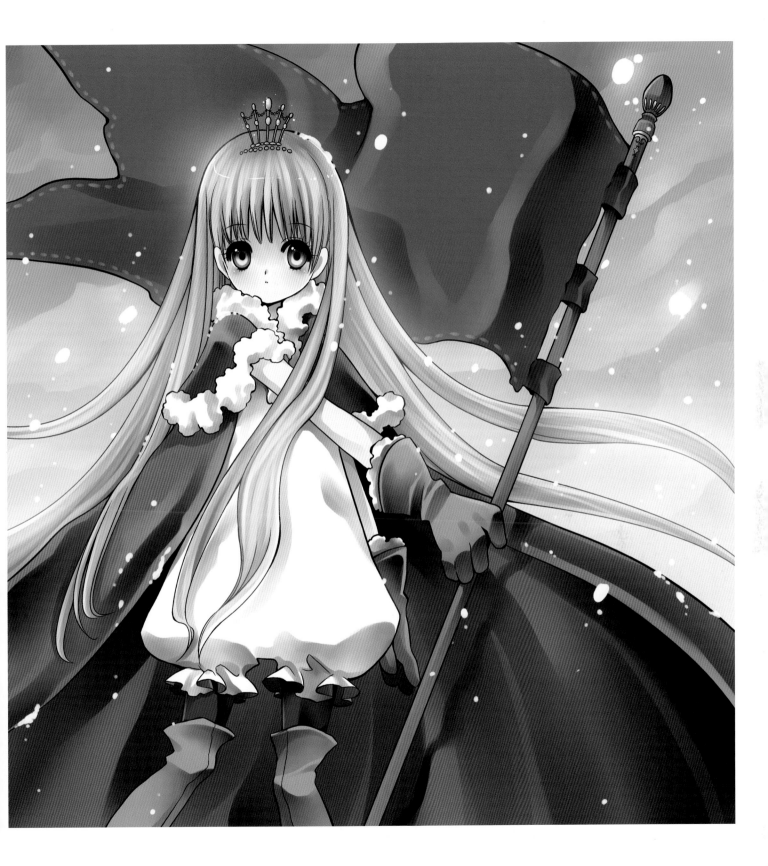

KINGDOM OF THE ROSES

How beautiful is the Kingdom of the Roses, surrounded by precious red flowers, flanked and shielded by hard thorns, yet saddened by strange events that are the cause of pain and suffering. What mysteries will it hold inside? It is said that, in the shadows, someone is pulling the strings, taking advantage of the young, inexperienced son of the king, who assumed the throne after his father's death.

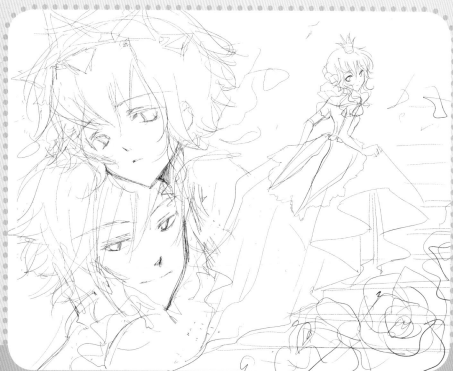

1. SKETCHES

All three images represent the mood of the Kingdom of the Roses perfectly, but the image we chose for coloring shows the characters' expressions more closely and with more detail.

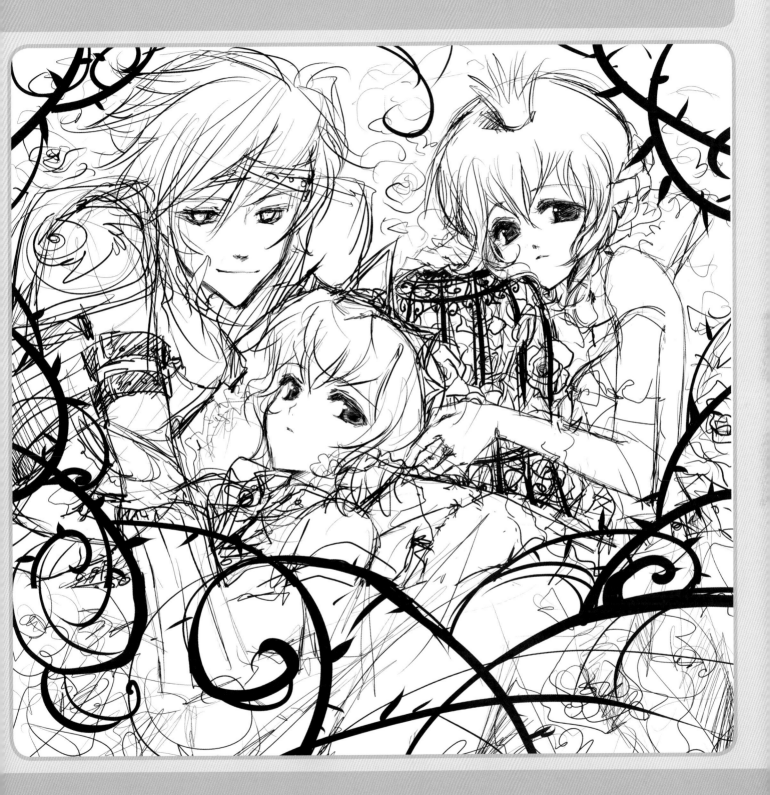

2. STRUCTURE

The characters' figures overlap, forming an imaginary triangle. All three bodies are slightly tilted.

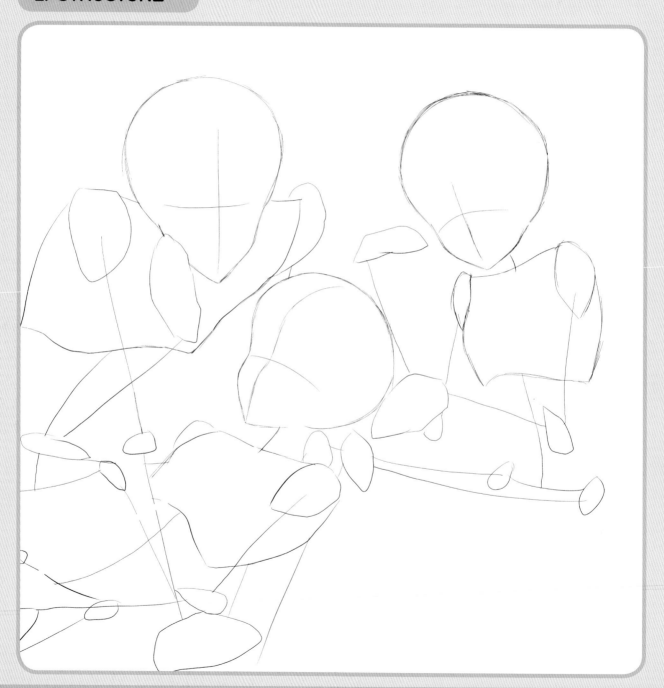

3. VOLUME

We complete the shapes of the characters trying to make them fit as naturally as possible. Both the pose and the extremities must look gentle.

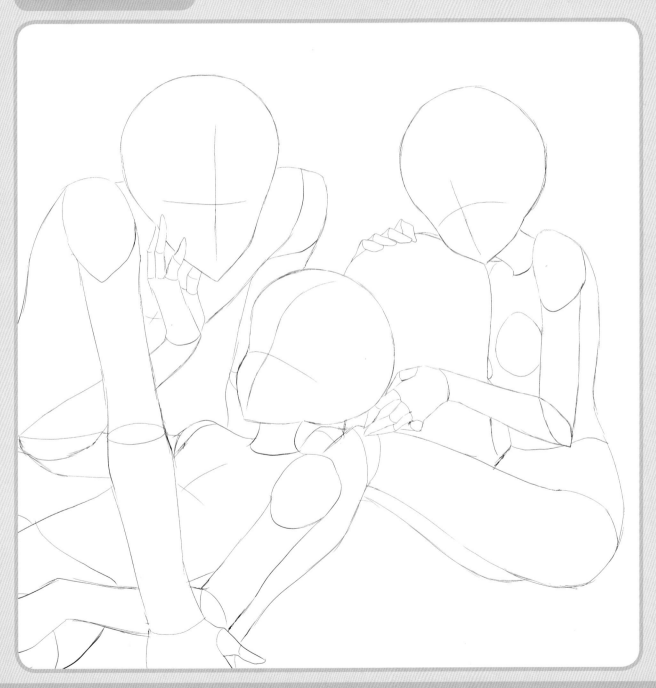

4. ANATOMY

We complete the drawing with the hair, cleaning the line drawing and defining the final bodies of the characters.

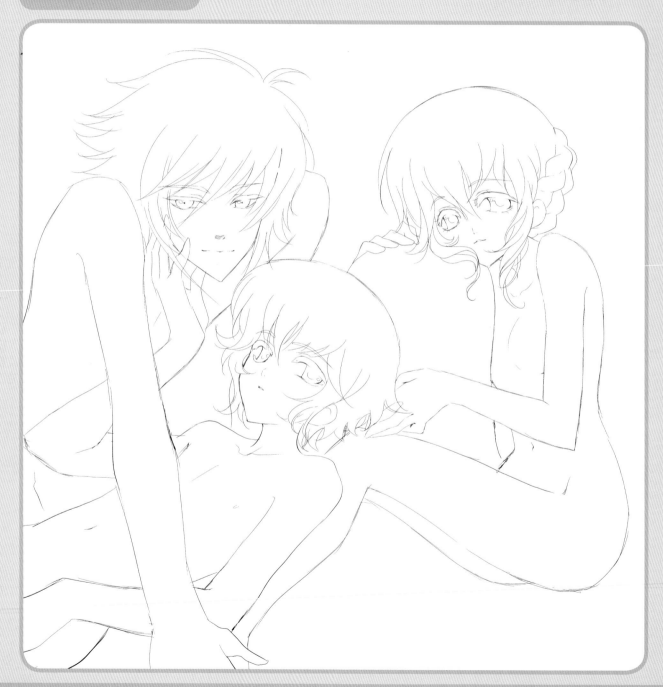

5. DETAILS

We dress the king, the princess and the warrior with medieval clothes, with a touch of fantasy, adding elements of retro-futuristic video games.

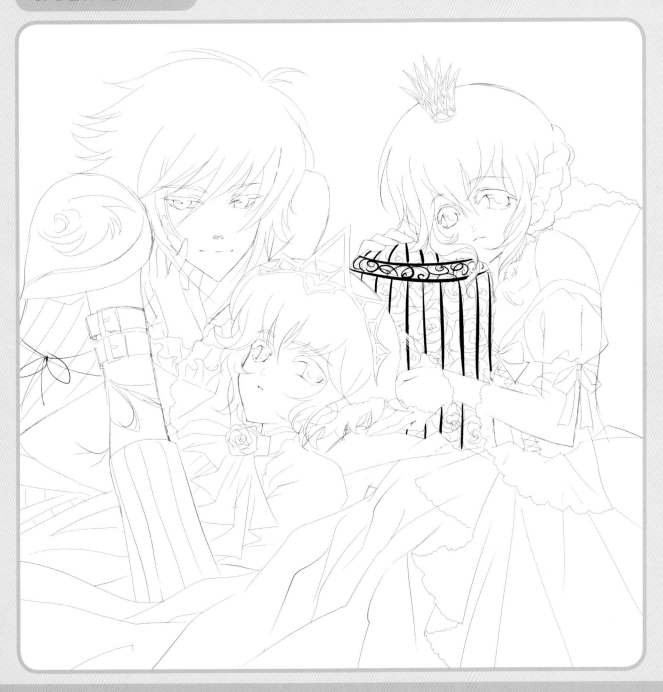

6.1. COLOR

We fill in the background of the image with a greenish tone and start to define the areas of light and shadow on the characters' faces using the brush tool and varying opacity.

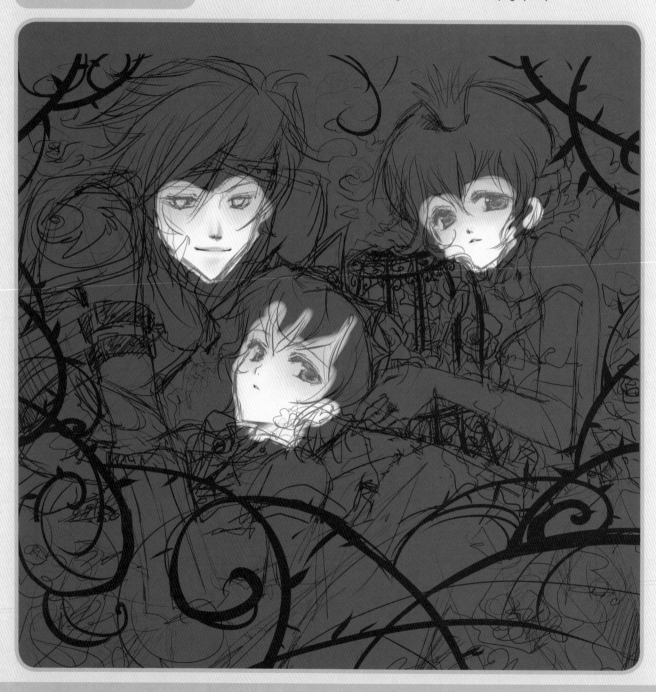

6.2. COLOR

We continue by adding the details of the remaining facial features, paying special attention to the eyes, which will be what gives the image its expressiveness, as their faces are a great focus of attention.

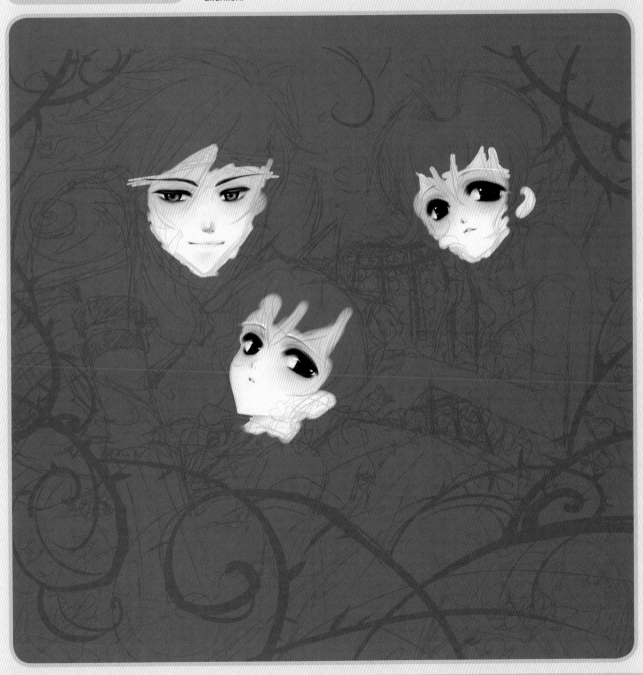

6.3. COLOR

We apply a bright color base for the hair and use soft brush strokes to add shadows as well as some highlights to the warrior's hair.

6.4 COLOR

Now it is time for the dresses, and we define their creases with the Brush tool. The princess' dress includes decorations made with a digital texture.

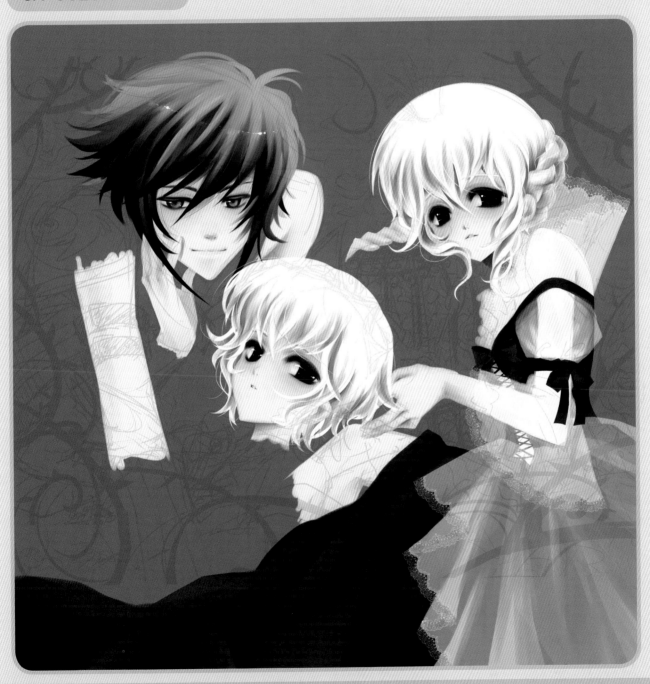

6.5. COLOR

Little by little we create the remaining details of the clothing, using the line drawing as a reference.

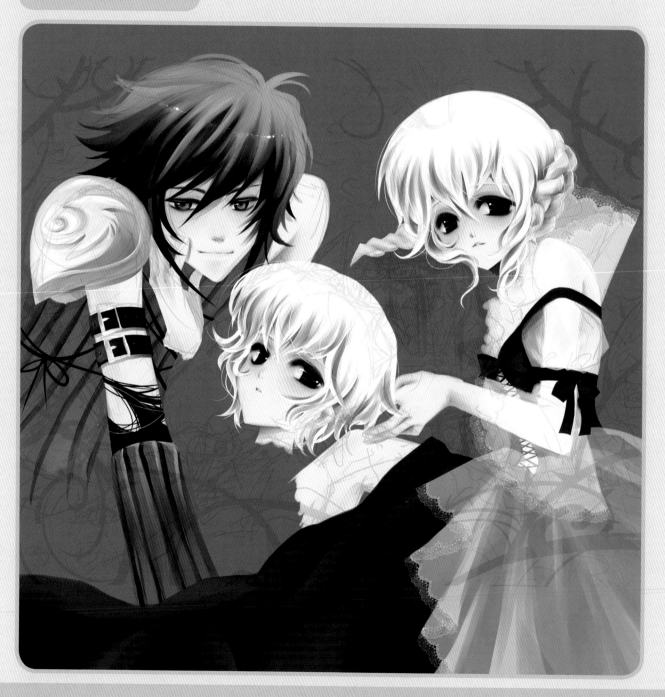

6.6. COLOR

When choosing the color palette, we use a range of red and maroon tones, as well as white and gray or green, and black.

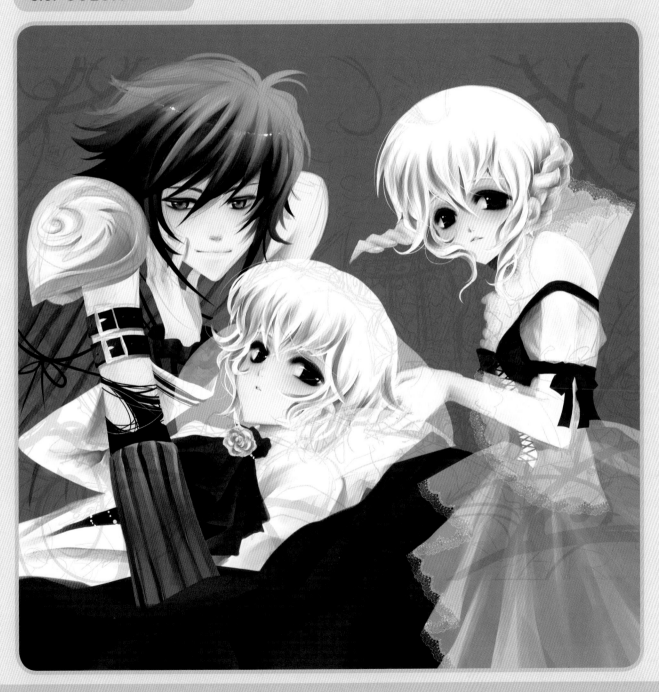

6.7. COLOR

Now that we have painted the final elements in the illustration, we remove the layer with the line drawing that we have used as a guide up to this point.

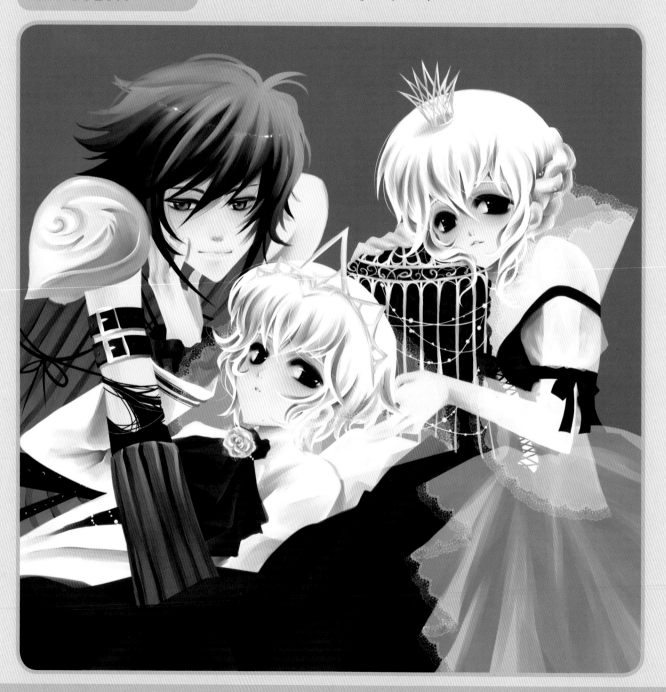

6.8. COLOR

We add rose petals all over the image as well as white dots resembling highlights. For the background we create a montage of graphic elements to simulate old letter paper.

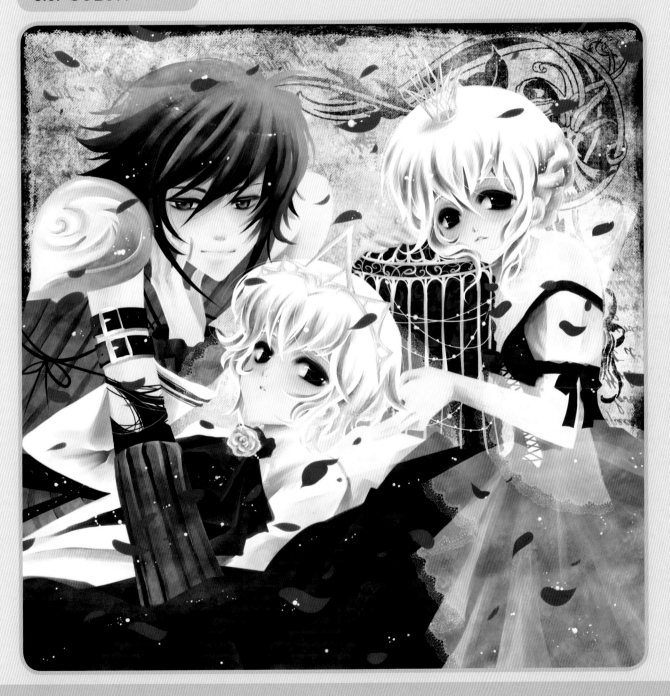

Finishing touches

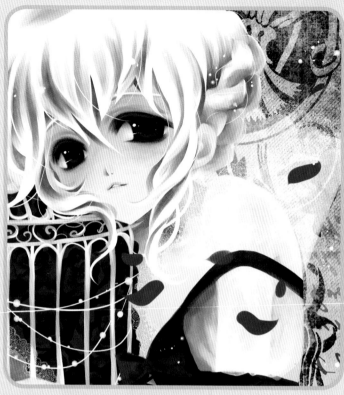

- We alter the tones in the background using two layers with their blending mode set to Multiply, to which we apply a Gradient Overlay effect in their blending options.

- With this we achieve a greenish tone that is more intense in certain areas, which fits better with the colors of the illustration.

- Lastly, we apply a paper texture on top of the illustration with its layer blending mode set to Overlay.

Tips & tricks

- Backgrounds do not necessarily need to represent a physical location. We can also think of them as yet another ornament of the illustration, as a complementary element.

- Designs like this one are easier to create in a separate file, and then include them in the illustration on a new layer.

- If necessary, as it happens in this case, we add more effects afterward to make the color match the characters in the foreground.

316

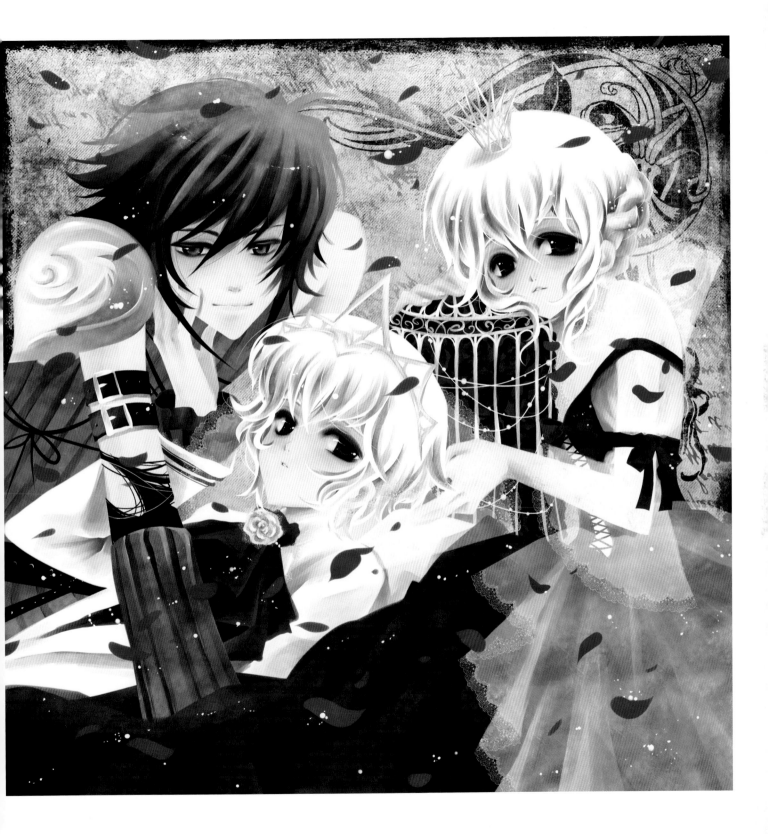

KINGDOM OF THE ROSES: Bonus!

After the mysterious death of the monarch of the so called Kingdom of the Roses, his son, heir prince Klaus, must assume the rule of the country. But a young man of his age has other priorities above his duties. His friendship with his knight protector, Dustin, or his relationship with his sister, Marlene, prevail over his royal obligations.

THE PRINCE

Young prince Klaus has a slightly sad facial expression and an air of mystery and melancholy. Klaus and his sister Marlene are identical twins, thus their resemblance.

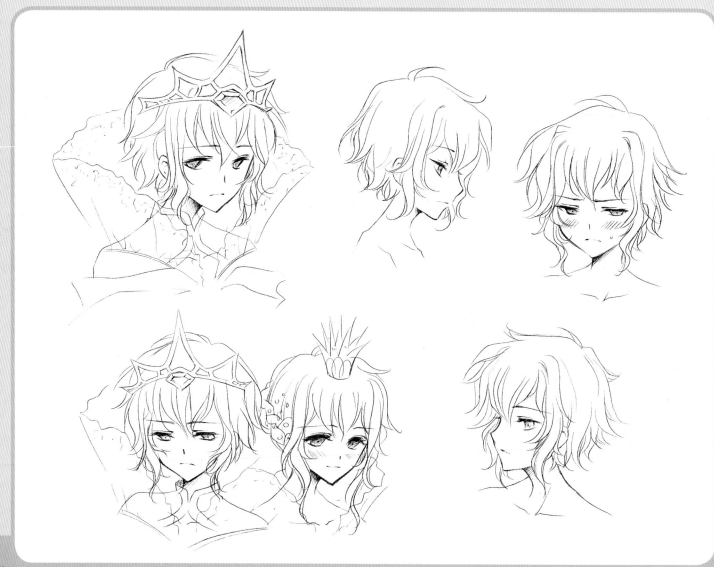

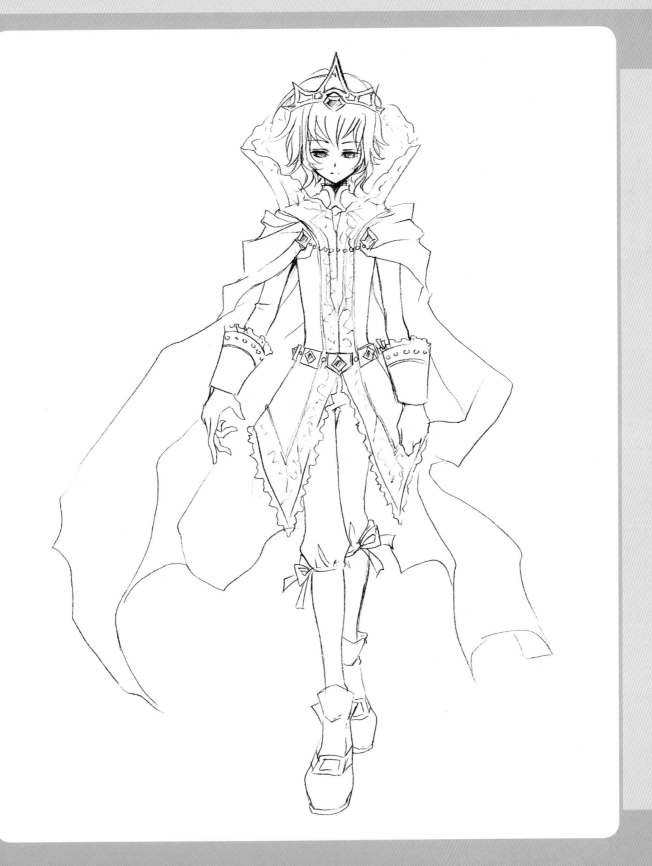

THE KNIGHT

Dustin is the captain of the royal guard. He is the right hand of the prince and he is also his protector and close friend. Their relationship became much closer after the king's death. However, behind his strong, cheerful and decisive look, some terrible secrets lurk.

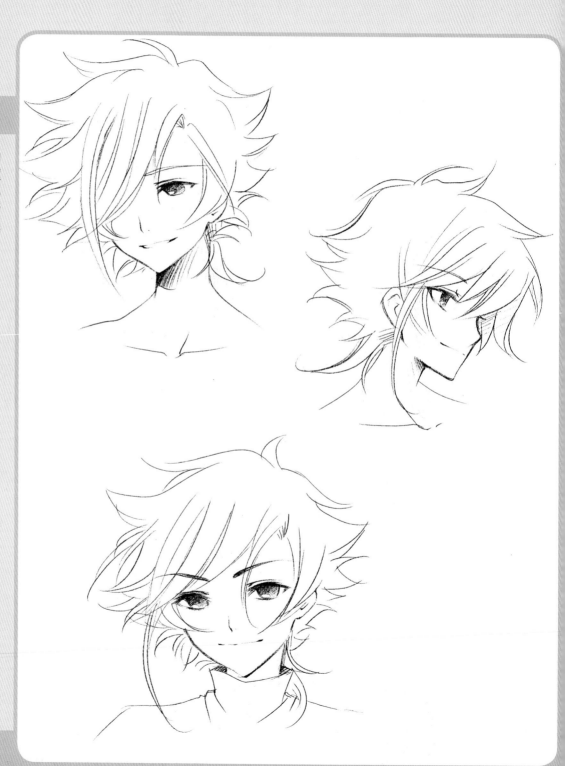

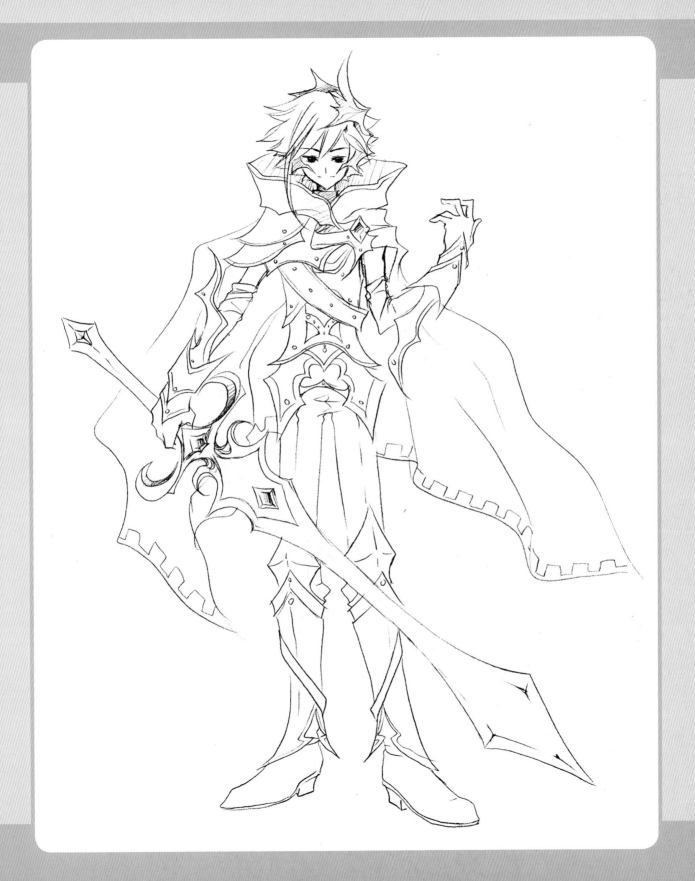

THE PRINCESS

Princess Marlene has always lived a happy life, thankful for not having to bear the weight of the responsibility that has fallen on his brother Klaus. Marlene is overprotective of Klaus, especially after their father's death. But deep inside she envies his brother's relationship with Dustin, with whom she is secretly in love.

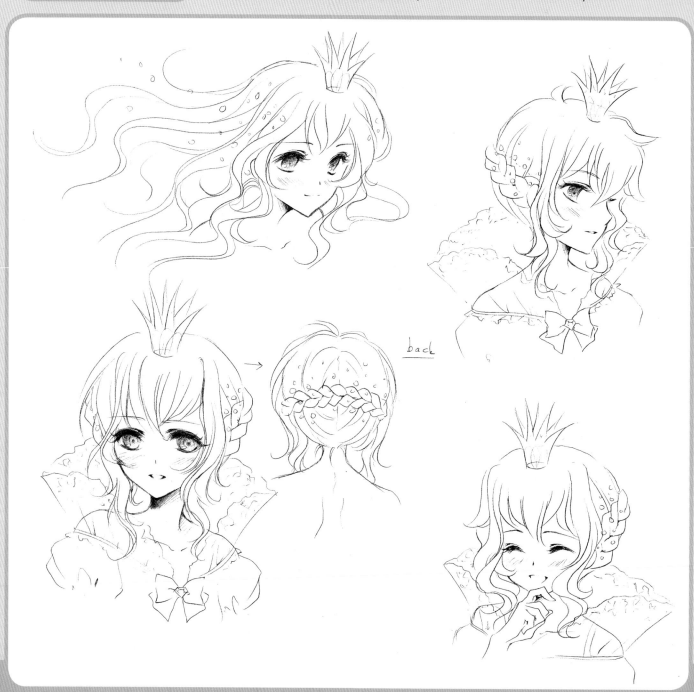

back

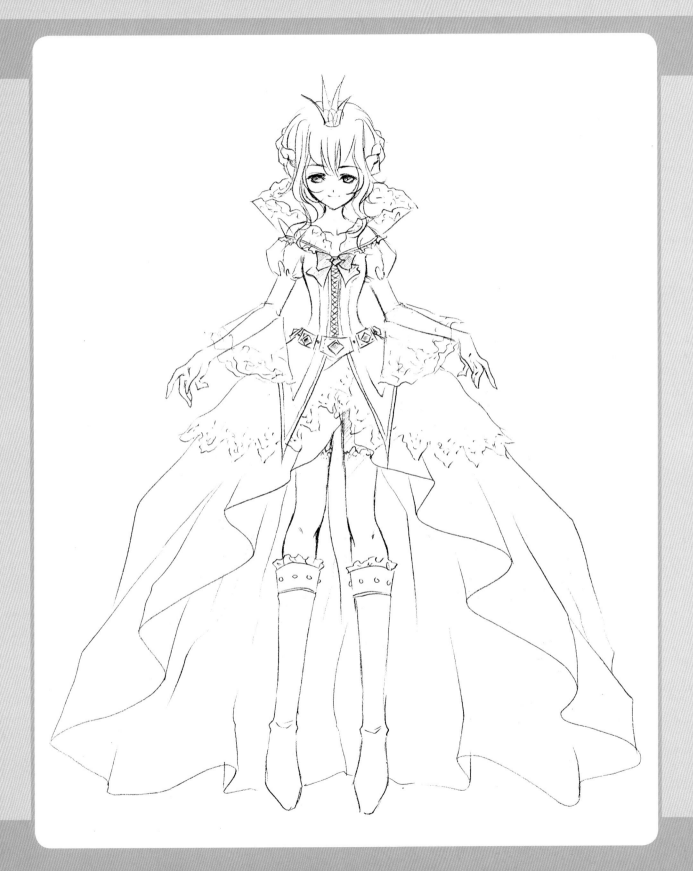

Extras

CREDITS

ARTISTS

GALLERY

CREDITS

 VICTORIA by Ayame Shiroi

 LOLITAS by Alicia Ruiz

 THE LADY OF SHANGHAI by Ayame Shiroi

 A DAY AT THE FAIR by Helena Écija
Final tweaks: Eli Basanta

 THE ARISTOCRATS by Irene Rodríguez
Final tweaks: Eli Basanta

 DETECTIVES by Aurora García

 LITTLE CHINESE GIRL by Pásztor Alexa

 SURFER GIRL by Miriam Álvarez

 THE VIOLINIST by Ayame Shiroi

 HIGH SCHOOL LOVE by Alicia Ruiz

 THE POPULAR GIRL by Ayame Shiroi

 ROCKSTAR by Aurora García

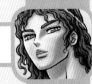

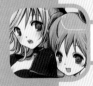
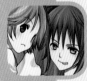

ARTISTS

ALICIA RUIZ

Hardened in the world of *dōjinshi* (self-published Japanese amateur fan works), Alicia's work first appeared in the *manga* series *Yaruji! St. Cherry High School*, which reached a total of six published volumes. Since then, her work has been featured in HarperCollins' book *Kodomo Manga: Super Cute!* and in theItalian magazine *Mangaka!* But she has garnered the most recognition through online video games and the fan arts she created based upon the characters of her favorite series. Along with her sister Inma, she participates in the illustrated classics of the collection *Guru Guru*.

AURORA GARCÍA

Aurora's first works were the monthly series *[Lêttera]*, which was published in the magazine *Shirase*, and the series *Garou-chan*, created in collaboration with her studio colleague Diana Fernández. Years later they showcased work in the American market with two *yaoi*-themed pieces that were also licensed for various European countries: *Saihōshi* and *Stallion*. *Saihōshi* received the Expocómic "Best + by a Spanish artist" award in 2006. Auorora's most recent work is the series *Daemonium* for the publishing house TOKYOPOP, although they are preparing a big volume version of *[Lêttera]*. In the illustration field they have completed projects for the magazines *Maxim* and *Rolling Stone*, the educational books *Japonés en Viñetas* volumes 1 and 2, by Norma Editorial, *Kodomo Manga: Super Cute!*, published by HarperCollins, and *How to Draw* by Christopher Hart.

Web: www.stkosen.com

AYAME SHIROI

Ayame started her professional career illustrating the marketing materials for the travel agency Portal Japón in 2002, and continues to work for this company. Shortly after she began her career, she had a chance to illustrate a collection of *Light Novels* for their publication in Japan, a country for which she still works as an illustrator and *manga* artist. In Spain, she has published several works like the *manga Rosa Cruz* and she has also illustrated the handbook *Japonés con Yumiko,* in both cases for Medea Ediciones. She has also taken part in several collective exhibitions such as the one organized by the Illustrators Association of Andalucía.

Web: www.ayameshiroi.deviantart.com

HELENA ÉCIJA

Helena's first nationally distributed work was the design of the animated version of the TV host of the show *Diario del Analista Catódico,* aired on the Spanish network La Sexta in 2005. Her creations have appeared online, with special mention of her designs for games at wambie.com. She created the poster for the *XIII Jornaícas de manga y anime de Zaragoza* and her work has also been featured in books like *Kodomo Manga: Super Cute!,* published by Harper Collins. She has given several master classes in the US and Europe, thanks to her combined education in both Madrid and the American midwest. She went to the School of the Arts Institute of Chicago, and it was there that she established herself as a professional illustrator for children works and advertising. Her works have been featured in collective exhibitions both in and outside of Spain.

Web: www.helenaecija.com

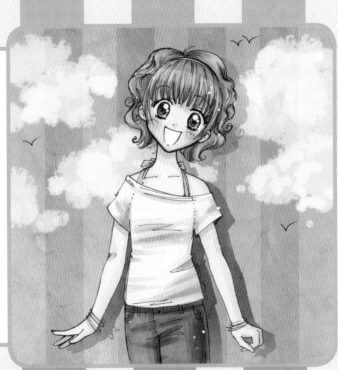

ARTISTS

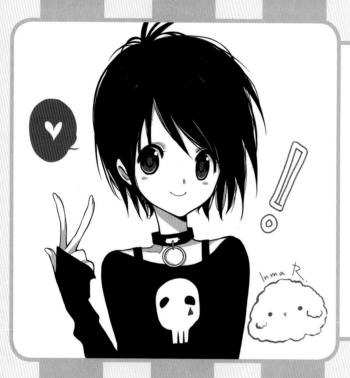

INMA R

Inma became known in Spain with the series *3x1,* a teenage *manga* published in six volumes, although she also has an extensive career as a *dōjinshi* author. For her work as a *mangaka* and illustrator, she received the award as the best Spanish *manga* in 2005 at the *Expomanga* in Madrid, and she twice won the annual *manga* competition of Ficomic. After winning the *manga* competition organized by Norma Editorial, she published the successful *manga* book *O.U.T.* As an illustrator, she has participated in the book *Kodomo Manga: Super Cute!*, published by HarperCollins, and the illustrated classics of the collection *Guru Guru.* She also has experience in the multimedia field, designing the virtual *manga* for the website "*Que no se respire miseria*" by the company Ncora.

Web: www.golden-nights.com

IRENE RODRÍGUEZ

In 2003, Irene won her first comic competition at the *IV Salón del Manga de Jerez de la Frontera,* and in 2007 she won first place in the *XIII Concurso de Cómic Ciudad de Dos Hermanas.* Earlier, her work had appeared in publications for *manga* fans. In 2008, she made the poster for the *Primeras Jornadas de Manga y Anime de la Ciudad de Sevilla,* after which she embarked on various *manga* projects like *Japan Walk,* for the magazine *B'S Log,* published by Planeta de Agostini, and the volume *La Canción de Ariadna,* for the publishing house Glénat, besides taking part in the book *Kodomo Manga: Super Cute!*, published by HarperCollins.

Web: www.ireneroga.deviantart.com

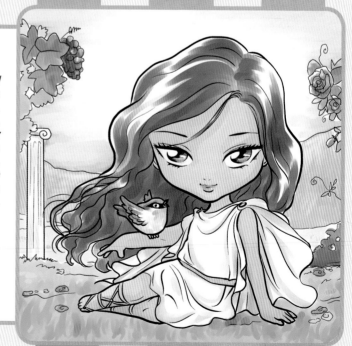

MIRIAM ÁLVAREZ

After becoming one of the most renowned illustrators in specialized *manga* and *anime* magazines, with her works featured in publications such as *Ohajo!, Kame* and *Dokan*, she specialized in video editing, doing work for *Calvin Klein* and *KLB Studio*. As a designer, she excels at logo and brand designs, flyer designs and photo retouching. Among her latest works are illustrations for the video games at wambie.com and the book *Kodomo Manga: Super Cute!,* published by HarperCollins. She has also worked as a fashion illustrator, doing graphic work for the kids clothing lines *Magic Kids* and *Coolhunter,* in addition to designing patterns for the brands *Harry* and *Arviva* and doing other work for *Stradivarius.* Currently she is part of the illustration and design team *Charuca.*

Web: www.mimiloverwomen.deviantart.com

PÁSZTOR ALEXA

During more than eleven years, this illustrator polished her drawing style until she found a style that dazzled everyone. She got a good number of followers through the website on deviantART, which encouraged her to create her own *dōjinshis* and to participate in other people's projects. She has published illustrations and tutorials in the Hungarian magazine *Mondo,* which specializes in *manga* and *anime*. Her illustrations took a great leap in 2008 and landed in Japan at the annual exhibition of the *Gallery Space Factory* in Tokyo, where they were displayed alongside other artists' works.

Web: www.lilikoi-dream.com

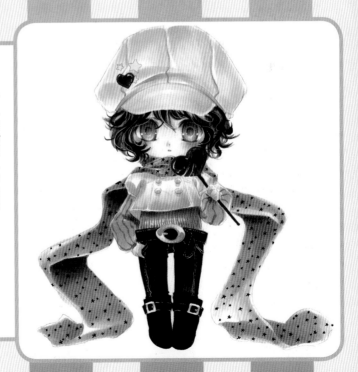

GALLERY

Rocking Alice

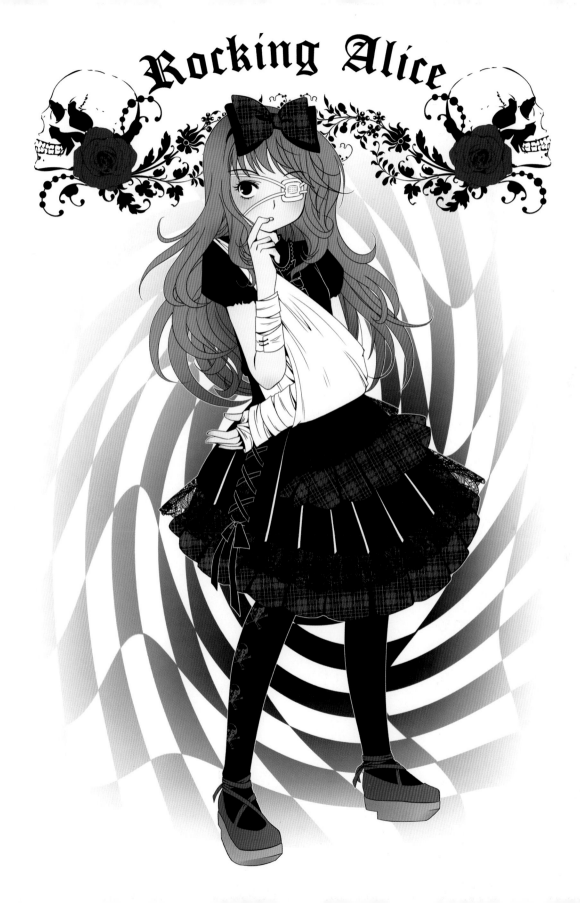

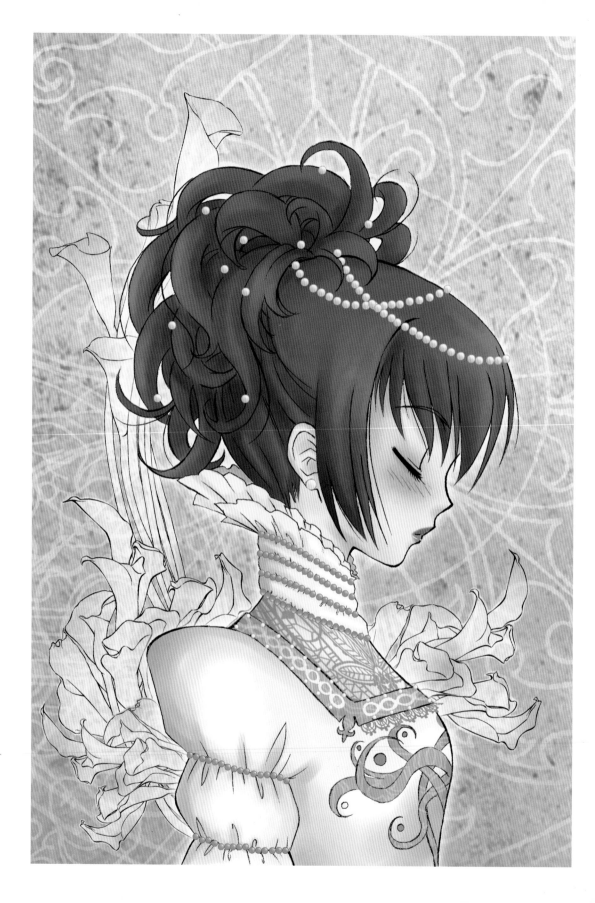

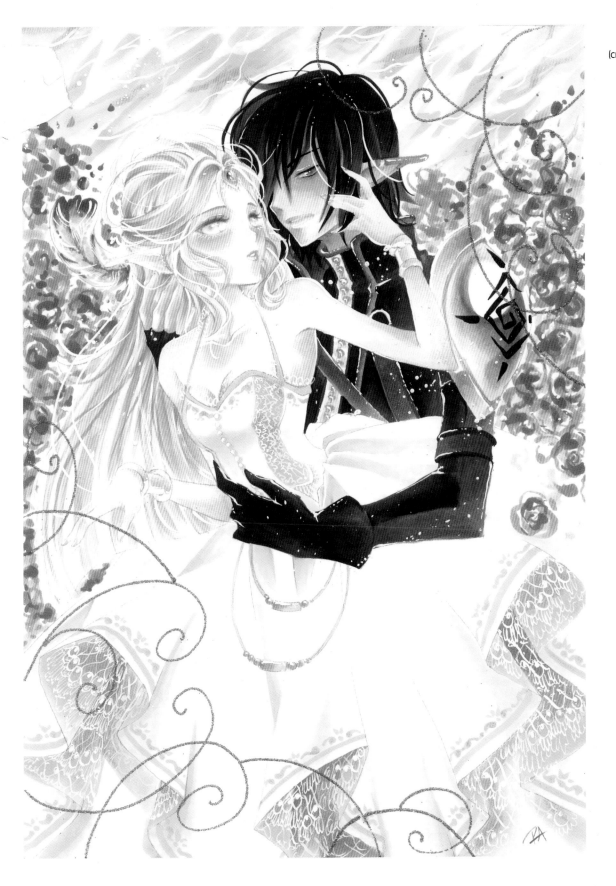

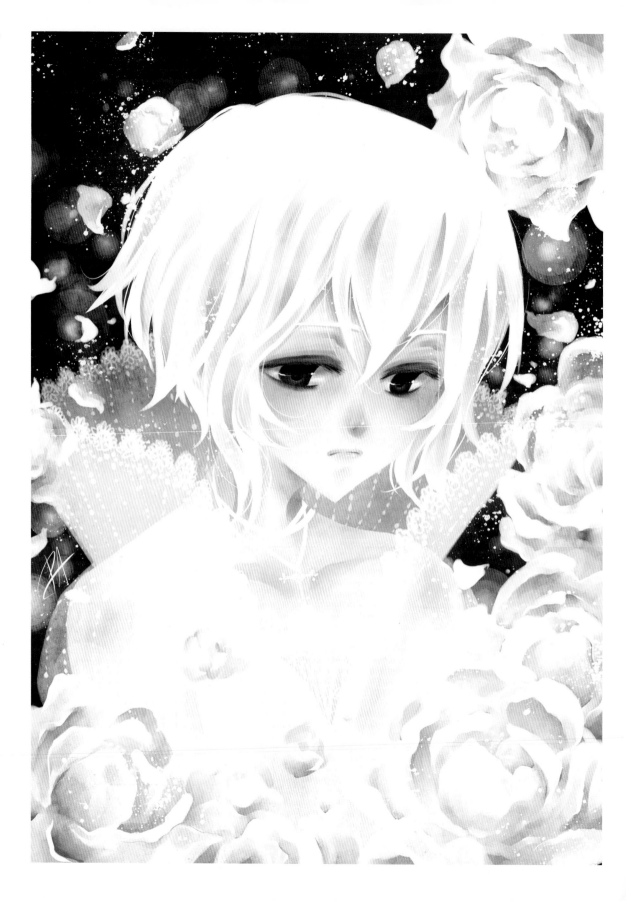

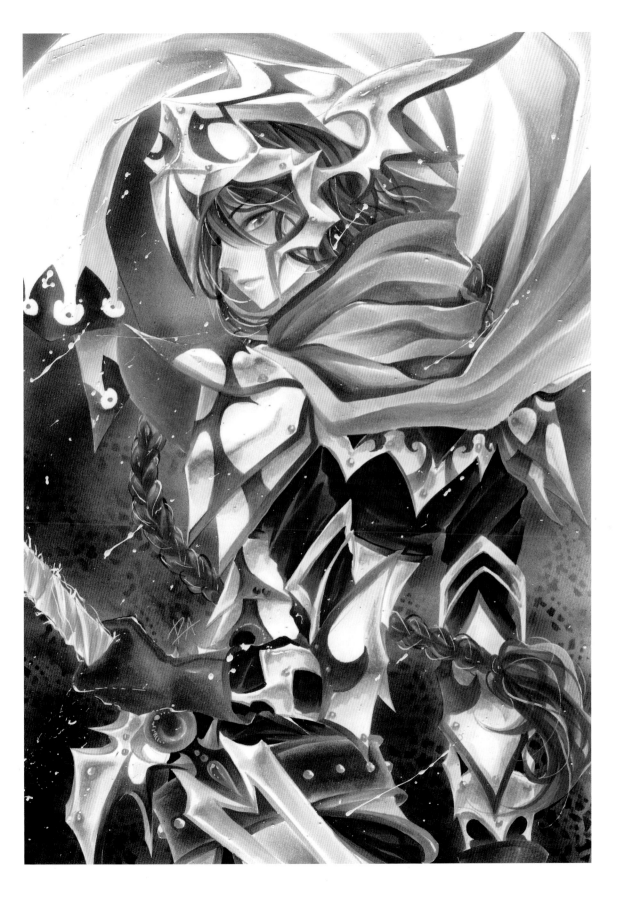

Love me under the moon
Pásztor Alexa

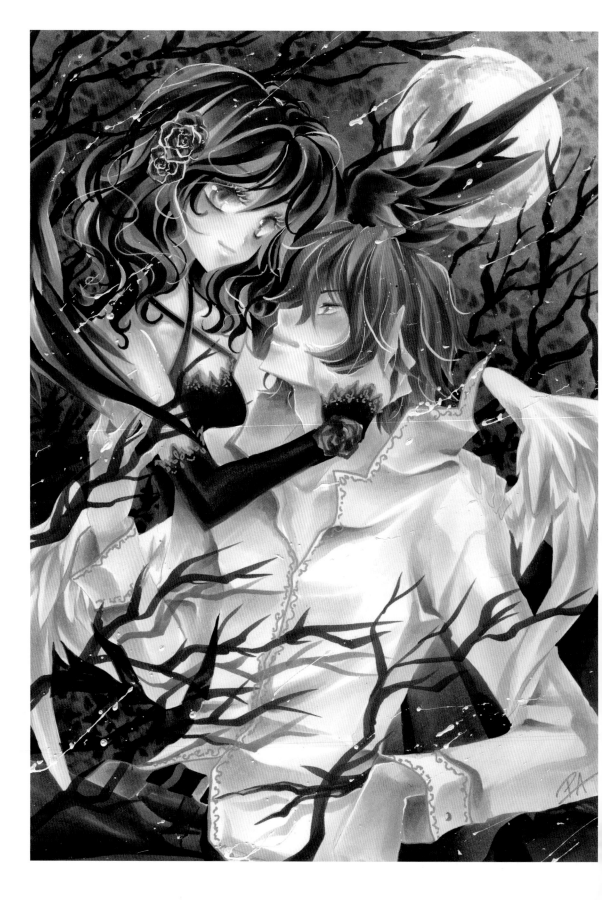

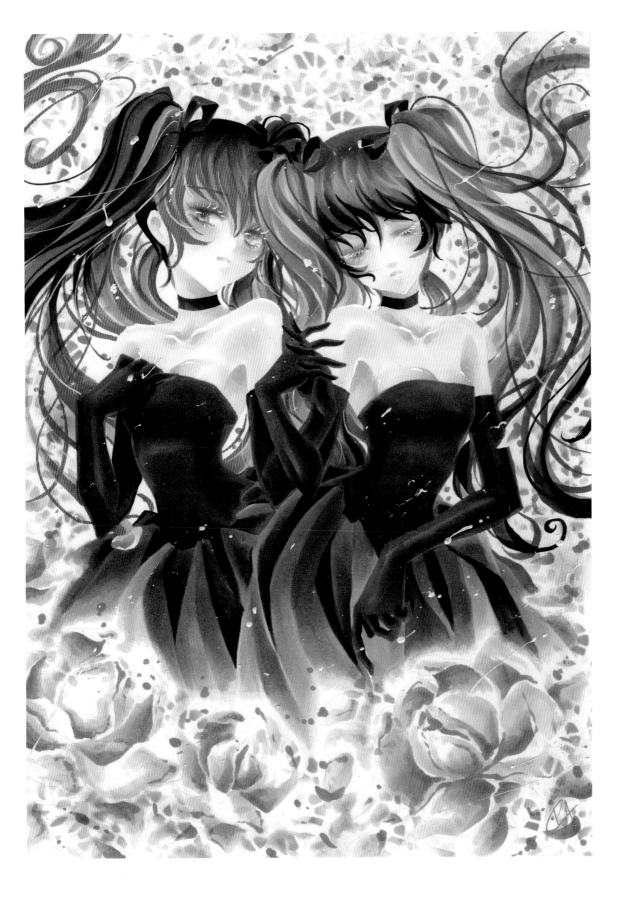

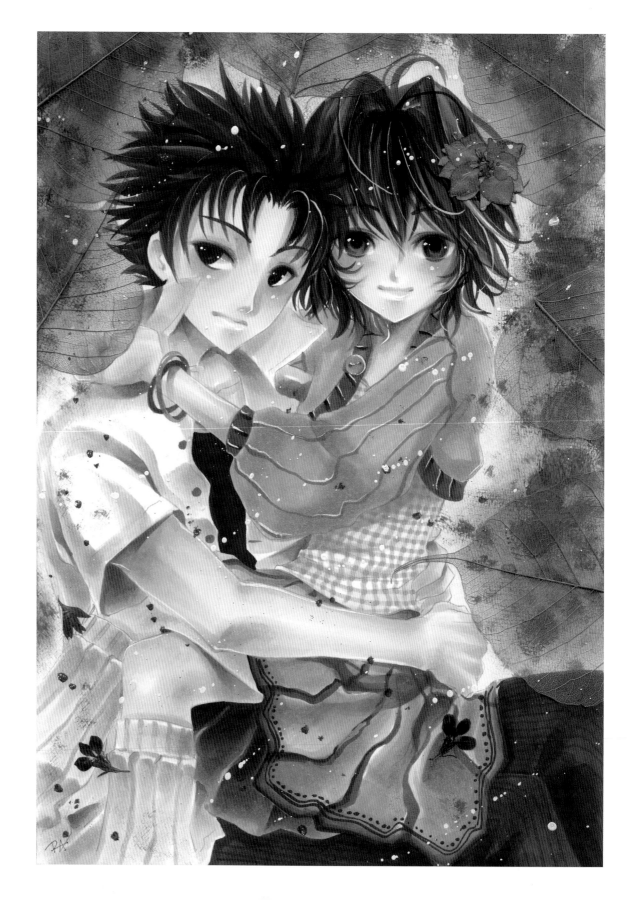

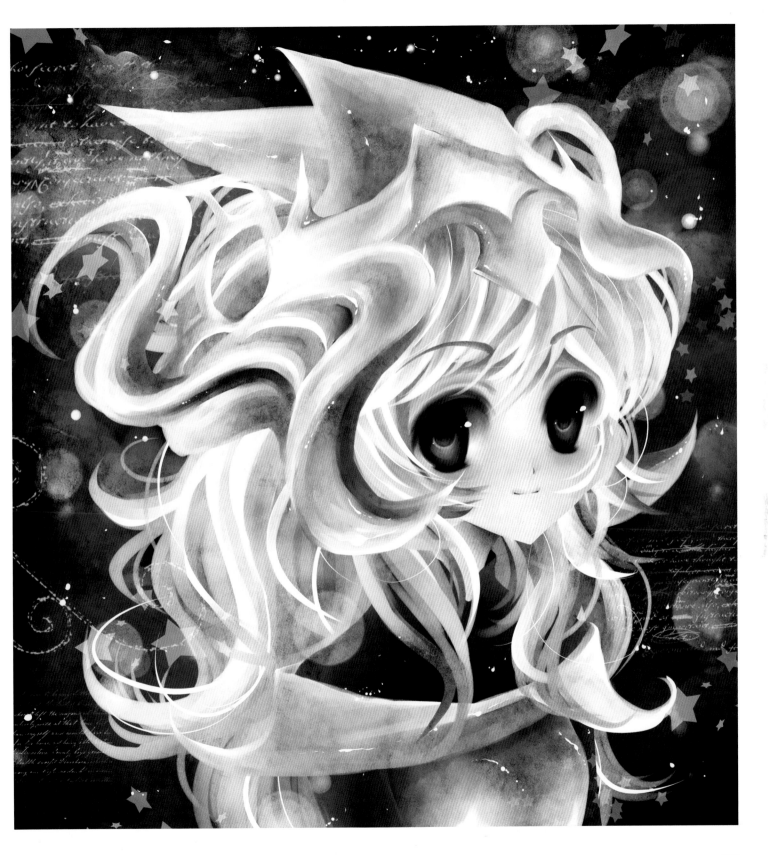

Masquerade
Pásztor Alexa

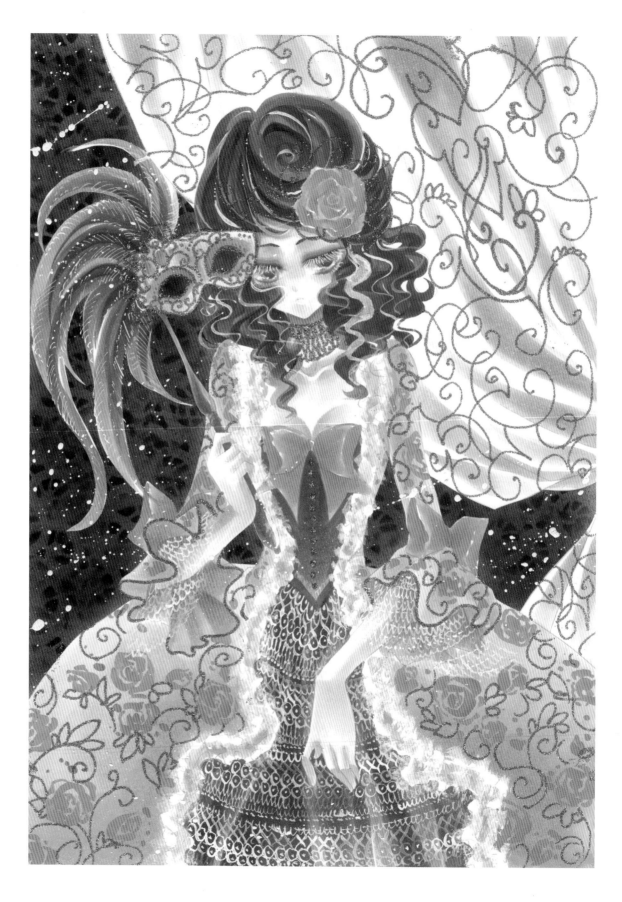

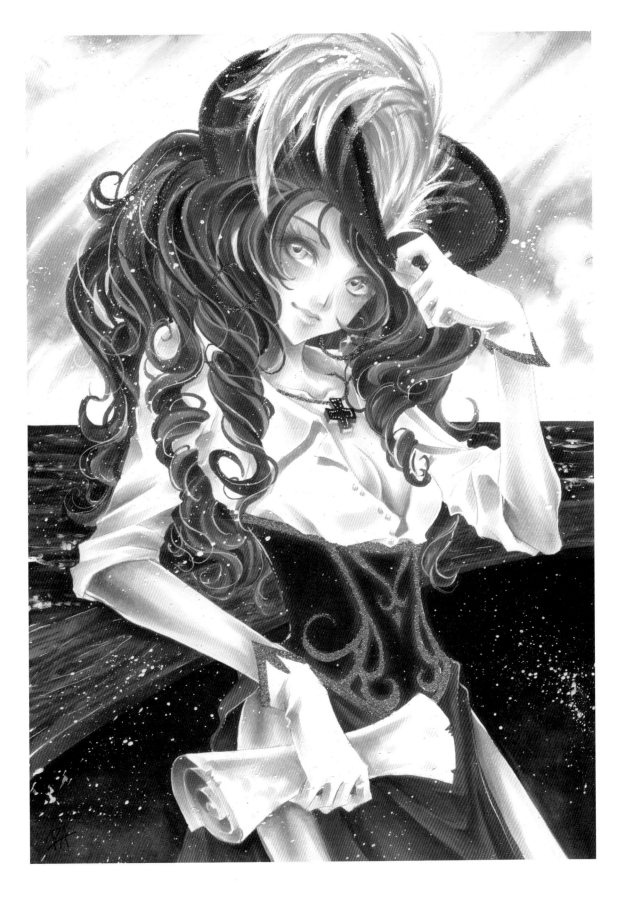

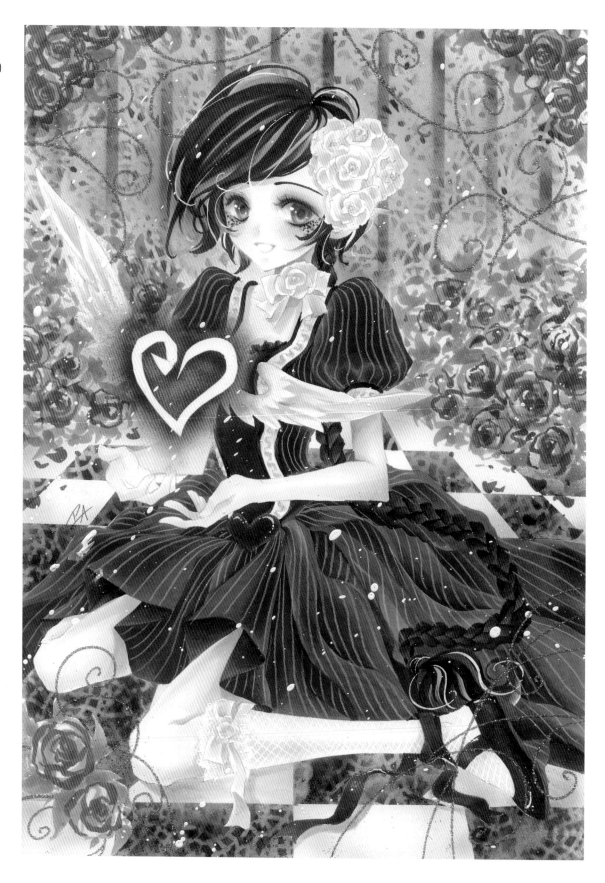

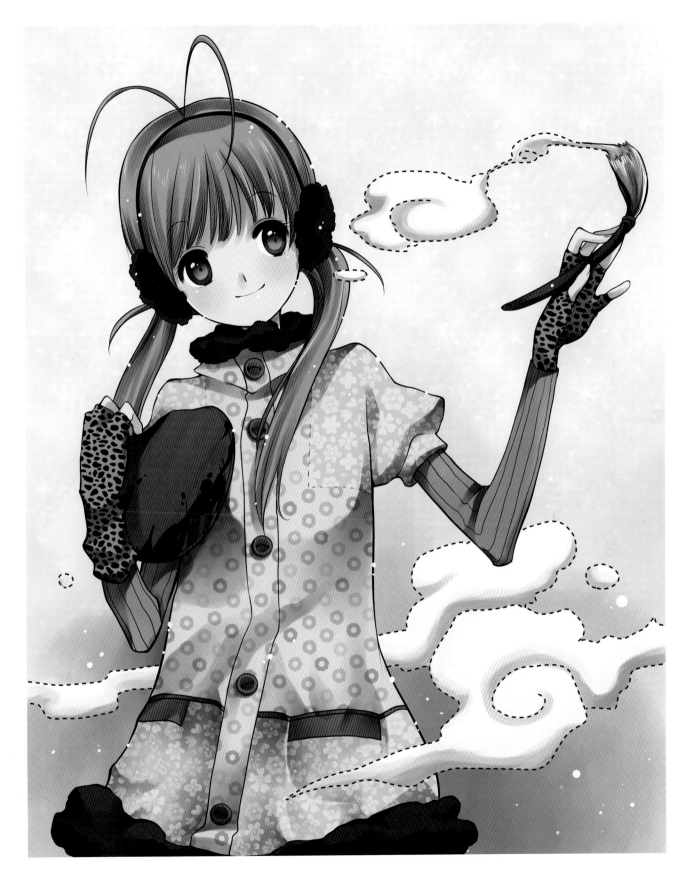

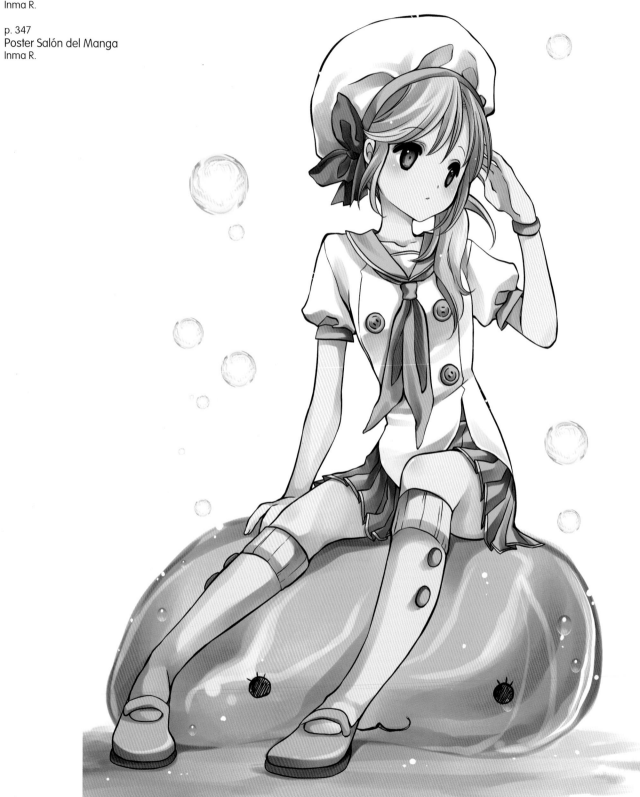

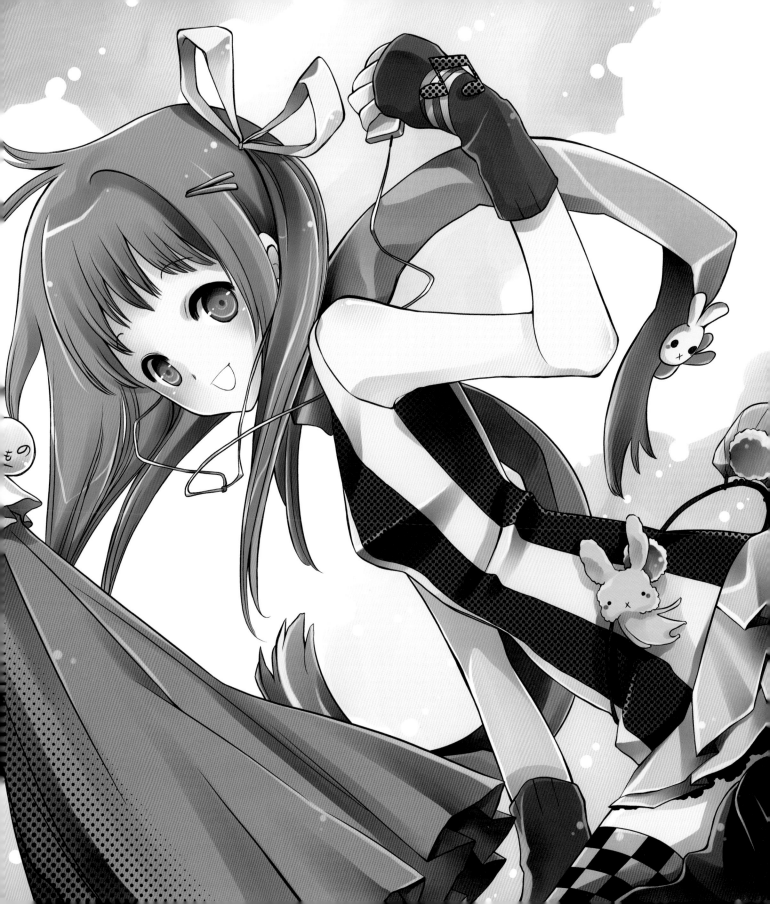

Snow White
Irene Rodríguez

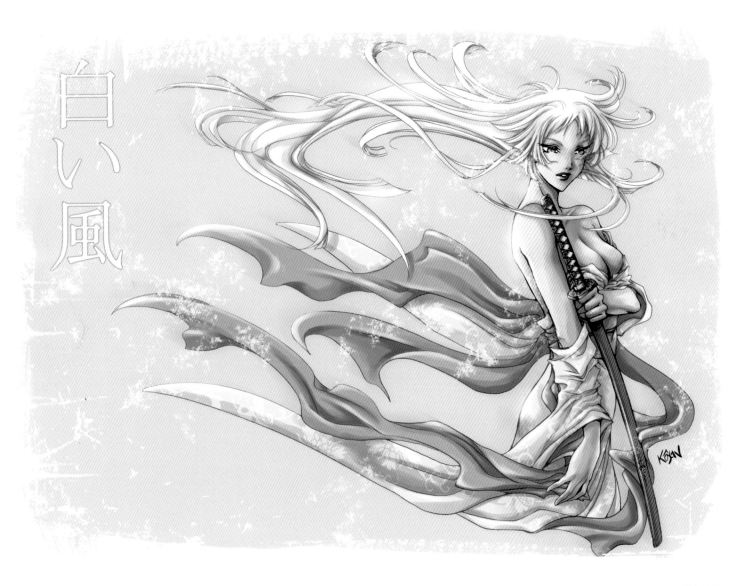

白い風

Shiroi Kaze
Aurora García

KAMIKAZE FACTORY STUDIO
www.kamikazefactory.com
info@kamikazefactory.com

Kamikaze Factory Studio is a Barcelona-based studio specializing in manga design work. Throughout their long careers, its team members have worked for companies like Canal Buzz, Pepsi and Chupa Chups, among others. Their work is focused on the publishing and advertising fields, multimedia creation and packaging design.